Critical Praise for the Mysteries of Sheila Simonson

"Good news for Sheila Simonson's readers. To her intelligent style and convincing characters she has now added an intriguing locale [Columbia River Gorge, in *Mudlark*], making an already superior series even better."

—*San Diego Union Tribune*

"Sharp characterization—particularly of the marvelously wry Lark—and a mystery that is skillfully intertwined with Lark and Jay's life as they try to start a family grip the reader's interest up to a resolution that puts an intriguing twist on the standard sleuth-in-danger finale."

—*Publishers Weekly*

"Beautifully crafted prose [in *Buffalo Bill's Defunct*] lays out an interesting, multi-faceted story, filled with a varied array of three-dimensional characters you believe in and care a lot about, with a distinctive, vividly depicted setting.… I'm delighted to see Sheila Simonson back in print and look forward to the next book in her new series. Highly recommended."

—Kim Malo, *MyShelf.com*

"Sheila Simonson covers some interesting issues—small-town politics and budgetary constraints, extremist beliefs and Native American problems with land development and the looting of Indian artifacts. The camaraderie between the cops and the evolving relationship between Meg and Rob add a richness to the story. Oh yes, and there's a swell dog named Towser who plays a big part in this excellent mystery. VERY HIGHLY RECOMMENDED."

—Sally Powers, *I Love a Mystery*

"As the body count climbs, [Simonson] proves that the stereotype of the timid, mousy librarian is not only out of date, it's just plain wrong. *Buffalo Bill's Defunct* is a nail-biting roller coaster ride which becomes increasingly exhilarating as the book races along. And the finale, complicated as the plot has been, ties up every loose end."

—Betty Webb, *Mystery Scene*

An Old Chaos

MYSTERIES BY SHEILA SIMONSON

THE LATOUCHE COUNTY SERIES
 Buffalo Bill's Defunct
 An Old Chaos

THE LARK DODGE SERIES
 Larkspur
 Skylark
 Mudlark
 Meadowlark
 Malarkey

An Old Chaos

A LATOUCHE COUNTY MYSTERY

Sheila Simonson

Perseverance Press / John Daniel & Company
Palo Alto / McKinleyville // 2009

A Perseverance Press Book
Published by John Daniel & Company
A division of Daniel & Daniel, Publishers, Inc.
Post Office Box 2790
McKinleyville, California 95519
www.danielpublishing.com/perseverance

Distributed by SCB Distributors (800) 729-6423

Book design by Eric Larson, Studio E Books, Santa Barbara, www.studio-e-books.com

Cover image: Monotype by Lillian Pitt, from the *Ancestors* series
Collaborative Master Printer: Frank Janzen, TMP
Printed at Crow's Shadow Institute of the Arts, Pendleton, Oregon
Photographed by Dennis Maxwell, Portland, Oregon

"Sunday Morning," from *The Collected Poems of Wallace Stevens* by Wallace Stevens, copyright 1954 by Wallace Stevens and renewed 1982 by Holly Stevens. Used by permission of Alfred A. Knopf, a division of Random House, Inc.

"As I Walked Out One Evening," copyright 1940 and renewed 1968 by W.H. Auden, from *Collected Poems* by W.H. Auden. Used by permission of Random House, Inc.

10 9 8 7 6 5 4 3 2 1

LIBRARY OF CONGRESS CATALOGING-IN-PUBLICATION DATA
Simonson, Sheila, (date)
An old chaos : a Latouche County mystery / by Sheila Simonson.
 p. cm.
ISBN-13: 978-1-880284-99-5
ISBN-10: 1-880284-99-5
1. Indian reservations—Fiction. 2. Sheriffs—Fiction. 3. Real estate development—
Corrupt practices—Fiction. 4. Real estate developers—Fiction. 5. Columbia River Gorge
(Or. and Wash.)—Fiction. I. Title.
PS3569.I48766O63 2009
813'.54—dc22
 2008055730

For my best friends, and best first readers, Roberta Schmalenberger and Sarah Webb. Bless you both.

AUTHOR'S NOTE

For the purposes of this story, I rearranged the scenery and political geography of the western end of the Columbia River Gorge, subtracting Skamania and part of Klickitat counties from Washington and combining them into fictional Latouche County. Latouche County does not exist outside my imagination. Klalo, the county seat, resembles at least four small towns in western Washington, but is its own imaginary place. I hope there are real toads in it. It does have real bridges—to Hood River and Cascade Locks in Oregon.

I changed the demography of the local tribes as well as the geography, though I tried to make the ethnic variation plausible. The Klalo tribe is Chinookian in language and in some of its customs, but it is as much a product of my imagination as Latouche County. Its principal chief, Madeline Thomas, doesn't exist, but I wish she did.

An Old Chaos takes place early in 2005, about three months after the events I chronicled in *Buffalo Bill's Defunct*.

We live in an old chaos of the sun,
Or old dependency of day and night. . .
Deer walk upon our mountains, and the quail
Whistle about us their spontaneous cries;
Sweet berries ripen in the wilderness;
And, in the isolation of the sky,
At evening, casual flocks of pigeons make
Ambiguous undulations as they sink,
Downward to darkness, on extended wings.

—Wallace Stevens,
"Sunday Morning"

An Old Chaos

Prologue

T HE MOUNTAIN CROUCHED above a meadow as it had since it was made, not long ago as the life of mountains is measured, but long enough. To the north, the great volcano that had formed it stirred, setting off moderate earthquakes that came in swarms when an eruption was near, but singly or in twos and threes at quieter times. The other nearby peaks trembled, too, as if in sympathy, though sympathy was irrelevant, being a human emotion.

When the time came, the volcano would set off another chain of small earthquakes. When the time came, the smaller mountain would move, too, changing its shape. It would only take the right combination of forces—ice and rain, lots of rain, and one of those minor tremors. It was all a matter of time.

Part 1: Disaster

And the crack in the teacup opens
A lane to the land of the dead.

—W.H. Auden,
"As I Walked Out One Evening"

Chapter 1

Early January 2005

BETH HAD PLANNED the dinner party like the invasion of Iraq, though she hoped for less dire consequences. Apart from glitches associated with a new house, the problem was the basic incompatibility of the guests, but she was used to that. She was the wife of a politician.

Beth often thought her husband had been happier as undersheriff, just another cop. That was a long time ago. Mack was now into his fifth term as Latouche County sheriff. It was probably his last, because he was sixty-five and she was sixty-one, and both would be happy to retire in a few years to enjoy their grandchildren. For now, Mack was a politician. Lately, he had been behaving like a politician. She wondered whether he had noticed her disapproval.

Probably not. She sighed and shoved a platter of Costco hors d'oeuvres into the oven to warm.

On New Year's Eve, Beth had thrown a big bash to celebrate the general election. More than a hundred of what passed for glitterati in Latouche County had swarmed in, drunk California champagne or local beer, scarfed down the tidbits on offer, and swarmed out, heading for parties where no one would ask how much they'd drunk before driving home.

As they left, Beth mentally ticked them off her list of people she had to entertain. She poured fresh-ground coffee for those who stayed after the New Year toast, and gave thanks that paying off so many social debts had been so easy. Nevertheless, gloom descended. Their comfortable old house had never looked better—warm and welcoming and quirky. And then the movers came.

Now here she was, miles outside Klalo, in the granite kitchen of her perfect new McMansion, putting the last touches on another political dinner. Mack was still in the shower. She couldn't hear the drowned-porpoise noises he always made in the shower, because the master bathroom was several miles from the kitchen.

Everything was miles from everything else in the house. It was grotesquely large, even for a couple with five children and seven grandchildren. All my fault, Beth reflected grumpily. When she and Mack had gone over the plans with the developer and his architect, she had asked for changes and got them. What she had not said was that the place was too damned big, not just for Mack and herself, but for any family smaller than a corporation. It was wasted space. Beth did not like waste, and never mind that the developer had given them a fantastic price on the house.

She threw her pot holder on the slab of rock by the stove and took off the chef's apron she wore to protect her silk pantsuit. Time to check the bar. The dinner table had been set since three o'clock and looked nice enough. At least she'd had the wit to keep her battered old table. It sat invisible beneath Irish linen, covered with china and silver and wineglasses, all at the right distance from each other for people to talk to their neighbors. Houses should be that way, too.

This one wasn't. She trudged across the Great Room to the entryway. The bell rang again as she reached the door. Two complete strangers stood shivering under the light.

"Mrs. McCormick?" The woman gave a glossy smile and memory clicked on.

"Call me Beth, please. You must be the new county commissioner." Beth had seen Mrs. Bjork on TV for ten seconds the night of the special election in December. Catherine Parrish Bjork had replaced the late Hal Brandstetter. She was green. He had not been. Her victory changed the balance of power. Mack wanted to know how.

"Oh, Beth, call me Cate." The woman's gaze slid sideways to the trim, elderly figure beside her. A retired banker from California, Mack had said, older than his wife by a good twenty years. "This is my husband, Lars."

"Come in before you freeze. The wind's straight from Alberta."
Beth stood to one side as the Bjorks entered. The doorway was
wide enough to admit a Humvee.

Outside, a gust swirled pellets of snow across the triple-wide
driveway where the Bjorks' BMW stood under the security light,
creaking as it cooled. Beyond the street lay the county road and
the dark bulk of Prune Hill, named for a long-dead orchard. To the
right, across the street and closer to the highway, Beth could see
the Gautiers' house, floodlit always. The development held only
four other homes, all of them large, all illuminated to prevent in-
truders from breaking in. The lights did not make Beth feel se-
cure. They made her feel targeted. She'd never felt that way in town,
where chances of a break-in were higher.

It was a clear night. The sky glittered with stars—this far from
Portland you could see stars at night—and most of yesterday's
snow had sublimed away. Mount Saint Helens, quiet but still ac-
tive, lay twenty-five miles to the north and Mount Hood a bit clos-
er to the south. If you looked down the Gorge, you could just make
out a dim smear of light from Bonneville Dam. The views in every
direction were spectacular on a clear day, as real estate speculators
had found out. The assessed value of real property in the county
had tripled in the last eighteen months.

Murmuring friendly sounds, Beth divested her guests of their
coats and settled them on one of a pair of love seats in front of the
fireplace, which was drawing nicely now after an earlier puff of
smoke. She had retrieved the platter of canapés from the oven, set
it on the warming tray, and supplied the mute banker with a glass
of sherry and Cate with Perrier (twist of lime for the designated
driver) before the bell rang again.

As Beth plodded back toward the door she heard the woman
say something, low and sharp, and the man respond in a rusty
baritone. So he could speak. She also heard sounds that suggested
someone else had come into the room. Male voice.

Not Mack. Skip Petrakis. Skip was the father of Beth's seventh
grandchild, Sophy. Mack despised him. In Mack's day, a decent
young man who knocked a girl up married her. Beth had explained

several times that it was their daughter, Peggy, who stood in the way of little Sophy's legitimacy. Peggy wasn't ready to get married, not yet. Skip had offered.

When Beth opened the door, smile in place, she saw Jack Redfern and his formidable wife, Madeline Thomas, principal chief of the Klalos and a woman to reckon with in county politics. Under her unzipped Gore-Tex parka, Maddie had chosen to wear a lavishly beaded elkskin robe, a matching headband, and calf-high elkskin boots, also beaded. They became her. As usual, Jack wore jeans and a Pendleton shirt. His parka was zipped to the neck against the knife-blade wind. Jack was not smiling.

Mostly to protect her heirloom boots, Maddie had decided to let Jack drive west from Two Falls to Klalo, though he drove like a cowboy on meth. Tonight he was erratic as well as fast because he was angry. Jack did not want to enter Sheriff McCormick's house or eat at his table.

Since her husband was not a talker, it took Maddie a while to dig out the reason. As sheriffs go, McCormick wasn't bad. Her sister's son was a deputy, so Maddie was willing to reserve judgment, even cooperate with the sheriff. But Jack was set to explode, and so far Maddie had been unable to defuse him.

She winced as he squirreled around a sharp bend in the face of an oncoming car. "You know, Jack, I did talk to Rob. Mack offered him the promotion, and Rob turned him down. Rob doesn't want to be undersheriff."

"That don't matter. It's a slap in the face, appointing that kid Minetti."

"Rob says he's a born politician." Maddie thought that was true. She'd met Earl Minetti. "You know the undersheriff is groomed to run for office. Mack will retire soon. He wants to train his successor."

"Minetti was Rob's sergeant!" Jack tromped on the accelerator. The pickup leapt forward and skidded a little on the frosty surface. Fortunately there was no traffic. Jack eased back.

Maddie opened her eyes. "I suppose it does look bad."

"It *looks* like a fucking slap in the face," Jack growled, "whether or not it's meant that way."

Probably true. People would be talking. It surprised her that Jack, who usually didn't care what other people thought, should be so concerned about appearances.

She sprinkled calm on her husband's fury the rest of the way to Klalo. Then she had to start navigating, because the McCormicks' new house lay some miles out of town, off the county highway that followed the course of Beaver Creek.

As the road began to twist, Jack slowed down a little. "I don't understand you, Maddie. He saved your life. More than that, he laid his own life on the line for you." By *he*, Jack meant Robert Neill.

"I know. I'm grateful." And embarrassed. Maddie had been in that state since October, when she had managed to get herself taken as a hostage. She was rarely embarrassed and did not like the feeling. She added in her most conciliatory voice, "I like Rob. I even trust him. If he wanted the job I'd call out the troops."

Among Maddie's supporters were a number of dedicated young people from all three of the Klalo bands. She could picture them picketing the courthouse, no problem, but over this? She was saving them for the casino battle.

Jack said seriously, "They'd come running."

She nodded. "I can see their signs now. 'Minetti Out.' 'Neill for Undersheriff.' 'We Want Justice.'"

Jack grunted approval.

"If we were loud enough, the Portland stations would send cameras."

"Yeah."

"And then what?" she demanded.

"At least Rob would know you give a damn."

Maddie sighed. "He'd be mad as fire. He has to work with this guy." Rob was the county's chief investigator.

"*Under* this guy. If Rob didn't want the job, the sheriff should've gone outside the department."

"Maybe so." But Minetti was a known quantity. What racist thug might turn up if Mack hired an outsider? The trouble with

Jack was, he didn't think. There was nothing wrong with his brains and nothing at all with his heart. He was all heart. But he did not think things through.

Headlights shone, a horn blared. Jack cursed and dipped his lights. He twisted the wheel, and the pickup screeched around the next bend. "Where now?"

"Turnoff's coming up…there."

Jack headed uphill in third, shifted down. The engine growled, and the truck's lights bored a hole in blackness. No house lights out here. Yet. Sooner or later some fool would build a glass palace with a cantilevered deck leaning out over Beaver Creek.

"It's an insult," Jack muttered.

Maddie said softly, "Don't borrow trouble."

They came to a Y junction. She pointed to the right.

Jack leaned forward and peered into the dark. Steep black hills rose on either side of the ribbon of asphalt. "Here? No shit?" He drove on, much slower.

"Should be less than a mile now."

They rounded another curve. The land opened out to the right in a strip of prairie that sloped gently down toward the creek. House lights shone through scattered trees, but a vast black hill loomed on the left. Elsewhere it would have been called a mountain. The county road, recently widened and resurfaced, skirted its base.

"Jesus, Prune Hill."

"Cat Crouching," Maddie said in Klalo. That was the old name for the hill. *Cat* meant cougar. She shivered and turned up the heater.

When Jack pulled into the McCormicks' driveway, he parked the mud-splattered Toyota Tacoma behind a BMW that was already in place. The bumper of the pickup almost touched the car's gleaming trunk. Jack was still mad.

━━━

Kayla Graves slipped into the little black dress she kept to wear when she was dating somebody respectable and smiled at her image in the long mirror. Not bad for a thirty-two-year-old. Her January birthday always started the New Year with a blast. She was

recovering nicely from the celebration, which had not been at all respectable.

Tonight might be dull or fun, depending on who the McCormicks had invited. Her escort, Fred Drinkwater, was a dead loss, but maybe Rob would show up with the librarian. Back when Kayla had been on the right side of thirty, she and Rob had had an affair—well, more like a hot weekend—and she retained a soft spot for him. She bore the librarian no ill will, but Rob had a sly sense of humor, and Kayla thought an encounter under the sheriff's righteous eye might amuse him. Serve the old bastard right for putting that dork, Earl Minetti, in over Rob's head.

Kayla leaned toward herself and concentrated on inserting beaded and feathered earrings into her lobes. Fred would hate the earrings, she thought complacently as the doorbell rang.

She grabbed her black cashmere coat from the walk-in closet and inspected it for dog hairs. Tiffany's Lhasa Apso had left souvenirs. Kayla's ex-roommate had been gone two months, and she'd vacuumed heavily since then, but the dog hairs still rose up and smote anything black. She needed a new roommate, someone to help with the mortgage, but no pets next time. No more wind surfers either.

The doorbell rang, insistent. "Coming!" She was wearing three-inch heels, so she took her time going down.

"You're late," Fred snapped when she opened the door. "Come on, Kayla. I told you this dinner was important."

Important to Fred. He was a developer with a single-track mind, and the track led straight to Profit. When she'd locked the house, she shoved her small purse into her pocket. Have to get one of those gigantic leather handbags the fashionistas were flaunting this year. Maybe Fred would buy a pistachio green one for her. He liked to bestow expensive gifts, if he could write them off.

Fred took her elbow, so she let herself reel against him, hip to hip. He staggered but didn't lose his footing. For an old guy, Fred was pretty athletic. More ways than one. She grinned.

He inserted her into his warm Lexus and himself into the driver's seat. "The new commissioner will be there."

"Mrs. Green?"

"Bjork." He let out his breath in a huff when her joke registered, put the car into Drive, and pulled out onto Old Cedar Street. "You look good, Kayla, but you should lose the earrings."

Kayla was peering at the librarian's house across the way—lit up, somebody moving around, yeah, there was Rob in the hallway with his back to the street. His own house on the corner was dark. So he *was* coming. Contented, Kayla adjusted her seat belt and leaned back to enjoy the ride.

"We're going to be late." Meg McLean flicked on the air conditioner of her ancient Accord.

"Hey!" Rob gave an exaggerated shudder.

"It's the fastest way to defog the windows." She swished the wipers a couple of times. She was driving her car because neither of them had wanted to go in Rob's somewhat newer pickup. "Won't take long."

"You do realize it's twenty-two degrees out." Rob yawned and stretched. He'd had a stressful day at his laptop, writing reports.

"Seat belt," Meg murmured. When Rob clicked the belt into place, the little warning bell stopped. She eased down the street behind a county sand truck. "You know the way?"

"The development's on the open land below Prune Hill. According to Maddie, the Klalos never had a settlement there. Probably for good reason." Rob had grown up in town and knew the area almost as well as the chief did.

Meg had grown up in Los Angeles. "I have no idea where or what you're talking about." No traffic. She passed the truck and headed out on the county highway.

Rob laughed. "I know Prune Hill. Apart from that, I'm parroting Maddie."

"She's quite a character." That sounded patronizing to Meg as soon as the words were out. She winced.

"Quite a bulldozer," Rob said dryly. "I figure she and the new commissioner are evenly matched. If they decide to team up, look out."

"I don't see a San Francisco greenie like Bjork touting a casino."

"Maddie has interests other than the casino. She stopped a clear-cut up by the lake without breaking into a sweat. Bear left at County Road 12—about half a mile."

"Thanks." Meg squinted at the odometer.

"Turn the AC off."

She complied. "Sorry." The Accord began to warm up.

"Staff meeting okay?"

Meg had met with the library supervisors that afternoon to announce her plans for a bond levy next fall. She'd been head of the county library system for only two months, and she'd kept changes to a minimum to begin with. The levy would be her first big project. She described the meeting in some detail, and Rob listened with the intelligent attention she had come to expect and appreciate.

"Jackman giving you trouble?"

"Giving me the ten-year history of failed levies." Meg's chief assistant had also been her rival for the top job. "I can handle her. What she doesn't understand is that tax revenues will jump with all the new housing. She knows," Meg amended. "She just doesn't *believe*."

"I have to sympathize with her. Things have been tight for a long time." Unemployment was still high in the county among people in traditional occupations like logging.

Meg signaled for the turn and headed uphill. The Accord sighed and shifted down. They rode awhile in silence. She could not get used to the utter blackness of the countryside at night.

"Watch it!"

She stood on her brakes. The car spun out and stopped on the shoulder facing backward. Two black-tail does walked across the road unscathed. Meg let out a shaky breath.

"You okay?"

"Y-yes." Very carefully, Meg wheeled the Accord around and drove on, but she was still trembling with reaction when she parked in front of the McCormicks' gaily lit house. Rob rang the

bell and gave her shoulders a hug as they waited for someone to come to the door.

When Meg and Rob entered the Great Room, the guests were in cocktail mode with the sheriff and Fred Drinkwater—smoothly fit, dressed in casual winter wear, and half a foot shorter than McCormick—in deep conversation by the bar. The developer had brought Kayla Graves. She looked gorgeous, as usual, and winked at Meg in a neighborly way. Mack and Drinkwater glanced around. Madeline Thomas, in full regalia, turned away from a greyhound-like woman and smiled.

A brief hush fell. Everyone except an elderly man sitting by the fireplace looked at Rob. There was a burst of over-hearty greetings.

Meg stole a glance at Rob. He flushed and a muscle bunched at the hinge of his jaw, but he smiled and went into the hand-shaking ritual with Meg trailing him. Beth slipped out of the room. The sheriff, red in the face, poured Meg's tonic and lime and asked Rob what he wanted.

"Whatever Jack's drinking."

Mack poured a Full Sail Amber. Meg hadn't noticed Jack Redfern. Given Maddie's flamboyance, he was easy to overlook. Meg had the feeling that might be a mistake. He rose from one of the love seats by the blazing hearth and strode over to Rob, beer glass in one hand.

"Rob."

"Jack," Rob said amiably, shaking hands. "Good to see you. Not exactly fishing weather."

Jack snorted. He had been known to use a gill net, about which he and Rob had a running joke, but he didn't look to be in a joking mood. "I want to talk to you."

"Sure." The two men strolled to a conversation area that featured two armchairs, a lamp, and a framed print, a sophisticated takeoff on the petroglyph Tsagiglalal, She Who Watches. Clearly Beth had kept her old furniture. It didn't suit the house, and there wasn't enough of it to fill the huge room.

As Rob bent his head to listen and Jack started to wave his arm,

Meg turned away. They were probably going to talk about the appointment of Earl Minetti as undersheriff, which Rob thought was hilarious, though so far he'd shared his amusement only with Meg. As a subordinate, Earl had been a pain in the butt. Now he was so grateful to Rob for not raising a fuss, he'd probably bend over backwards to cooperate with Criminal Investigation—for a while anyway. Meg didn't like Earl, but she also thought Mack would stay on as sheriff for at least two more terms, so she had come around to Rob's way of thinking. Mack would keep Minetti under control.

As Maddie introduced her to the new commissioner, Meg saw that the man on the love seat was still staring at the fireplace. She thought he must be Catherine Bjork's husband, though the woman made no attempt to introduce him.

"We're late," Meg said brightly. "Have we missed the tour of the house?"

"The sheriff took us around." Mrs. Bjork sounded neutral.

Maddie did not look enthusiastic.

Time to get down to business. Meg meant to sound out the new commissioner on the subject of library levies.

Maybe it wasn't going to be so terrible, Beth reflected as she dished up the entrée in the kitchen. Rob had apparently eased Jack Redfern's anger. Skip and Peggy were removing the soup plates—the tiny Willapa Bay oysters in a light cream stew had vanished with satisfying speed. The roulades smelled great—sage stuffing. She napped each slice with wine sauce and began to dollop garlic mashed potatoes onto the plates.

Peggy whisked in. "What's with the old guy, Mom?"

"Mr. Bjork? I don't know. He's hardly spoken."

"He didn't touch the soup, either. He looks like he's going to cry."

A squawk came over the baby monitor. "Speaking of crying, is that Sophy?"

Peggy sighed. "I hope not. She should sleep for an hour. God knows she ate enough, little pig." Peggy was breast-feeding. Since

that gave her boobs worth mentioning for the first time in her life, she didn't complain much about the inconvenience.

"Maybe you should bring Sophia into the kitchen." Skip carried the last soup plates in. "She could snooze on the counter here while the dishwasher runs." He began putting the shallow bowls into the machine without rinsing them.

Oh, well. "Dishwasher lullaby," Beth said.

Peggy sprinted for the bedroom wing. "Back in a sec."

Beth took a slotted spoon and doled out the fashionably crisp beans-with-blanched-almonds that looked better than they tasted. She preferred to cook the hell out of green beans, seasoning them with garlic, chopped bacon, and a dust of cayenne, but that was family food. Skip hoisted three plates and made for the dining room.

She and Skip were pouring another round of cabernet when Peggy slipped back and took her place between Fred Drinkwater and Maddie. As Beth poured, conversation rose like the buzz of bees drunk on fresh nectar. Mack and Fred had a three-way flirtation going with Kayla Graves, who was a subversive rogue. Beth wished her well. Rob, Maddie, Jack, and the commissioner were talking across the table with Maddie in full flow and Jack almost cheerful. Beth sat down and picked up her fork. Silverware clanked.

"There's a crack," Lars Bjork said. He looked at his plate. A wisp of steam rose from the beans.

Beth stared. She hoped the movers hadn't damaged her china. Surely not. "A crack in the house?"

"The house. It's a new house. Did I say that?"

"Uh, no, but you're right. It's new."

He looked relieved and picked up his knife and fork.

"We just moved in," Beth babbled. "Haven't had time to buy much furniture. I really haven't decided what to do with the living...the Great Room. It's a large space."

He chewed. "Tastes good."

"Glad you like it." Beth took a bite of the beef.

"There's a crack," he repeated. "Did I say that?"

Beth felt a chill.

"I can't tell you how much I like the house," Cate Bjork inter-jected, smooth. "I recognize the idiom."

What did *that* mean? "Thank you."

Lars was silent. Cate talked pleasantly of her own new house, which stood on a twelve-acre parcel with a view of Mount Hood. They were leaving the high meadow natural—no lawns or intrusive alien plants. The air was like champagne, she said.

The baby woke, and Skip took her off for a change while Beth and Peggy served dessert. Eventually he brought his daughter back for a round of admiration. Then there was coffee. Beth poured it in the Great Room. Lars Bjork was sitting on the love seat again, staring at the fireplace.

"There's a crack." He took the cup Beth handed him and gave her a smile that subtracted twenty years from his age.

Beth smiled back. She felt like crying, but she didn't have time because somebody noticed it was snowing, and suddenly everyone wanted to leave. It wasn't until after the last guests had driven off—Fred and Kayla in the Lexus —that Beth could think.

"He must have dementia."

Mack gave her a bear hug. "Who, me? Not yet, old girl, but I'm glad the meal's over. How about that Sophy? Great timing, the little minx. Come to bed, Betty Boop."

Beth wandered back into the Great Room and sat down where Lars Bjork had spent a good part of the evening. Tears welled, and she wiped them away. "The poor soul. I wonder what he meant?"

She stared at the mantel and the flagstone chimney. Running down the wall beside it, from the high cathedral ceiling to the ledge at its base, was a hairline crack.

Chapter 2

January 2005, the following Friday

THE WEATHER CHANNEL was promising an ice storm. It had better deliver, Meg reflected, snug in her warm kitchen (propane furnace) with a pot of soup simmering on the range (also propane). She had just closed the county-wide library system. She was going to look like a dumb Californicator if the storm turned out to be a flash in the pan.

Tales from her staff that chronicled weeks without electricity had convinced her the locals enjoyed scaring new arrivals. After she'd shut down the library, Meg had driven to Safeway to stock up on candles. Half the town got there first. Meg took the last of the regular candles. Latecomers would have to be content with perfumed votive objects in Christmas colors. And it *was* slick out. She almost fell twice bringing her loot in from the garage.

When the phone rang, Meg answered on her cordless. Her cell phone sat charging on the counter, calls forwarded. She was saving it to use when the lines went down. Everyone said they would.

"You're home." Rob's voice crackled with atmospherics. In the background she heard clanging and a siren's whoop.

"I closed the library. What's happening?" She poured herself a scotch and settled in for a cozy chat.

"Fender bender." He sounded irritated rather than gloomy. If he had been investigating an injury accident, his tone of voice would have told her. Still, there he was, out in the storm, doing a job the uniforms usually handled. It was a small department. In emergencies, everybody took a hand at everything, and ice storms rated as emergencies.

"Are you coming here tonight?"

"Are you making soup?"

"Chicken with rice. It's already on the stove."

"I'll be there." Amusement warmed his voice. Rob thought feeding people was her ingrained response to disaster and was apt to tease her about it.

"Good." At least she hadn't had to make soup from scratch—she'd thawed it.

"Don't stay up for me. God knows when I'll get in. Oops. Gotta go. Jeff just fell on his ass." Jeff Fong was Rob's new sergeant, replacing Earl Minetti. Must be a big fender bender if both of them were sorting it out.

She clicked the phone off and went to look out the side door, which led onto the wraparound porch.

Ice had formed a delicate coat on every twig, weed stalk, and blade of grass. In the dim light of afternoon, the effect was magical. Icicles drooped from the garage roof. Branches of the huge old-growth cedar tree near Rob's garage bent almost to the ground. Under the spell of the ice, telephone wires looked like fairy chains, and everything shone silver. "Silver thaw" was the local term for ice storm. Meg shivered with alarm and delight.

As she watched, an old pickup with a camper edged around the cedar. Freezing rain slashed the beams of its headlights. Moments later a blue Civic started to pass, slid, overcorrected, and headed like a demented billiard ball toward the left rear end of the pickup. Neither vehicle was going fast, but the result was inevitable.

"My garage!" Meg shrieked.

The car hit and slid slowly around, stopping in the middle of the street. The heavier pickup, with the driver hunched in a futile effort to maneuver, oozed sideways up Meg's short new concrete drive. Rear-end first, the truck smacked into the door of her garage. The new door buckled. Plumes of exhaust from both vehicles streamed in the icy rain.

Meg stuffed her feet into her boots, yanked her coat on, and dashed out. That was a mistake. She skated across the porch and saved herself at the last moment on the rail. Icicles tinkled

and fell. She clung to the post and watched as the driver of the pickup opened his door and jumped down. He took two long strides, then both feet went out from under him, and he fell flat on his back on the slick asphalt of the street.

Kayla Graves got out of the Civic and walked toward her victim, flat-footed. She was shouting something. The pickup driver didn't move.

Still clutching the rail, Meg let herself down the steps and onto her flower-bed, which was covered with two inches of snow and a scum of ice. Her boots crunched through to solid dirt. "Is he all right?" she called.

By the time she had picked her way to the street, Kayla was on her haunches examining the man's head. Kayla was an RN, head night nurse at a large care facility on the River Road. Her patients were elderly, and many of them died, which went some way toward explaining her hot pursuit of life on her nights off. Meg wondered why Kayla was up and driving around when she ought to be asleep.

"Is he okay?" Meg repeated as she reached Kayla's side. It was raining hard now, and the rain froze on everything it struck, including Meg, Kayla, and the man on the street.

"Out cold."

More ways than one, Meg thought. Kayla brushed ice from the man's face.

"I don't think his skull is fractured. Big bump, though. He's probably concussed."

"He'll freeze!"

Kayla was taking her coat off. "Go to my car and bring my purse. I need the phone." She made a tent of the coat, shielding the man's face. "Open the back, too. My medical bag's there and one of those aluminum emergency blankets."

"Right." Meg made for Kayla's Civic with her feet flat and her arms out for balance. The engine was still running. Very gingerly, she drove the car to the curb in front of Kayla's house, popped the hatchback, grabbed the purse, and turned off the lights. She found the medical bag and the blanket as well as a plaid stadium rug,

all of which she carried back without falling down or dropping anything.

Kayla whipped the phone from her purse, and the number she dialed was not 911. While she waited for an answer, she retrieved her coat. Meg substituted the plaid rug.

For the first time, she got a look at the man who had fallen. He was about Kayla's age, early thirties, and had red hair, tousled and in need of a trim. He had strong bones that were a little too prominent and a nice mouth. It looked as if he hadn't shaved for a couple of days. The bristles were orange. He seemed oddly familiar, as if she ought to recognize him, but she didn't.

Kayla was mumbling medicalese to the cell phone. Meg had long ago given up translating doctor-speak, so she whisked ice from the man's body. He wore jeans and a jacket over a faded flannel shirt. His heavy boots pointed at the sky. They had a coating of ice, too. Meg brushed them off and stuck her hands into her coat pockets. Move him? How?

Kayla handed her the phone and took a stethoscope and a blood-pressure cuff from her bag.

"Hello, er," Meg said. "She's taking his vital signs."

"Who is speaking, please?" A foreign voice.

"A neighbor."

"Huh." The doctor, if he was a doctor, sounded cross.

Kayla beckoned imperiously, and Meg handed the phone back. Kayla recited the kind of statistics Meg forgot as soon as she left a doctor's office, listened for a considerable while, chewed on her lower lip, and said, "Yeah," several times. "But he's still unconscious."

Meg cleared ice from the man's hands. He groaned.

"An hour...okay. Thanks." Kayla shut the phone off and slipped it into her handbag. "Dr. Singh says all the ambulances are in use. We'll have to move him."

"How?"

"The emergency blanket. Lay it out beside him and we'll slide him onto it. I can cradle his head."

"You're sure?"

"Nope. I'm setting myself up for a lawsuit, but what the heck. I'm supposed to be a care-giver, right?"

"Right." I, on the other hand, am a librarian. Meg didn't say that. She stood up. Her knees creaked. "You'll have to tell me what to do."

"Take this into your house—it's closer." Kayla handed her the purse. "Light some candles while you're at it. The power's going to go out."

Sure enough, it did, just as Meg was pumping the Coleman lantern on her kitchen table. She managed to ignite the intimidating thing. The light it shed was bright and blue. When she got back to Kayla's side in icy darkness lit only by the pickup's headlights, the man was stirring.

"Can we wait for him to wake up?"

"No. Hypothermia."

Well, duh. Meg's teeth were chattering.

They contrived to slide the victim—or most of him—onto the aluminum blanket. His legs stuck over the end of the blanket. Kayla shielded his head.

"Now what?"

"Now we scoot him to your porch and lift him onto it. Then into your kitchen."

Meg spared a thought for her back, which was middle-aged. "I'm going to do the pulling?"

"I'll keep his head from banging on things. You pull."

It took some doing. The blanket slid readily enough, and the man didn't roll off it. Clutching his ankles, Meg duck-walked, low to the ground, to avoid slipping. So did Kayla. Halfway up the sidewalk to the porch, the man moaned and threw up. Kayla had turned his head, so he didn't choke on his own vomit, but it was a close call.

"Cheerios and a Mars bar," Kayla said, looking at the mess on the ice. She took a tissue from her pocket and wiped his mouth. He was unconscious again, if he had roused at all. Fright gave strength to Meg's flagging arms and screaming thighs. She tugged hard at his ankles. When they reached the porch steps, she was panting.

Kayla was not even winded. "One giant boost up to the porch, then we drag him into your kitchen. You have gas heat, right?"

Meg shook the kinks from her arms and legs. "Propane. Rob said it should keep on working, because the thermostat's so old it's not electronic." Meg's house was the oldest on the block, older even than Rob's gingerbread Victorian.

"You may have the whole neighborhood in with you before the night's out. *My* heat's electric." Kayla grinned.

"You're welcome to stay." By tomorrow everybody in the county would know that the new librarian was having a flaming affair with her next-door neighbor. If they didn't know already.

"Thanks," Kayla said. "On the count of three…"

The first attempt failed. The man rolled off the blanket, face down in freezing slush. Under Kayla's grim direction, they did better the second time, and Meg didn't quite spring her back. She opened the door on a blast of heat. They got their patient into the room eventually. He lay still in a widening puddle of water.

"Towels and dry clothes if you've got them."

Meg scurried off. She found a set of Rob's sweats in the power-less dryer, and a thermal blanket and half a dozen towels on the folding table. It took a while to mop up. By the time they'd dried a place on the floor, laid out the blanket, and stripped their victim naked, he was mumbling.

He was a true redhead, Meg noted with interest. It seemed that Kayla was still in a clinical frame of mind, however, so intent on warming him up, she didn't pause to admire his anatomy. Rob's gray sweats were an inch short but fit him otherwise. He lay inert.

Meg hauled his sopping clothes and the wet towels back to her tiny utility room. Then she changed her own wet clothes at the folding table. One of these days she would put the laundry away. She brought Kayla a set of sweats.

Kayla still knelt by her patient. She was slipping a self-sealing bag full of crushed ice under his head.

"Ice!" Meg offered the dry sweatsuit. It was pink.

"Reduces the swelling." Kayla took a look at the sweats and burst into laughter. "Yours? Way too short. I'm going home." She jumped

to her feet. "Back in fifteen minutes. If you have more towels, warm them in the oven and wrap him in them."

"What if he wakes up?" Meg wailed.

"Talk to him. Find out who he is."

"His wallet fell out of his jeans."

"So what's his name?"

Meg flipped the scuffed leather wallet open. "Charles Morris O'Neill. Pullman address, Visa card, debit card, gas card. What's he doing down here?" Pullman lay three hundred miles to the northeast, on the Idaho border. Its chief claim to fame was Washington State University, the science and engineering school. Maybe O'Neill was a professor. He was too old to be an undergraduate. Maybe he was—what was the current euphemism?—a returning student.

When Kayla disappeared into outer darkness, Meg set the oven to two hundred degrees, lit it with a long match, and ran upstairs for more towels. She also found socks. She warmed everything and swaddled O'Neill, then sat by him on the floor. He still looked cold, but that might be the light of the Coleman lantern. Ice slapped the windows. She thought of her neighbors trapped in their chilling houses and of Rob out on the road.

The man said something. Meg jerked from her reverie. "What is it, Charles, uh, Charlie?" Maybe he went by Chuck.

"Head."

"Yes, you fell and hit your head. We think you have a concussion."

"Mmmm." He drifted back into stupor.

Meg sat still, willing Kayla to hurry. After what seemed ages, O'Neill stirred again and said something else.

"What did you say?"

"Cousin."

Meg stared.

He was frowning. His eyelids fluttered and opened. His eyes were blue. "Looking for my cousin."

"So you shall but not now. You've hurt your head."

The brilliant eyes closed, but the frown didn't ease. "Got to find him. They must've lost the report."

Meg digested that, or tried to. It didn't make sense. "Where does he live? Your cousin."

"Right here." He sounded aggrieved.

She opened her mouth to say no he doesn't, closed it. "Er, what's his name?"

But he had drifted off again.

Meg was busy adding and subtracting. O'Neill. Neill. Rob was this man's cousin. Charles O'Neill looked familiar, not because he resembled Rob, but because he looked like Rob's father.

Rob had shown her one of those studio portraits taken of soldiers before they go on active duty. Charles Neill, staff sergeant, killed in Vietnam in 1968, a long time ago. He'd had red hair. Rob took after his maternal grandfather, Robert Guthrie, who had raised him in Klalo. He talked of the Guthries often and with affection, but he rarely mentioned the other side of the family.

"Nasty out there!" Kayla shouldered her way in the door carrying a load. She'd been gone half an hour by the kitchen clock, which was battery-operated.

Meg relieved her of a laptop computer.

"It's his." Kayla shifted her remaining burdens, a small carry-on bag and two grocery sacks. She had changed into wool slacks and an angora sweater under a parka. Ice slid from the parka onto Meg's antique linoleum. "I shut the pickup down. The engine was still running. I think he was living in the camper." She held up the grocery bags. "Clean socks and underwear, jeans, a sweatshirt. I locked the camper. He's a rock hound."

"What?"

"Trays of rocks. Books on geology."

"It's cold weather for rock hunting. He was probably going to ask Rob for shelter from the ice storm."

"What?"

"I think he's Rob's cousin. Something he said."

"Strange." Kayla shook her head. A spray of water sprinkled their patient, and he stirred again. "Good. He's waking up. Where can we put him? I don't like the idea of hauling him up the stairs. Is there a downstairs bedroom?"

"It's my office these days. There's a hide-a-bed in the living room."

"That'll do."

"I'll have to make the bed up."

"Well, hurry." Kayla knelt at her victim's side.

Meg ran upstairs. As she hunted down linens, pillows, a duvet, and a blanket, she wondered where she was going to put Kayla, who was clearly set to stay the night. There were three upstairs bedrooms, but Meg didn't want Kayla lurking up there, and she didn't intend to send Rob home.

By the time Meg had transformed the hide-a-bed, O'Neill had wakened and was sitting up, though he looked green.

Kayla was kneeling beside him with her arm around his shoulders. "Do you think you can walk?"

"Give me a minute." He clenched his eyes shut. "Christ, what a headache."

Kayla explained the concussion in earnest detail. He was obviously not listening. After a while, he opened his eyes and held out his hands to Meg. She grasped them, and with Kayla's help, he staggered to his feet. The three of them lurched down the hall to the living room, where he collapsed on the bed. The wonder was, he didn't throw up. Kayla went back for another Baggie of ice for his head.

Meg thought he'd passed out again, so she was startled when he spoke. "What's your name?"

"Margaret McLean. Call me Meg."

"Okay. I'm Charlie. Thanks for taking me in."

"You're welcome. You asked about your cousin."

"Robert. Neill he calls himself."

"I think his father dropped the O."

He smiled. "Caused a big stink. My grandfather was a local light of the IRA. They quarreled, and my namesake went off and joined the army."

"I see."

"Doesn't matter. Grandpa died last year of old age and bad temper. The IRA will do the same any time now."

Meg laughed. "I'm a Scot myself."

"Jaysus, I'm in enemy hands." The smile faded. "Robert is some kind of cop, right?"

"How do you know?"

"I Googled him."

Well, of course. "You were curious?"

"I was. Uncle Charles, Robert's father, must have been an interesting man. I have two first cousins named Charles and one called Charlotte." His mouth quirked. "The other guys, Chuck and Chaz, are older than I am, so I got stuck with Charlie."

Meg smiled. "I expect Rob will be glad to meet you."

"Well, I dunno. I e-mailed him last time I was in the area and didn't get a reply."

"Maybe you came across as spam."

"Maybe. He's a deputy?"

"He's head of Criminal Investigation for the county."

"That's good. I need to talk to him."

"Did you stumble across a crime?" Meg spoke lightly.

He frowned. "Not exactly. I just need his advice." He flopped back on the pillow and groaned. "Ow."

"Well, he'll come here sometime tonight. I promised him hot soup."

"Sounds good."

Kayla bustled into the room. "This is the last of the ice, Meg, unless there's some in your freezer."

Meg's turn to groan. The refrigerator and freezer were definitely electric. She could send Kayla out to the nearest snowbank for ice.

———

It was half-past two in the morning before Rob entered Meg's kitchen. He was cold, tired, and hungry. He was also annoyed, because he'd run a make on the pickup embedded in her garage door and discovered it belonged to a Charles O'Neill, who had to be his shirttail relative, the one whose e-mail he had deleted a year ago last July.

Rob stripped off a layer of clothing, removed his boots, and

carried the wet stuff into the utility room where he'd left a set of sweats in the dryer. They were gone.

Irritated, he fumbled his way back to the kitchen for a candle, lit it, and returned. No sign of the sweats. He did find another sweatshirt and a pair of dry jeans, which he put on. He tossed his wet clothes into the dryer before he remembered the power was out. Must be really punchy.

When he'd eaten a cup of succulent chicken-with-rice soup and swallowed a shot of whiskey, he ladled more soup and went exploring, cup in one hand, candle in the other. A dim light burned in the living room. Meg waiting up? Unlikely. He padded down the hall barefoot.

Kayla Graves was dozing in Meg's recliner. When Rob entered the room she sat up, blinked, and smiled at him.

"Hey, Rob."

"Hey, yourself. Your house cold?"

"I'm on duty." She nodded at the couch, which was in its bed configuration. A candle burned on the end table.

He looked at the sleeping figure and felt a jolt. Hot wax from his candle spilled on his hand.

"What's the matter?"

He shook his head, not ready to trust his voice.

She got up. She was wearing flannel pjs, a heavy wool robe, and bedsocks, startling get-up for a Victoria's Secret kind of girl. "Let him sleep. I'll wake him in half an hour." She took Rob's candle and herded him back down the hall. "Your cousin, Meg said."

He cleared his throat. "I guess so." There was no doubt in his mind. The man on the hide-a-bed looked so much like Rob's father it was the same as seeing a ghost. Worse.

As Kayla explained his cousin's concussion, Rob, emotions still churning, listened with only half his mind. She ladled soup for herself and warmed his. "So I'm giving him the private patient treatment. Maybe he won't sue me."

"Maybe not. Why aren't you out at the nursing home?"

She wrinkled her nose. "Please. The managed care facility. I

have Friday and Saturday off. With any luck, the ice storm will clear out by Sunday."

"I doubt it."

"You're a bundle of good cheer." She ate soup.

"Comes of dealing with idiot drivers." He was beginning to feel more like a sane person. The man on the couch was not, after all, a ghost. Rob offered Kayla a drink, which she refused, poured himself another, and yawned. "I ought to go to bed."

"With Meg?"

"Well, not with you, sugar. Mind your own business."

"What I'm doing." She gave him a crooked grin. "Stick around a few minutes and meet your cousin. I like him. Even concussed, he has a sense of humor."

Unlike me, he thought ruefully. He supposed it would be best to get the grand reunion over with. With luck, the kid wouldn't want to move in or borrow money. That pickup was a real beater.

Kayla gave Rob a comic account of the accident and its aftermath. She was chattering, filling in his silences. When he had swallowed the last of his scotch, she stood up. "You bring the candle. I'll do the introductions." He followed her down the hall.

It took a while for her to wake O'Neill, which she was apparently supposed to do every hour lest he slip into a coma. Whatever she did was bound to be correct. Kayla was a good nurse, and she was sharper than a tack when it came to reading people. Too sharp, sometimes.

"C'mon, Charlie, wakey-wakey." She shook his shoulder, and he groaned. "Time to meet Cousin Robert."

"Nnngh." He opened one bleary eye. "Hi."

"Hello."

He held up an unenthusiastic hand. "Glad to meet you."

Rob took it. It was hot—or his own was icy.

"Need to talk to you."

Now it comes, Rob thought. The favor. "Okay."

"You work for the county, right?"

Rob gaped. "You could say that."

"Good." He blinked hard as if trying to wake up. "Drove out

County Road 12 yesterday—'s after midnight—day before yesterday. Beyond milepost 18."

"Prune Hill."

"That's it. New houses out there, six of 'em."

"I know the place. What about it?"

He frowned. "I was working for the state, summer and fall, doing site surveys. Year ago last summer. That hill's a Class II site."

"Class II," Rob echoed, mystified. "They're expensive houses."

"Matchwood." His eyes closed. "Match…mmm, mass wasting. High LHA."

"I don't understand."

"Fucking hill's going to slide over those houses." He made a face and forced his eyes open. "Sorry, Kayla."

"It's all right," she said faintly.

O'Neill tried again. "LHA. Landslide Hazard Area."

"Good God."

"Yeah. I want to know…weren't they warned? Should be a notification—LHA Notice—filed with the county."

"I see."

"Can you check the records?"

"I…yes. Or have them checked. Can you give me plat numbers?"

"Prob'ly." The eyes blinked wide. "Hell, my laptop! My fucking dissertation!"

"I brought it in," Kayla said in her most soothing voice. "Calm down, Charlie, and go back to sleep now. I'll wake you in an hour." He groaned, but his eyelids drooped. It took Rob a lot longer to go to sleep when he finally made it upstairs.

Chapter 3

IT HAD SNOWED half a foot during the night, but ice was now forming on the new fall like, well, like icing. It was eight A.M., and the house was dark, with Rob sound asleep upstairs, Kayla snoozing in the recliner, and O'Neill on the hide-a-bed. Meg stood at the porch door admiring the snow while her old percolator burbled. The candle on the kitchen table cast dancing shadows outward.

She supposed her sense of natural beauty must have developed from sights she saw as a child—surf rolling in at Malibu or mornings in the desert—but those sights had not included snow. Her parents moved to California to get away from midwestern winters, and they never went back. On her one weekend at Tahoe in winter, Meg had been too preoccupied with her boyfriend to take in much beyond her nose.

The snow was beautiful, no doubt of it—a treacherous beauty. Beyond the edge of her garage, she could see the snow-laden hood of Charlie's pickup poking out through the sleet. She wondered whether she ought to drive the truck to the curb in front of the house. His keys still lay on the kitchen table next to the laptop, so she could do it. But she didn't want to look at the damage to her garage.

" 'A blanker whiteness of benighted snow.' "

She turned, smiling. "You're in a cheerful mood. Have I found another English major?"

Charlie was leaning against the doorway, looking as haggard as a man with an orange beard can look. "That was just Sister Joseph

in sixth grade with her long ruler. I used to recite Frost when I had to shovel snow. Bathroom?"

Meg pointed. When he padded back she said, "How's the headache?"

"Better." He slumped on the nearest chair.

"Food? Not a greasy breakfast, I think."

"I couldn't keep it down. How about soup?"

Meg investigated. "Enough left for a cup or two." She filled a big bowl for him, found a spoon, then rinsed out the soup kettle. Thank God for city water.

While he ate, she poured coffee for herself and sipped. "Are you living in the camper?"

"Yes. At that new campground on River Road—at least, it was new when I stayed there a year and a half ago."

"I've driven past it." Rob had investigated a killing there last fall. Meg shivered.

Charlie ate another spoonful of soup. He ate slowly, as if he had to make an effort not to throw up. "It's a good place—toilets, showers, laundry, a kitchen."

"Vending machines."

He laughed. "Them, too. The manager lets me use his Internet connection for a modest fee. The place is quiet now, which is what I need. Bow hunters on weekends. Otherwise it's just me and Bellew—he's the manager. When I get tired of wrestling with data, we play pinochle or watch DVDs. I introduced him and his lady to the Coen brothers."

Meg glanced out the window. "*Fargo?*"

"They liked *Raising Arizona*."

"What kind of data? You said something about a dissertation."

"I'm almost finished with it."

"Geology?" Meg ventured.

"Yeah, I want the doctorate *and* the license. That takes time, but I should be done by June."

"Why are you here?" Obviously not to bond with Rob.

"The department gave me a couple of sections of Geology 102 to teach at the Vancouver campus spring semester. I may rent a place

in Vancouver or commute. I haven't decided. I have a community ed class already under way here at the high school. Next session's on Tuesday."

"Let's hope we thaw out by then."

"Amen, sister." He shoved the bowl away from him.

"Coffee?"

"No stimulants, no booze, according to her ladyship."

Meg smiled. Kayla, maintaining a professional persona. How long would that last? He was an attractive man.

"I suppose you wonder why I was looking for Robert."

She set her cup down. "Something about a lost report?"

"My supervisor filed the site analysis with the state, and the state was supposed to send an LHA notice to the county—Landslide Hazard Area notice."

"Where?"

"Prune Hill. That's what Robert called it."

Meg let out her breath in a startled *whoosh*. "But that's where the sheriff has his house. We ate dinner out there last week."

"The sheriff?"

Meg described the McCormicks' new house and watched Charlie's face.

Candlelight flickered on lines and hollows. He was frowning. He rubbed the spot between his eyebrows the way Rob did when he had a headache. "If the sheriff's in on it, the last thing he'd do would be to buy a house there."

"In on what?"

"Suppressing the warning notice." He drew a long breath. "Maybe there's no fraud involved. Maybe some clerk in Olympia forgot to file it. No, that won't fly. The builder has to have a geological survey done before the county approves his plans. There *has* to be a survey." He peered out the window. "It's unrealistic to expect him to do anything about it today, I suppose."

"By him, you mean Rob." Meg's mind skated in circles. "I ought to call Beth McCormick to warn her."

"Whoa! D'you want the developer to file a lawsuit? We have to find out what went on first."

"We."

"Robert. Somebody."

"You say landslide. What can happen exactly?"

He was silent awhile, frowning. "At best, rocks are going to fall on the road, rocks and mud if it rains a lot. I'm willing to bet it's been closed before, probably more than once."

Meg relaxed a little. "Inconvenient."

"That's the best case. This area is geologically mixed up."

"What else?"

"The worst case would be mass wasting. The whole hill could slide. It's a cinder cone sitting on top of layers of ash, over silt and mudstone and rafted boulders and God knows what. Water percolates through to the sandstone beneath it all. The hill has already slumped several times. The Wind River slide area isn't far from here, and there's another huge slide upriver that's constantly in motion. A landslip at Prune Hill would be a slide on top of a slide."

Meg gave a nervous laugh. "And it's twenty-five miles south of an active volcano." In the decades since the disastrous eruption of Mount Saint Helens, whenever the mountain burped, the small eruption was preceded and followed by moderate earthquakes, usually in swarms.

"You're from California?"

"LA. I survived the Northridge quake. People live with hazards all the time."

"I think you'll agree they should be warned, though."

"Yes. If the state hadn't enforced high standards, that quake would have killed a lot more people than it did. Still, there's such a thing as crying wolf."

"Sure. Which is why I want Robert to check the records—find out what happened to the warning notice—before I start talking about the danger in public."

"If the hill goes, those houses will be wiped out."

"That's only part of the problem. A big slide would dam the creek, at least temporarily. When the water broke through, it would flood everything in its path. Bye-bye River Road campground."

"And Kayla's nursing home. And all those fishing cabins built

on Beaver Creek." Many of them were cabins in name only—lodges with three-car garages.

"It could take out the east side of town, too." Charlie shoved himself to his feet. "I'd better go back to bed. Thanks for the soup."

Meg returned to her view of the ice storm. She was thinking about Beth McCormick, and Peggy and little Sophy. They should be warned.

———

Beth was surprised by the thank-you notes she received after her dinner party. Guests usually took care of that courtesy with a phone call, and Maddie Thomas did call. She was polite, as usual, but she startled Beth by offering to conduct a purifying rite for the new house. Though Maddie was a thoroughly modern woman, she had been raised by traditional grandmothers.

Purification of a new house? When Beth asked why—choosing her words carefully—Maddie just mumbled something vague. "It's what we do." Beth thanked her and didn't dispute the need, but she was baffled.

From the commissioner she received a formal note on correct, recycled paper. "Lars and I are grateful for your generous hospitality," the note said. Beth wondered how poor Lars was faring. Kayla sent a chirpy e-mail and Meg a warm one, praising Sophy's beauty and the quality of the cooking, two sure ways to Beth's heart. Even Fred, who always talked over or around her, sent an e-mail with his company's logo and an attached brochure in three colors.

She also received an attachment from Rob that showed Nancy Reagan gazing adoringly at the late president. Keep up the good work indeed.

Beth enjoyed a cheerful, mostly maternal relationship with Rob. After Hazel Guthrie's death, she'd helped him sort through his grandmother's things. She'd also been able to help him with his daughter. Like a lot of noncustodial parents, he worried about Willow more than he needed to.

When the child first came north in the summer, his impulse was to drop everything and plan a lot of activities. Since Willow suffered from an overanxious mother, Beth advised him to relax

and let the girl decompress. He'd done that, and Beth was happy to see they'd worked through to a comfortable relationship.

Rob's almost total lack of ambition was a puzzle to Beth, but she was grateful for his quiet loyalty to Mack. She hoped his relationship with the new librarian would work out. She thought it might.

As for the crack in the Great Room, new houses had to settle, didn't they? When Mack called Drinkwater, Fred made a joke about the crack but sent a crew the next day. They plastered over it and left her with another mess.

After the dinner party, Skip returned to his apartment near the University of Portland where he was a graduate student, but Peggy, who was still on maternity leave, stayed on. Beth enjoyed her company, but she also rejoiced that the house was so large she couldn't hear the baby crying during the night. She let Peggy deal with her daughter's colic, which Peggy did with competence and only a few tears.

At the courthouse, Mack was busy bringing his new undersheriff Earl Minetti up to speed. As for herself, Beth went back to teaching the remedial English classes she'd been coping with for twenty years. When the ice storm forced the high school to close early, she wasn't heartbroken. She forgot how isolated the new house was.

———

It was Monday before Rob got around to checking what had happened to Charlie's LHA notice, because he kept having to deal with accidents. The state people responded right away. The original survey, signed by Joseph Knapp, licensed geologist, and Charles M. O'Neill, M.S., did indeed constitute a Class II warning of landslide hazard. Rob called Professor Knapp, who turned out to be head of the geology department at Pullman. A genial fellow, Knapp praised Rob's cousin as an exemplary graduate student, experienced, looking at a career in hydrology, whatever that might be.

Rob thanked Knapp. Just in case, he also ran a police check on Charles Morris O'Neill. Nothing questionable turned up. He was who he said he was, born in Chicago to Thomas and Mary

O'Neill, B.S. from the University of Wisconsin and the M.S. from Washington State. He had worked in construction off and on, so he probably didn't object to development on principle.

O'Neill was teaching a geology class for rockhounds in Klalo and was listed to teach academic classes in Vancouver when the new semester started. He had no criminal record and had served four years in the army without distinction or discredit. He was thirty-three, which meant he was born several years after Rob's father was killed.

Thanks to a reserve generator, the courthouse and the annex that housed the county's emergency and police services had power. After a morning wasted freezing his buns on a logging road north of State Highway 14, Rob set his cousin's laptop to charge and slipped around to the courthouse to look at the records.

Slipped was the operative word. When he had crawled up the icy main stairway to the entrance of the Art Nouveau structure, Rob found only two offices open. That meant the records clerk would pay more attention to him than he liked, but he was too impatient to wait. She brought him the relevant documents, including Fred Drinkwater's approved plan to develop the site.

Rob double-checked the plat numbers to be sure. The geologist listed in the county's records was not Joseph Knapp but Martin Woodward of Vancouver, also a licensed geologist. The site was rated as Class III, approved for residential development. Construction had begun the previous May. Rob checked the date of Woodward's survey. About three months after Knapp's. He wondered how it had come to replace the original recommendation.

When he called Woodward, he got voice mail. Rob didn't leave a message. Frustrated, he settled in to write up the nine accidents he had responded to in the previous seventy-two hours. He called again, before he went out to tend to one last wreck, but still got voice mail.

It was eight in the evening when he returned to Meg's warm and welcoming kitchen. The pickup had been removed. Meg's garage door looked awful but could probably be coaxed to work. He found Meg and Charlie at the kitchen table playing dominoes

by lantern light. Charlie thanked him for charging the laptop. He looked better—shaven and wearing a WSU sweatshirt that clashed with his hair.

Kayla had already slid off to work in her little Civic, they said. Meg hadn't waited dinner for Rob, but she'd saved some pot roast. He could have eaten roadkill. He took a hot shower while Meg dished up.

"Have you had time to check yet?" Charlie demanded.

"Let the man eat," Meg said. "Your turn."

He grumbled but placed a tile on the Mexican train. Meg laid a double on the train, a double on her own train and another tile on that one. "One," she announced, smug. Charlie groaned.

Rob wanted to think through what he should say. The pot roast was caramelized to perfection and the vegetables tender as young love. Meg had made horseradish sauce. He ate, savoring, and edited what he knew.

The domino game progressed; Meg went out. While Charlie tidied the tiles away, she dished up ice cream that was on the edge of melting, she said, so they'd better eat it. She also set out a plate of cookies.

Rob smiled at her. "I'd like to see what you serve after earthquakes."

She wrinkled her nose. "Everything in my freezer is thawing, and you make jokes!"

"They *are* working on the power lines. It's supposed to warm up tomorrow, too."

"You believe that?" Charlie ate a cookie.

"'Hope is the thing with feathers.'" Rob stirred his ice cream. "I'll tell you what I found out, Charlie. Maybe you can fill in the blanks."

Charlie pushed his bowl aside, eyes intent on Rob's.

Rob mentioned his call to Joseph Knapp in Pullman and described the two conflicting reports.

"And you couldn't reach this Woodward?"

"No. Do you know him?"

"I don't, but Joe will."

"If a developer disagrees with the state geologist's conclusions, can he bring in his own man?"

"He can, as long as the guy's a licensed geologist."

"And then what?"

"Then the commissioners decide which version to accept, and argue it out with the state."

"Sounds like a recipe for corruption," Meg murmured. Both men looked at her. She went on clearing the table.

Charlie said, "There's a lot of that around. It's worse for archaeologists." Most counties require the evaluation of a site's historic significance as well as its physical stability. "The big developers have pet archaeologists on retainer and trot them out whenever an innocent government man finds a village or burial ground."

Rob winced and avoided Meg's eyes. He had reason to know the value of Native American artifacts. "I could call Chief Thomas. She told me there was no Klalo settlement out there, but she'll know if there's a history of corruption."

"Good idea. You said the state has my report on file, though. If Drinkwater's man got his survey accepted, the county should have notified the state people of the change."

Rob whistled. "Somebody fucked up."

"Or somebody suppressed the original survey before it got to the commissioners." Charlie rubbed his face. "Christ, what a mess. As far as the state is concerned, nobody built out there. I wonder how Drinkwater, or whoever, found out about the Class II designation."

"Maybe he called your supervisor and asked." Rob watched his cousin.

Charlie's hands dropped and his eyes blazed. "If you're claiming Joe took a bribe—"

"Hey! I think like a cop. I doubt that Professor Knapp is on the take, but stranger things have happened."

"I bet you checked me out, too." Charlie glowered. Then the steam went out of him. "I guess you had to."

"Knapp was complimentary. Why the army?"

"Maybe I was following in your father's footsteps."

Rob went cold.

Meg said, "That was uncalled for."

"Sorry," Charlie muttered. "I joined up after high school for the education benefits. Fortunately I didn't join the reserves, or I'd be on my third tour of Iraq."

"Desert Storm?" Meg asked.

He nodded. "Three wonderful months. Lots of rocks. Mostly I was in Germany. I liked that."

Rob had taken several long, calming breaths. He decided the best, and nastiest, course was to ignore both the insensitive wise-crack and the apology. "You'll want to consider your next step carefully."

Meg was running a sink full of hot water. Like the stove, the water heater ran on propane. "You guys do the dishes. I'm going to bed early like our pioneer mothers."

"Me, too," Rob said promptly.

"Dishes first."

Charlie stood and went to the sink. Maybe he felt guilty. After a while Rob got up and found a towel. They worked in silence. Stiff-necked genes. Rob sighed. "So you're teaching a class tomorrow. I hope you're up to it."

"I'm fine." Maybe Charlie thought that sounded surly. He de-scribed the course, adding, "I hope my students are up to it. They have a great excuse to cut class. Uh, Robert."

"What?" Rob dried a bowl.

"I appreciate your efforts. I'll call Joe Knapp tomorrow and see what he knows."

"He may not remember."

"I'm sure he will. We joked around about fools building at the foot of a slide. He'll have the data."

"If he does and the state does, we can see what the commission-ers have to say about the discrepancy. And we can talk to Maddie Thomas."

"*We.* Thanks." He hesitated. "I'll clear out of here as soon as the power comes on."

"I hope you're not going back to that campground. The man-ager moved his family into a motel yesterday."

"I decided to rent a room from Kayla."

Rob suppressed a laugh in time. "Uh, if it doesn't work out, you can always move into my house. There's lots of space." And I'm hardly ever there. He didn't say that.

"It'll work out." Charlie smiled dreamily at the saucepan he was scrubbing.

It warmed up during the night. When Kayla came in from work at half past six, she announced that it was raining—rain, not ice. By eight the temperature outside had risen ten degrees, and the electricity had been restored.

———

It rained hard for a week. By the second day the ice had melted, the schools reopened, and Maddie was planning the purification ceremony, really a ritual designed to avert bad luck, for the sheriff's new house. Beth was polite about it. Maddie thought it was urgent and said so, several times. They settled on a date in early March. She hoped that wouldn't be too late.

———

Rob called the geologist in Vancouver again. This time a tired female voice answered over the din of children squabbling.

He asked for Martin Woodward. "Your husband?"

"Father-in-law. We're house sitting. The lucky bastard's in Yuma until March first."

Rob identified himself and asked for a phone number.

"Latouche County. Not in trouble, is he?"

"I want to ask him about a survey he did out here."

She yelled at her kids and eventually came up with a Yuma number. Woodward answered on the third ring.

"Where?" the man asked when Rob had identified himself and described the problem.

"Latouche County," Rob said again. "County Road 12."

"Let me check. This will take a while. Have to boot up the computer." He listened while Rob gave him the site specifics. "Can I call you back?"

Rob agreed and hung up. It must have been a slow computer. He was just about to go out for coffee when Woodward finally phoned.

"I checked it out. Class III, residential. Did the survey for Fred Drinkwater. What's the problem?" He sounded bored.

"Do you recall the site?"

"Nice bit of open prairie, ideal for one of those upscale developments."

"What about Prune Hill?"

"Never heard of it," Woodward said. "Listen, I have a date to play golf in ten minutes."

Rob read out the plat numbers again. "If you know the site, Mr. Woodward, you know Prune Hill."

"Must be a local name." The man sighed. "We surveyed the area, gave it the full treatment. What's the problem?"

"A little disagreement with an earlier survey."

"Joe Knapp's kids. When a developer moves in on virgin territory there's always disagreement. I took my team in, did the survey, crawled all over the hill, took core samples, read up on the history. There have been minor slides on the road, surface debris, but the slope's stable."

"What was the weather like when you did your survey?" Rob was staring out his office window at sheets of rain.

Woodward snorted. "How am I supposed to remember that? It was October, probably cold and clear. The state boys are always cautious. I've done half a dozen surveys for Drinkwater. Two of the sites were unsuitable for construction, and I told him so. This one was fine. Drinkwater was happy, said the commissioners okayed his plans. That's all I know." He hung up.

Rob stared at the rain awhile longer, then sat at his desk and pulled up his calendar on the computer. He called Maddie and listened to her. She knew a lot about the Board of Commissioners past and present. Then he made two appointments, one to see the sheriff and one to talk with Catherine Parrish Bjork, the new commissioner.

Mrs. Bjork was noncommittal, as Rob had expected, but he thought she might ask her fellow board members a few questions. He was careful to point out that she had nothing to lose. Mack was not noncommittal. He blew up.

"Landslide hazard? That's nonsense. Why are you wasting department time on cockamamie complaints from nonresidents? Who is this O'Neill character anyway?"

"My cousin." Rob watched Mack's face. His indignation seemed genuine, but like most politicians, he was a good actor. "A geologist."

"Licensed?"

"Not yet, but the man he was working for when the survey was done is not only licensed, he's head of the WSU geology department. Look, Mack, I'm not trying to make trouble, and neither is Charlie. You're living out there. I thought you should be warned."

"Thanks. You've warned me. Get back to work."

Rob said softly, "I intend to look into this. Somebody didn't notify the state that the commissioners had accepted Drinkwater's survey, and there's no record that the matter came under discussion in the minutes of any board meeting. They just accepted the later survey without question. That bothers me." That and Prune Hill itself.

"Drop it," Mack growled.

"Why?"

"Because you are overloaded with serious investigations that matter to the people of Latouche County. I don't want you wasting department time."

Rob said nothing.

"That's an order."

Rob rose. "What about Beth?" He didn't wait for Mack's response, but he heard the explosion as he closed the door. He was willing to bet money that Fred Drinkwater would know he had trouble within half an hour.

Chapter 4

Early March 2005

IT WENT ON raining. Sluggish storms bred in the tropics kept the temperature in the fifties. Half the Pacific Ocean recycled through Latouche County in ten days.

Meg and Rob bickered after Charlie moved out. Meg knew the investigation was under way, and she understood why Rob wouldn't tell her what he'd found out about Drinkwater Enterprises, but the air of secrecy disturbed her. At dinner one night, she asked him when she could call Beth to warn her. He said he'd already talked to the sheriff.

"Well, that's good. Receptive, was he? Worried? Ready to move, lock, stock, and barrel?" She waved her fork.

"Be real."

"You be real. I bet he said 'nonsense,' or words to that effect. And he was angry that you doubted his good buddy Fred. He probably told you to forget it."

Rob's mouth tightened, but he didn't contradict her.

"Is he going to whisk Beth off to a nice safe motel? Not bloody likely. What's likely is that he won't trouble the little woman with bad thoughts about landslides. I think you should call Beth. And the neighbors."

"No. Don't interfere, Meg. It's not your business."

That frosted her cake. Ordinarily, Rob was open with her. At one point last fall, he had even sworn her in as a reserve deputy so he could talk a case over with her, and she had been able to help him in a material way. He knew he could trust her discretion. Since the ice storm, though, he'd been distant, preoccupied, unconfiding.

When she let him know how she felt about being shut out, he left. The next morning he phoned to apologize, so she did, too. Calling him a macho jerk had been unfair. He was not a jerk, and her timing had been poor. Rob came back that night, but Meg's uneasiness did not go away. The dreary weather was no help.

Two small events convinced her to override Rob's MYOB injunction.

The first was a minor library problem. The bookmobile driver, Annie Baldwin, called to say that she couldn't reach the community of Flume, because a landslide had blocked the road. Flume, at the north end of the county beyond Tyee Lake, was nowhere near Prune Hill, but a landslide was a landslide as far as Meg was concerned.

She reorganized Annie's schedule and called the county road crew to see how long it would take them to reopen the road. Several days, they said, during which the settlement would be cut off. North of Flume lay Mount Saint Helens, and there was no other way in because of the Gifford Pinchot National Forest.

The second event was a half-heard news report that the mountain was on the verge of another steam eruption. The lava dome inside the crater was swelling. There had been a swarm of tremors associated with the build-up.

It was after five, and Meg was on her way home. She stopped in the Safeway parking lot, sat in the car with the radio still on, and fiddled with the buttons. Its allotted four minutes of news over, the local station launched into a Conway Twitty retrospective. NPR was deep in commentary on lobbying scandals. Nobody cared about Mount Saint Helens.

Frustrated, she got out, ran through the rain to the automatic doors, and went in search of fresh salad makings. In the produce section, she bumped into Beth, Beth smiled at her, and suddenly it was too much.

Meg said, "Do you have time for a cup of coffee?"

Beth consulted her watch. "Just about."

As Meg poured two black coffees and pulled paper napkins

from a balky holder, she considered what to say, but there was really nothing to do but come right out with it.

The eating area had an ice cream parlor motif. Beth had nabbed a small round table. Meg handed Beth her coffee and sat on a wrought-iron chair. "Did Mack tell you about the landslide hazard at Prune Hill?"

Beth started. Hot coffee slopped on her hand. "What are you saying?"

Meg gave her a brief account.

"We're in danger?"

"Charles O'Neill thinks you are."

"Rob's cousin?"

"Yes. He did the original survey."

"But how could Fred…" Her hands clenched. "I thought there was something wrong," she blurted. "We don't have that kind of money. We haven't even sold the house in town…just making monthly payments on the new one…used my retirement to get a loan for the down…oh God, Michael! He *said* Fred contributed to his campaign fund."

Michael was the sheriff's given name, Meg recalled.

Tears welled in Beth's gray eyes. "It couldn't have been that much. Mack doesn't have to spend a lot on campaigning." She dabbed her eyes with a paper napkin.

Meg touched her wrist. "I've been thinking about it. I can't see him taking a bribe. He's an honest man. Isn't it possible Fred arranged the deal so he could go around saying the sheriff was living in his new development? That's much more likely than a bribe."

"My husband, the loss leader?" Beth sniffed. "The dumb galoot. I'll murder him." She did not mean Fred Drinkwater. She took a couple of hot gulps of coffee and stood up, trembling visibly. "Thanks, Meg."

"I don't mean to cause trouble." Meg bit her tongue. She knew she was causing trouble. Beth would shoot the sheriff, and Rob would kill *her*. Still, by the time she got home she hadn't learned to regret her impulse.

Rob was going to be late—a meeting with his investigation team.

She ate a solitary dinner, read her e-mail, talked to her daughter in Palo Alto, and had a long bath. Then she trailed off to bed to doze over a book. *Artemis Fowl.* Some anxious parent had challenged it. Meg thought it was funny. She dreamed she was conducting a public hearing with lots of angry patrons. Nobody listened when she spoke.

After a while she woke with the light shining in her eyes and a strong sense that she was not alone. She blinked her vision clear and saw Rob, like a ghost in his gray sweats, doing a karate exercise over near the window. Light glinted on his cropped silver-sandy hair.

Rob had been a student of karate since childhood, though he was not a fanatic. He often did the breathing exercises, which were similar to tai chi, at home or here in her bedroom, but he usually did them in the early morning. A form of meditation, he said. She liked to watch him, all quiet and inward, moving with excruciating slowness, but this night session puzzled her. If he needed the solace of meditation, something must have upset him. She glanced at her clock. It was only eleven.

Abruptly she remembered that she had told Beth about the landslide hazard, contrary to his advice. She sank back against the pillow and awaited his wrath.

At last he sighed and straightened, wriggling his shoulders, and padded barefoot to the bed.

"I'm sorry," she murmured.

He smiled. "Hey, you didn't break my concentration. Scoot over, lady. It's cold." He flicked the light off, slid under the covers, and gave her ass a friendly tweak.

It would have been honorable to confess then and there. She didn't. She pulled him close, and they engaged in another kind of exercise, skin to skin, that sent them both into heavy sleep.

When Rob's cell phone started ringing, he mumbled something and dug deeper into the covers. Annoyed, Meg grabbed her nightgown, yanked it over her head, and walked to the dresser, one sleeve straggling. Rob left his phone across the room, so he'd be awake by the time he answered.

"H'lo." She thrust her arm through the errant sleeve.

"Meg, it's Teresa Morales. Put Rob on, please." Teresa was the night dispatcher. She sounded flustered and not because Meg had answered.

"Mnn. Okay." Meg carried the phone to the bed and shook Rob awake.

Eyes still closed, he took the phone and muttered his name. Meg glanced at the clock. After five. Almost time to get up. As she found her slippers and robe, Rob sat up. He was frowning but said nothing. Time to make coffee.

She stumbled downstairs while he was giving Teresa brief, coded orders. Grateful for electricity, she pressed the button on her coffeemaker and hunted around for fast food. She found a bagel, sliced it, and popped it into the toaster. Turning from her dish cupboard with two mugs, she saw that a cop car had drawn up outside with its blue light revolving slow and steady. The shower was running.

When Rob clattered down two minutes later she was pouring the coffee into a Thermos.

"What happened?"

He pulled his heavy jacket on. His hair was wet and he hadn't shaved. "You were right." His voice sounded thick, as if he had a cold. "Commuter called in." He drew a long breath and took the Thermos, cradled it against his chest. "He was driving down from the north and couldn't get through. Prune Hill just slid across the county road."

Meg gasped.

"That's all I know." He turned to leave.

"Rob, I warned Beth. Yesterday."

He whirled, eyes blazing. "You did? Thank God!" He strode to her and kissed her on the mouth. "I love you. You ought to know that."

"I love you, too." Relief made her breathless.

He yanked the door open. "Call Charlie for me, will you? Ask him to drive out to the site. I'll tell the uniforms to let him through." Then he was gone.

Meg poured herself the dregs of the hot coffee and ate the whole bagel to calm down. She called Charlie's cell phone. He answered on the tenth ring. She explained what she knew and told him Rob expected him at the site.

"No way. I'm going to warn Kayla, and Bellew at the campground." He sounded grim and wide awake.

"Well, after that."

"They'll have to evacuate the nursing home if the creek's dammed."

"But you don't know it is. Go find out." Silence. She had taken the cordless phone down the hall to the front door, and she could see lights coming on in Kayla's house across the way. "Isn't her shift about over?"

"I'll call her first, tell her to wait there. She won't want to leave if there's trouble. After I've checked on her and Bellew, I'll drive to Prune Hill."

"I don't think it's a hill anymore."

He had already hung up.

Meg went to her office in the back bedroom, booted the computer, and called up her staff directory. She rang Annie Baldwin and told her not to take the bookmobile out on County Road 12. Annie thanked her, sounding scared. Her brother was a deputy.

On impulse, Meg also called her assistant, Marybeth Jackman. She explained what she knew and asked her to notify the rest of the staff, so they wouldn't drive into trouble coming to work. For once, Jackman didn't argue. There was no branch library to close near Prune Hill. Meg decided she'd done her managerial duty.

Then she tried calling Beth. The first time she got a busy signal. She went to the kitchen, brewed more coffee, and tried again. A mechanical voice informed her that the number was not responding.

She turned on the radio and heard the local station announcing a serious mudslide on County Road 12. Drivers should avoid the area, details at six. It was ten to six. She ran upstairs, took a shower, and was dressed with a mug of coffee in her hand when the news

came on again. Details? They had no details. She wondered if Rob had any. He probably hadn't got there yet.

She turned the dial and caught the end of a newscast from The Dalles. Mount Saint Helens had let off a steam plume that rose to 30,000 feet. The eruption, clocked at 4:58 A.M., was accompanied by a series of small earthquakes, the largest of which registered 4.2 on the Richter scale.

"Why didn't they call me?" Minetti demanded.

Rob gritted his teeth. "I *am* calling you."

"Immediately!" Earl went on as if Rob hadn't spoken.

The county car roared up the steep turnoff from River Road, light flashing. Jake Sorenson hit the siren, and an oncoming car slowed and pulled off.

"They called me to investigate the damage and Corky to deal with safety and traffic." Rob clutched his seat belt with one hand and the cell phone with the other as the car raced on. There were some conversations that should not occur on the police radio, which was crackling with calls.

He could hear Earl taking long, calming breaths. A plaintive female voice murmured in the background. Earl was newly married.

When he thought Earl would listen, Rob said, "I suggest that you go over to the courthouse. Phone the state disaster management people. Call in reserve dispatchers. Contact County Roads for earth movers—"

"Don't tell me what to do."

"Okay, I won't." Rob swore and clicked off the phone. Mack would have been sorting things out as soon as Rob opened his mouth. But Mack was not responding to calls.

Jake took a corner on two wheels and roared into the straight stretch. At the Y, he veered right without stopping.

"Better slow down. Might be rocks on the road."

Jake slowed to seventy. The radio crackled. "Isn't that your code?"

Rob identified himself. Teresa, still in control, patched him

through to Corky Kononen, head of the uniform branch. Laconic as always, Corky said he'd sent a car around to the north end of the slide to see if the creek was backing up. If it was, the people upstream would have to be warned to leave, and should he give the order?

"I think so, Cork. Call Minetti."

Kononen assented and signed off. Ahead, Rob could see the blue light of the first responder—Todd Welch, according to Jake. Todd was Maddie Thomas's nephew.

Rob couldn't see anything much. It was blacker out than the sewers of hell, and raining. When Jake squirreled his car in beside Todd's, Todd and Linda Ramos jumped out, Todd in uniform, Linda in a purple rainsuit. Rob got out, too, leaving Jake to tend the radio.

He glanced at his watch as he turned to look at the slide. Five-fifty—almost an hour before it would start to get light, sunrise well after seven. Then what he was looking at registered. He stepped back.

Debris sloped up in front of him higher than his head. "Move these cars. Now. Fifty yards that way, assholes. What makes you think it's stopped sliding?" Something rustled, and dirt and pebbles clattered down as far as Todd's car. They all jumped back.

Engines roared. Jake squealed away in reverse. Todd followed. Rob ran to Todd's car. "Point it so the lights shine that way. The houses are…were down there. Use the spotlights."

As Todd maneuvered, Rob strode to Jake's window and repeated the order. He straightened and peered into the dimly lit landscape. When Jake's spot came on, Rob thought he glimpsed something brighter than the chunks of ruined hill and upturned root balls that stretched down toward the creek. Roof tiles maybe. The first house they'd come to the night of the dinner party? All the houses had had roofs like California haciendas.

Todd's light wobbled, steadied. A boulder the size of a Volkswagen sedan rested downslope about a hundred yards. What did they call them, glacial erratics? Rob was no geologist, but that boulder had to have lain *beneath* the cinder cone. The whole damned

hill had fallen down. Jesus, Charlie, he thought, you're a fucking prophet.

He was still clutching the cell phone, so he redialed Minetti. The wife whose name he couldn't remember answered. "He's in the shower, Rob. Is it important?"

"Get him."

"Well!" She banged the phone down. After a good thirty seconds, Minetti came on, protesting.

Rob cut him off. "It's a *massive* slide. I need the lights." He meant the crime scene lights. "Send the SOCO van. We'll need Drinkwater's site plan, too, so we can find the houses. Send somebody into the Records office."

Minetti squawked.

"The closest house is buried up to the roof—over the roof. I'm afraid the slide hit Mack's place, too." He swallowed. "Call Drinkwater. I need to know who was in what houses. Don't forget lights, earth movers, shovels. Fast. And the creek's probably dammed. I don't see how it can't be. We need an engineer. Try Roads."

"What about dogs?" That was the first intelligent response Minetti had had. Rob had not thought of them.

"Yeah, dogs, and the search and rescue volunteers. Look, Earl, you're acting sheriff. *Organize* it. I'm going down there and dig."

━━━━━

Kayla had been on her last rounds when the medical assistant told her Charlie O'Neill was on the phone. "Tell him I'll call later."

"He sounds urgent, Nurse Graves." The medical assistant was a squat Bosnian with a droopy mustache and a formal manner. In the old country, he had been a doctor, he said.

She picked up the phone at the nurses' station. "What is it, Charlie? This better be serious." Kayla had made it clear that the relationship between her and Charlie was to be strictly landlady-to-tenant, and he had agreed. She was no longer sure that was what she wanted.

"Landslide upstream from you. Can you see the creek?"

"In the dark?"

"With this rain, it should be in spate."

She was peering out the nearest patient's room window. "I can't see a thing. No lights." That was odd. The interior lights were on.

"If you can't see white water, the slide dammed the creek." He sighed. "You may have to evacuate."

"What!"

"Not right away, but today, before noon I'd guess."

"You're guessing?"

He said with audible patience, "I'm giving you a heads-up, Kayla. Call your supervisor. If the slide did dam the stream, there'll be trouble both directions, flooding upstream followed by a surge when the creek breaks through, which it will."

The care facility's creekside location was one of its major amenities, with a wheelchair-accessible path following the stream bed. The lights along that path had gone out.

Charlie was saying, "If the county road crew has a decent engineer on tap, they may be able to siphon water off through a pipe or culvert, in which case you'll be okay, but it's a bad slide, according to Rob and the radio."

Kayla's mind skittered in four directions. He waited. At last she said, "Thanks. I'll call the boss. When will I see you?"

"No idea. I was going to come over to you, but I'd better drive on out to the site when I've warned the people at the campground."

She felt an absurd degree of disappointment. "Okay. You take care, and next time call me on my cell phone." When he hung up, she listened to the dial tone awhile. Then she called the general manager.

The facility had two buses with wheelchair lifts, capacity fifteen apiece. There were two hundred fifty-three residents, some of whom should not be moved if a move was avoidable. The Alzheimer's patients would be the most difficult, because many of them were mobile, but they were all fearful of change. In contrast, the patients on oxygen could be shipped to the hospital in ambulances—if the hospital had room, if there were enough ambulances. And where could the others go? As she talked, her mind began to spin out solutions.

"I hear something!" Linda Ramos cocked her head.

Rob and Jake Sorenson froze and listened, too. They had reached stable ground near where Rob thought the McCormicks' house had stood—exactly where was hard to tell. Rob had left Todd in his car to mind the radio.

Wind moaned and rain spattered. It was pitch black, still, with the power out and no sign of dawn, and their lights didn't reach far. They had already taken a look at the churned mass of brush, mud, pumice, timbers, and clay tiles that had been the Gautier residence, the house closest to the road. They'd heard no human sound there. Rob hoped the family had gone south for the winter.

"*¡También!* A baby." Linda was the single mother of one, attuned to a child's cries.

Rob heard it then, a thin wail, barely audible in the rushing darkness. He remembered little Sophy. Surely Peggy and Skip had taken their daughter back to Portland by now. The sound came again—ahead and to the right.

"Careful, Linda," Rob called.

Linda crashed ahead, heedless. "Here!" She yanked at tiles and rocks and splintered boards with her bare hands. The wailing continued.

Rob picked his way to her and grabbed her by the shoulder. "Take it easy. We don't want stuff falling on the baby. Back off."

Panting, Linda obeyed. Jake joined them, catfooted. Rob closed his eyes, trying to visualize the house. He'd seen the plans several times now, but he wished he and Meg had got to the dinner party in time for the grand tour. Jake and Linda were babbling. The baby whimpered. Rob ignored the sounds.

"It faced west. The entrance. This has to be the bedroom wing, one story above ground, daylight basement." Basement wasn't the right word. That level had held three bedrooms, one *en suite* and two with a connecting bath, hallway on the north, this side. The rooms had looked south, downslope, toward the creek.

"Master bedroom suite up here—bedroom, dressing room, bath, hall. This wing took the brunt of it. I hope—" He squinted to the right, shone his flashlight over the heaped-up ruins of the

Great Room. "Yeah, the chimney fell that way. We're at the edge of the upper hallway."

Where were Mack and Beth? If Sophy was here, where was her mother? He beat back panic. They should wait for the rescuers, people with experience, but what kind of experience? Around here, Search and Rescue dealt mainly with lost hunters, private planes that went down in bad weather, car wrecks in obscure canyons—not buried houses. And there was the matter of elapsed time. The sooner they reached Mack and his family, the better.

Where was the damned ambulance? Rob opened his eyes. "Jake, go back to the cars. Tell Dispatch we need an ambulance—now." The light from Jake's flashlight bobbed as he went off.

"Okay, Linda, let's do it together, slow, piece by piece. You hold the flash, I'll do the lifting. Talk to her. Her name is Sophy."

Linda began crooning, half in Spanish. Glancing at her, he saw tears streaming down her face. She jiggled with impatience, and the light wobbled. The child sobbed. The sound was muffled but not far away.

He scooped off mud, stones, and broken tiles, then began untangling the shattered wall joists and torn drywall. It was like a hideous game of pick-up-sticks. Pulling the wrong piece would send the rest crashing down. At least there was little glass. The north-facing hall had had only a few slit-like windows.

A fallen roof beam creaked and swayed. He jammed a piece of wall joist under it to steady it, then another. The beam was heavy laminate. He wondered whether the floor was intact, but it couldn't be. The whole mess sloped downward. He could hear material he'd dislodged sliding down. A tile clattered on something.

He pulled back, fearful he'd trigger a collapse that would take the baby with it. Linda gave a small shriek. "No, don't stop!" She swung the light, and Rob saw something, a purplish fragment, like a piece of cloth. He ducked under the beam he had propped up. A second beam had fallen sideways when something, maybe a boulder, smashed through the wall. Holding his flashlight in his left hand, he touched the fragment of cloth, and his finger came away damp. The color was drying blood.

He looked at the heavy beam with despair. It would have to be shifted. The baby howled almost at his feet.

"It's an arm," Linda whispered.

"Yes." An adult's elbow. Rob found another two-by-four, splintered at one end with protruding nails. He crept down past the patch of blood-soaked fabric and slid the joist under the beam to prop it so it wouldn't smash flat.

With small levers men have moved mountains.

"Jake," he yelled. "Bring a car jack!" The light skittered wildly as Linda turned to relay the message. Rob was already kneeling by the bloody arm, feeling carefully under and beyond it. Something wriggled, warm and wet. The baby. She whimpered.

"Little Sophy," he whispered. "Little Sophy." The arm had to be Mack's or Skip Petrakis's. Probably Skip's. He had shielded the child with his body. The baby gave a wail. She had enough room for that.

Rob tried to visualize as he felt along the arm. Right arm, crooked around. He touched the baby's head and another head, wet with blood. The man's body was pinned beneath the beam. Somehow he'd managed to twist sideways so that his shoulder took the blow, leaving the baby's head free in the small space between shoulder and chin. The child was stuck beneath his body and the heavy beam. Her cries and the fact that she was wriggling vigorously suggested she was unharmed.

The beam gave a heavy creak. Without thinking, Rob thrust himself under it and took the weight on his bent back. "Pull her out!" he gasped. "Ramos!"

Linda dropped the flashlight, scrambled to the protruding arm, and reached under. "I can't!"

Gritting his teeth, Rob strained upward. "Pull!"

Linda pulled. After what seemed minutes, the baby popped out, yelling. Linda scuttled away. It seemed safer not to move, though the strain on his back was hideous.

"What the hell?" Jake, arriving with the jack, dropped it with a clatter, squirmed to Rob's side, and the two of them shoved the

beam sideways. With a crash, it toppled against the boulder that had smashed the wall, exposing the upper part of the man's body. Debris rained down, quieted. Jake's light focused on the body. Mack. He was wearing pajamas, and both of his legs were pinned. He didn't move.

WHERE WAS PEGGY? Where the hell was Beth? Rob watched the ambulance bearing Mack and his granddaughter leave for the hospital. The siren gave a single yelp.

He was standing by the cars waiting for the search and rescue team with its dogs. The Scene of Crime van had arrived, and he'd ordered the crew to string light cables over to the Gautier place. He'd tried to call Drinkwater, to find out about the other houses, but got voice mail. He left another message, then called Minetti, who was busy looking for a hydraulic engineer.

Rob took a swallow of Meg's coffee and eased his sore shoulders. He'd eaten half a muffin someone offered and probably ought to finish it while he waited.

It hadn't taken him and Jake long to free Mack's legs with the jack, but Rob was afraid to move his old friend. The injuries looked too terrible. So they'd rigged a shelter with Jake's slicker. Mack wasn't bleeding a lot by then, and Jake claimed he'd found a pulse, but Rob wasn't optimistic. When they arrived, the medics looked grave.

Rob tossed his muffin into the darkness and headed back to Mack's house. Dogs or no dogs, he had to find Beth. He was not surprised that Linda, bereft of Sophy, tagged along.

"Somebody should stay with the radio," he said.

"I told Thayer to do that." Thayer Jones had driven the SOCO van.

"Where do you think the women are, Linda?"

"I don't know. It was a big place. The bedrooms downstairs? The bathrooms?"

"The slide hit around five o'clock. Mack was in the upper hall with the baby. It doesn't make sense."

"The baby, I think she has…"

He glanced at her. It was just light enough to see her face. She touched her stomach.

"Stomach ache?"

"Colic!" she said, triumphant. She was proud of her command of English idioms. "When Mickey cried like that, the doctor called it colic." Mickey was her son, Miguel.

Rob tried to remember if his daughter had suffered from colic. "I suppose it's possible." He turned his ankle on a rock and swore.

"So the mama's asleep. She's been up two nights in a row. The grandpapa is walking the floor with the baby and, um, the *abuela* is fixing coffee."

"In the kitchen?" They hadn't looked in the kitchen area at all. The Great Room had fallen on it. "You may be right." He quickened his pace.

They edged around the ruin of the three-car garage. The roof had collapsed, and the door had sprung. The mashed cars inside reflected glints of light. The ground beyond was not covered with much slide debris, just roof tiles, but it sloped down sharply, treacherous underfoot.

He couldn't remember what the basement level of the kitchen wing held, but it didn't matter, because the floor above had slumped, blocking downstairs entry. There was a door on the southwest side, a safety exit, probably from the kitchen, and the metal stairway that led down from it looked intact. He tested it. It creaked but held.

"I'm going up. Shine your light for me." It was getting close to dawn, but overcast and still raining, so it was dark. He made his way slowly, step by step. When he peered in the door, his flashlight shone on chaos.

Surely no one could live through that. Roof tiles, ripped drywall, cross beams, and ceiling fixtures had rained down on burst cabinets and fallen appliances. A big refrigerator lay on its front, cooling cables exposed. And that was just the kitchen. Beyond it,

the dining area had taken the brunt when the enormous flagstone chimney fell.

"Beth!" he called. His voice was swallowed by the darkness. He shouted her name again, and this time he thought he heard something. He cocked his head, listening.

"Help…" A reedy cry, barely audible.

Rob rattled the door. It was stuck. He looked down at Linda's anxious upturned face. "Get Jake and Todd, with a pry bar and the jack. Call for an ambulance."

"One is already coming." She trotted off.

Rob turned back to the door. "Beth, it's Rob. Can you hear me?"

A moan.

"Hold on, sweetheart. We've found Mack and the baby. They're on the way to the hospital. Are you all right?"

"I hurt…head…legs." She whimpered.

"Where are you?"

"Under…butcher block."

Rob had never gone into the kitchen. He tried to visualize what she was talking about and failed. He decided to distract her. "Do you know where Peggy is?"

"Sleeping." She hiccuped on a sob. "She was…downstairs, sleeping. Skip's not here. Oh God, hurts."

He talked soothing nonsense to her. It was hard to keep it up. After what seemed ages but was probably less than five minutes, Linda returned with Jake and Todd. They pried the door open, and Rob entered cautiously. He made the others wait outside. Everything was wet because most of the roof was gone, broken tiles on every surface.

Boots crunching the fallen shards, he kept to the edge of the room, inching down toward the far wall. Tiles fell as he walked. When he reached the wall, he found Beth almost at once, knelt, and took her hand. She whimpered but clutched at his fingers with surprising strength.

A roof tile had struck her head a glancing blow. A lump was forming, and there was a lot of blood. He touched the area

gingerly, and Beth moaned. He felt no fracture but couldn't be sure.

She was stuck beneath a cart with a butcher-block surface, which she must have dived under when she heard the slide. A falling roof beam had jammed it against the electric stove. Really a small table on wheels, the sturdy cart had protected her head and upper body from the beam, but her left arm was now pinned between the stove and one cart leg. A big square piece of what looked like granite had fallen onto Beth's legs. The counter? He heaved the slab off and examined her. Both legs were badly bruised. He thought one was broken, and there might be injuries he couldn't see. That she was alive at all was a miracle.

He smoothed her pink plush robe over the bruised legs. Her feet were bare. "Beth, we have an emergency here." No kidding. "Can you tell me who lives in these houses, who's likely to be at home?"

She gave a distracted moan.

"The Gautier house?"

"Um, four." She drew a ragged breath. "Husband, wife, teenaged boy." A gasp of pain. Her hand gripped his. "Mother-in-law. That's the wife's mother."

"Good. And the others?"

"Hurts!"

"I know, Beth. The medics are coming." He felt like a torturer. "Am I right in thinking there are two empty houses to the west?"

"Yes. And house sitter."

"What?"

"House on the creek. Friend is house sitting. They're in Palm Desert."

"Okay. What about the other house?"

"Family of three." She began sobbing with pain, so he let it go. A tile fell too near them for comfort.

Linda was summoning the newly arrived EMTs and a stretcher, but there was still the problem of freeing Beth without bringing the rest of the roof down. At that point, as in *noir* comedy, one of the search and rescue vans drove in. Rob hated to leave Beth, even for a few minutes, but he needed to talk to somebody who

knew what he was doing. Beth said she understood. As he left, he heard her crying. Against his better judgment, he sent Linda into the wreckage to hold her hand.

The rescue leader turned out to be a prize. He not only had an extra supply of hard hats, he'd also brought the site plan Fred Drinkwater had filed with the county. He'd got it from Earl. Drinkwater was still incommunicado.

Rob explained what he knew to the search leader, whose name was Bat Quinn—as in Bat Masterson, he said. Bat was a high school teacher and a hiker. He knew the area. He also had three burly construction workers on his team. They agreed to take a look at the kitchen and see what could be done, while Bat, his dogs, and the rest of the team searched for survivors. Rob suggested starting with Peggy McCormick, because he knew roughly where she was. After that, the Gautier house. Then the house sitter and the family of three. He'd heard nothing from that direction. He hoped they'd all gone off to Mexico for the winter. It was unlikely.

Bat set off toward the bedroom wing, eyes sparkling. One of the dogs, a beagle, was already snuffling the ground. Her trainer, a young woman in heavy hiking boots, let the dog pull her along. Rob felt his tension ease a little. He took a hard hat for Linda and put one on himself.

Bat's construction workers rigged supports so the EMTs could go in to Beth with their gear. Shortly after sunrise, Rob heard shouts from the bedroom wing that suggested the dog had found Peggy. He stayed with Beth—partly from affection, partly cowardice. He was afraid to know what had happened to Peggy.

Whatever they'd given Beth had eased her pain and made her drowsy, but she was thinking enough to start to fuss. By the time the medics manhandled her stretcher down the metal staircase, she was in a fine state.

"I'll see that somebody calls your kids and Skip," he promised. She'd said Skip had gone back to Portland.

"And Mack. What about Mack? You said he was on the way to the hospital."

Rob's throat tightened.

"Is he hurt? How is he? We quarreled." She was crying again. Rob hadn't thought of Beth as a crier.

He couldn't speak.

The paramedics picked up the stretcher—a gurney would have been useless on the uneven ground. Beth twisted her head with its turban-like bandage and glared up at him. "Tell me the truth!"

He cleared his throat, stumbled on a broken tile, and regained his balance. "He's hurt, Beth. I don't know how bad it is. He shielded the baby."

She cried harder. "I wish we hadn't quarreled."

Rob shoved aside his own guilt. When he had started the investigation, he'd been thinking in terms of correct police procedure. Common sense had taken a back seat. Meg was right. These people should have been warned, but there was plenty of blame to go around. When he thought of Drinkwater and the tame geologist, his hands itched.

Beth drowsed now, murmuring Peggy's name and Mack's, like a litany.

As they straggled up to the road, the young woman with the beagle bounded up to Rob. "Bat says to tell you Wienie found Ms. McCormick."

"I heard shouting." Wienie must be the dog.

"She's trapped in bed with a beam across her chest, not conscious, but she's still alive. Bat got to her!" Her face shone with hero worship. "Her pulse is strong."

"Thank you, uh—"

"Mindy."

"Right. That's Peggy's mother in the ambulance. I'll tell her the good news." If Peggy was unconscious and trapped, it was mixed news at best.

Mindy went happily off with the dog. Rob sent the three construction workers to see what they could do about freeing Peggy, then reassured Beth and sent her off, too. He called about ambulances. One was on the way. It sounded as if Earl was getting things organized at long last. Rob checked his watch. He told himself to be fair. It was seven-fifteen and barely light.

It was just possible to see the extent of the slide. The Gautier house and Mack's had taken the worst of the damage, but debris had rolled down around the two houses that lay to the east and on into the creek bed, which was dammed to about the height of a one-story house. The structures to the west looked untouched. Rob thought they were the ones no one had bought. Headlights bounced down the horse pasture on the south bank of the creek. He hoped the driver was an engineer, not just a sightseer.

Rob caught Linda as she headed off with Jake and Todd toward the Gautier house. "Get your camera."

Her mouth formed an O of surprise.

"Time to document property damage."

Her eyes narrowed. "Crime scene."

"Believe it." Among the defendants would be the County Board of Commissioners. He thought of Fred Drinkwater. If there were deaths, it might well be a murder case—at the very least wrongful death. On impulse, he called Judge Rosen and asked for search warrants for Drinkwater's office and house. He wanted to document the approval process every step of the way. The judge was sleepy, shocked, and ultimately responsive.

As Rob turned to go down to the McCormick house again, Charlie drove up in his camper, closely followed by another van full of rescue volunteers. They had brought digging tools and more hard hats. After he told them where to find Bat, Rob grabbed a hat for Charlie. It surprised him how glad he was to see his cousin.

Charlie stared at him.

Rob handed him the hat. "Did you call Kayla?"

"Right away." Charlie settled the hat over his red hair and scowled at the scene before him. "She was organizing a mass evacuation, last I heard. I told Bellew to close down the campground."

"Good man." Rob meant Charlie, but his cousin took the comment as a reference to the campground manager.

"Nice guy, interested in his customers. He says you investigated a murder out there last fall."

Rob didn't intend to get pulled into history, so he just nodded. "He was helpful. Deputies will go door to door along the creek, but

the sooner Bellew gets out of there the better. Now what about the creek, will it push through the blockage any time soon?"

"No idea. Let's go have a look."

As they did, they heard the yip of dogs and the shouts of searchers. Both rescue teams were swarming over the site of the Gautier house. Then they heard the house sitter's calls for help from the place on the creek bank. She sounded as if she'd been calling a while.

Madeline Thomas clicked her cell phone off. "That was Nancy Hoover. Landslide at Prune Hill. She heard it on the radio." A high school senior, Nancy was one of Maddie's corps of activists. She had also been Beth McCormick's student. Nancy was dyslexic; Beth had taught her to read when she was a sophomore. Maddie thought of Beth and the unperformed purification ritual.

Jack blinked sleepily and took a gulp of coffee. "She say Prune Hill for sure?"

"County Road 12. It's Prune Hill."

"If you say so, Chief."

She sniffed. She didn't like it when Jack kidded her. She was sure. Her dreams said so, and besides it stood to reason. Frowning, she stood at her kitchen window and looked out at the sodden village of Two Falls. She knew it wouldn't impress tourists, but she was proud of it because she remembered how it had been, a slovenly mass of decayed government housing and junked cars.

Tribal cooperation and pride had cleaned it up, repaired and painted the houses, and arranged credit for the new manufactured homes, some of them, like her own, double-wide. She was glad she'd had a hand in the regeneration, but there was still a lot to do. A casino might not be the only answer, but it was an answer. She consulted her list of phone numbers and rang Cate Bjork.

"You've heard about the landslide at Prune Hill?"

"The acting sheriff notified me." The woman's voice was cool. "We are all very concerned for Sheriff McCormick and his family."

Acting sheriff. That would be Minetti. Maddie felt a twinge of distaste. "Is Mack badly hurt?"

"The hospital said he's in surgery. The baby's fine."

Baby? Sophia. Anxiety swept through her. "And Beth?"

A pause. "I don't know, Chief Thomas."

"Have the commissioners conferred?"

The woman gave a yelp of laughter. "There's hardly been time. What can I do for you, Madeline? I'm afraid I don't function well until my third cup of coffee."

Maddie apologized and rang off. She did not like Cate Bjork, but the new commissioner might be useful. She was also an unknown quantity. No point in offending her.

"Wheeling and dealing?" Jack poured himself another cup of coffee and started to rummage in the refrigerator for breakfast makings.

"I'm just trying to find out what happened." There were three commissioners. Maddie had had confrontations with both of the other two, but she thought they respected her.

Karl Tergeson, the chairman of the board, was a dentist; Hank Auclare a realtor. She was about to call Auclare when she remembered her conversation with Rob about possible corruption on the board. His questions had been circumspect, but she owed him, so she'd been frank. She wished she knew the exact nature of his concern. She didn't think either commissioner was foolish enough to take a bribe. All the same, one hand washes the other.

Hank was always interested in new construction. People knew he would be when they voted for him. She didn't doubt that the developers sent business his way. Karl, a fiscal conservative and a stout Lutheran, was suspicious of change. He was pompous and susceptible to flattery, if not bribery. She didn't think he was smart, but he hid his defects well. If he skirted the edge of the law, it would be by accident. Karl was a straight arrow, and his daughter, Inger Swets, was the often-elected county clerk.

Maddie tasted the phrase "straight arrow" and made a face. Better not call the commissioners. Better call the hospital, then think about what it would mean if Sheriff McCormick was no longer a player.

No, she thought. Better drive to the hospital. By the time she got

to Klalo, someone would know what had happened to Beth. And someone would know how Minetti was handling the disaster.

"Want an omelette?" Jack said. "There's smoked salmon."

━━━━━━

Meg tuned the radio in her office to the local station and pretended to do paperwork to the music of Country Favorites. Her staff were busy exchanging rumors as they shelved books and greeted patrons. She'd seen Jackman at the information desk deep in conversation with one of the regulars. They glanced at Meg's office. She shut the door.

At eleven, the radio reported that the sheriff, his wife, daughter, and granddaughter had been taken to the county hospital. Mack was in surgery, Peggy unconscious but stable, Beth conscious but in serious condition with a broken leg and a head injury. The baby was well and would be released to her father when he arrived from Portland.

Karl Tergeson, chairman of the Board of Commissioners, made a brief statement assuring county residents that the disaster management team was out in full force and that the governor had been apprised of the situation. "Our prayers are with the sheriff and his lovely family on this tragic occasion," he intoned. He said the search for survivors was continuing. Nobody said anything about Fred Drinkwater.

When she heard Beth was alive, Meg indulged in a brief spurt of tears, but her relief soon gave way to anxiety for Rob. Not only was she concerned for his safety—he was bound to plunge right into the rescue operation—but she knew his fondness for Sheriff McCormick ran deep. Though Rob was aware of Mack's faults, the sheriff was more than a mentor, he was a father figure.

She knew she would be worse than useless at the site of the disaster, but there must be some way she could help Rob. Maybe she could find something to clear Mack.

Professional constraint would make it impossible for Rob to approach the matter of the missing survey that way, but Meg was not subject to the same limits. She decided to look sideways. She Googled Cate Bjork, and when a search of recent sites delivered

nothing more than what had come out during the election campaign, she took a more extensive look at Lars. She used Dogpile, a metasearch engine.

"Flash Bunsen is missing."

Kayla groaned. Mr. Bunsen, a sweet man in the early stages of Alzheimer's, had earned the staff nickname for his ability to disappear in a flash under the very eyes of his care-givers. And also because he sometimes showed up at breakfast in a state of nature. Kayla was fond of him.

It was almost eleven. They had sent off five of the livelier patients with dementia to a nursing home in town and were preparing to send ten more on the second bus. The other nine were waiting in the bus in varying degrees of confusion. She counted them. Flash was indeed missing.

She met the bus driver's eyes. A phlegmatic man, he nodded when she asked him to wait fifteen minutes before leaving. The two aides sitting with the agitated patients looked less resigned, but they didn't protest.

She had organized a search of the sprawling building and was about to return to the bus when the general manager, Patrick Wessel, caught up with her outside his office.

"Ah, Kayla, still here."

She bared her teeth. "Shall I go home, Pat?"

"No, no." Dismay froze his salesman smile in place. He cleared his throat. "Good news, my dear."

"Less with the 'dears,' Mr. Wessel."

"Sorry. Uh, the acting sheriff phoned. The hydraulic engineer managed to ease the water pressure somewhat. A ditch, I believe, and wide pipe."

"A temporary culvert?"

"Just so, but it is temporary." He cleared his throat. "He thinks we can stand down."

"No evacuation?"

"He's not absolutely sure, but he believes the building won't be flooded. The grounds, yes. There may be a surge. Water is already

eroding the ditch they've dug." Patrick beamed. "I checked the creek bed. The flow looks normal for this time of year."

Kayla frowned. Normal meant high. But the creek was at least partially dammed. She wondered if Wessel had actually left the building. If so, it was unprecedented exertion. Kayla gave him an encouraging smile, but not too encouraging. "Shall I unload the bus?"

"Oh, er, yes, maybe you should."

"Maybe?"

"Definitely."

She headed toward the bus. "Mr. Bunsen is still missing."

He *tsk-tsk*ed, his face sad. "We must expand the search then. When you've unloaded the other patients. Spare no effort." He meant that *she* should expand the search.

"Double overtime," she murmured. She was now halfway through a second shift and bone-tired. She would search for Flash Bunsen anyway, but organizing the entire evacuation effort was not in her job description.

After a pained moment, he nodded. "Double time." He checked his watch. "From now—"

"From the beginning of the shift."

He heaved a sigh and strolled back to his office, no doubt to revise the monthly budget. Salisbury steak for all hands. Oddly enough, most of the residents liked it.

Kayla and the two aides took the nine patients back to their rooms, two at a time, with soothing commentary. The blessing was that by dinner half of them would have forgotten the interruption to their routines.

She called the facilities to which the first five patients had been taken, then sent a bus and two aides for them. They would be back in time for dinner. That would save several thousand dollars. Patrick would be pleased.

She kept thinking about Mr. Bunsen. By that time, the building had been thoroughly searched to no avail. It was still raining. Surely he wouldn't have gone outside.

Her cell rang. "Hi, Charlie. I hear they lowered the lake."

He chuckled. "I thought I was going to give *you* the good news."

"It is good, but we have a patient missing. I think he's outside." She peered out a window that overlooked the creek and saw movement on the bank. Maybe it was just something in the water, a log. Wind whipped a squat rhododendron in the foreground and tossed a plastic bag into the air. "Uh, how's the search?"

"All the McCormicks are accounted for, and so is a house sitter whose cat disappeared."

"They're alive?"

"They are. Rob is pretty sure the people who lived up near the road are gone, though. He's at that house now, helping with the digging. Listen, Kayla, there's going to be a surge of water in the creek bed—"

"I see him!" Kayla interrupted. "My patient! He's heading for the creek. Talk to you later." She stuffed the phone into her pocket and ran toward the nearest emergency exit. "It's Flash!" she yelled to a passing aide.

She burst out into drizzle that made everything dim and indefinite, but she kept her eyes on the blue jacket. Mr. Bunsen moved fast for a man of eighty-seven, and he had gone fairly far upstream. What was he doing?

"Chester!" she called. That was his given name. He paid no attention or perhaps didn't hear. The creek was roaring. Kayla took pride in her fitness, but she was panting by the time she reached him. He looked at her with mild blue eyes. So intent was she on not alarming him, she didn't see the wall of water coming.

Chapter 6

A BOUT THE TIME searchers at the Gautier place uncovered the first body, the sheriff's office got a phone call from a David Vanderbrook to say that he, his wife, and their ten-year-old daughter were skiing at Timberline Lodge. The Vanderbrooks owned the last house in the Prune Hill development to be accounted for. Rob didn't find that out until noon, when he called to tell Earl about the body.

Earl sounded almost exuberant. Rob was so relieved to hear of the Vanderbrooks' survival, he felt as if someone had knocked the wind out of him.

He gathered his wits. After he let Earl know they'd found a dead woman, perhaps the Gautier mother-in-law, the undersheriff assumed a properly solemn tone. "I'm sorry to hear it. You don't know for sure it's the mother-in-law?"

"We're sure it's a woman, but not sure of the age." And it would be nice to know her name.

The corpse had been found at the point of maximum impact, where tumbling boulders, mud, and broken tree limbs had exploded the two-story house. Still queasy from what he had helped to uncover, Rob watched an ambulance drive away with the mangled body.

The rescuers paused and watched, too. Linda and Jake were still comforting the uninjured house sitter. Todd had gone off duty. Thayer was minding the radio. Earlier, Charlie had raced off in his pickup to see what was happening with Kayla downstream, now that the "dam" across Beaver Creek had given way.

As Bat Quinn and his team turned back to work with their shoulders drooping, Rob filled Earl in on the flood, too, though he knew the engineer from the Roads Department had already sounded the alarm.

Earl assured Rob that everyone who lived on the banks of the creek had been evacuated, or at least invited to leave. Corky Kononen was on top of things.

"That's good." Rob scratched his unshaven chin. "I need a crane."

"So you can be on top of things, too?" Earl chortled at his own wit.

"For lifting roof beams. The tow truck you sent isn't heavy enough."

Earl said everything that could be done was being done. Rob doubted it.

"How's Mack?"

"Well, you know hospitals. They aren't saying. The surgeons operated to relieve the pressure on his brain."

Rob felt his stomach churn. "And Beth?"

"They put pins in her leg. I guess her head's okay, no fracture. The daughter has a skull fracture. I've got another call here, buddy."

"Right." Rob signed off. He sent Jake and Linda to town with the house sitter and told them to go off duty. They'd done enough on top of a full night shift. Jeff Fong could take over Linda's camera. So far they hadn't been swamped with media ghouls, though the Channel 6 news helicopter had braved the rain for a flyover.

Exhaustion dragged at Rob's bones. Now that they knew how many people they were looking for, Jeff could take over, period. While he waited for his sergeant to show up, Rob went on digging, though he was pretty sure he shouldn't. The muscles of his back had begun to cramp.

▬▬▬

Charlie O'Neill called Meg around 2:30. She was in the middle of a staff meeting. Since patrons were told to turn their cell phones off in the library, the head librarian was embarrassed when hers rang. She apologized and ducked out into the hall to answer.

"What's wrong, Charlie? Is it Rob?"

"His back seized up. A deputy just brought him in to the hospital. I didn't call about that." His voice sounded muffled. "It's Kayla."

Meg's heart was jittering. "What happened?"

He cleared his throat. "She went out to look for a runaway patient just before the flood surge hit the creek. She tried to save him." He gulped, and Meg realized he was crying. "One of the aides spotted her and got to her, pulled her ashore. They lost the patient. The thing is, something hit Kayla's face. Her cheekbone's smashed. They think she's going to lose her right eye."

"Oh, Charlie, honey." The thought of Kayla disfigured sickened Meg. "I'm so sorry."

"Her eyeball was just lying on her cheek."

She swallowed nausea. "What can I do for *you*?"

He took a ragged breath. "Her family, do you know anything about them?"

"No, but I have a key. I could go into her house, look for her phone book. Wait, wouldn't her employer have next-of-kin records?"

"I can call the bastard who runs the place, I guess. Sorry to interrupt you at work."

"You phone the nursing home. I'll come to the hospital. Are you in Emergency?"

"Yes. Thanks, Meg. I'll stay here, and I'll tell Rob you're on your way. Uh, he's kind of dirty. Can you bring him some clean clothes?"

"Yes."

Charlie hung up.

Rob's back had seized up. What did that mean? Meg returned to a cloud of chatter in the staff room. Silence fell. Everyone looked at her with the blank expression of gossips in the presence of their victim.

Meg turned to Marybeth Jackman, who looked even blanker than the others. "My neighbor has been seriously hurt. I'm going to the hospital."

Jackman raised her neatly penciled brows.

Meg turned back to the other staffers, meeting their eyes. "You've reached item three on the agenda. I'm sure Marybeth here is capable of taking you through the rest." She bared her teeth in a smile. They nodded. One or two smiled back. Meg turned to leave.

"Which neighbor?" Somebody tittered.

Meg stopped at the door and turned back. "Two of my neighbors and several of my friends are in the hospital right now. Elizabeth McCormick, for one, is a long-term Friend of the Library, so that should be of some concern to you. And surely, at a time like this, everyone is your neighbor." She shut the door neatly behind her, but she was trembling, whether from this small confrontation or from anxiety for Rob and Kayla, she couldn't tell. Unfortunately she couldn't punch Jackman in the nose.

When she'd found Rob some clothes, she drove to the hospital and followed an ambulance to the Emergency entrance. It went on past the brightly lit area—to the county morgue, Meg supposed. She parked with careful attention, locked the car, and ran to the waiting room. Charlie was there, red-eyed and haggard. She grabbed as much of him as she could reach and hugged. He hugged back.

"Kayla?"

He sniffed and shook his head. "They couldn't save the eye. They're flying her to Portland for reconstructive surgery on her cheekbone."

Meg consoled him as best she could, herself mourning Kayla's beauty. Finally, she said, "What's this about Rob?"

He rubbed his face. "Sorry, you must be worried. He hurt his back. They took him in for an MRI."

"That will take time." Relieved that the news wasn't worse, she patted Charlie's arm. He had a lab to teach in Vancouver, more than an hour away, so he left almost at once, looking wretched.

Meg had never been good at waiting. She made up her mind to check on the McCormicks while Rob was undergoing what she knew could be a slow procedure. She handed his clothes to an aide and had found the door of Beth's recovery room when the surgeon

came in to tell the sheriff's wife and children he had died on the operating table during a second surgery. He had suffered a massive coronary.

————

Maddie went to the hospital twice. The first time was shortly after Beth was brought in. The harassed hospital spokesmen were not giving out information. Maddie knew at least three nurses and half a dozen aides, however, so she was able to assure herself that Beth was not in immediate danger. The sheriff and his daughter were in critical condition, both in surgery. It was not the time to intrude on the family, all beginning to assemble, all stunned and bewildered, so Maddie went off to her favorite café in search of coffee and rumors.

After a late lunch with Hank Auclare, who was depressed at the prospect of lawsuits and irritated with the acting sheriff for holding an impromptu press conference, she decided to return to the hospital. She was in time to catch Earl Minetti's second press conference of the day.

Ablaze with television lighting, one end of the hospital lobby rang with urgent media voices—clearly not an impromptu P.R. exercise. The acting sheriff sat at a table with Commissioner Karl Tergeson on his right hand and a man in surgical scrubs on his left. Reporters occupied a row of folding chairs. Minetti, his hair slicked back and his glasses polished, wore a suit and tie. Madeline did not approve of the ostentation—he wasn't in court, after all—but she had conducted enough press conferences herself to take a critical interest in the setup.

When he had caught everyone's eye and the shouted questions subsided, he said, "I have the sad duty to announce that Sheriff McCormick died about an hour ago during a second operation. He had a long and distinguished career. I've summarized it for you on the green fact sheet. Our sympathies go to his family on this sad occasion." He paused as a deputy handed out the sheets of pale green paper. Maddie took one with numb fingers. So Mack was dead. The king is dead, long live the king, wasn't that what the Bostons said on these occasions? A sad way of looking at things, she thought.

She looked around the lobby. Despite the chatter, she saw only half a dozen reporters she knew and one video camera. Relatives of patients and passing staff were taking fact sheets. She wondered if Minetti realized that the press turnout was less than spectacular.

Minetti said, "I've asked Dr. Powell of the Latouche County Hospital to explain what happened."

Maddie tuned out as the surgeon began to speak in tongues. It was clear that Mack's injuries had been hopeless. A mountain had fallen on his head. Why are they doing this, she wondered, staring at Minetti's tight face. It's like something off the TV, like the time that nut shot Reagan. But Mack was not president of the United States.

Like a lot of white men, Minetti had an almost lipless mouth. Every once in awhile, as the doctor spoke, it quirked in a smile. Maddie had not loved Sheriff McCormick, but Mack had been a human being, not some kind of...

She was a scrupulous woman, so she searched the archives of her own culture first for the right term for Minetti—witch, shape-shifter, ghost? Not really. Robot? No. What Minetti reminded her of was the superheroes of kids' electronic games, the kind who solve everything by going *Shazam!* and zapping the bad guys. He had that kind of cartoon reality. And he was taking over.

As Karl Tergeson launched into pious platitudes, Maddie edged away from the pool of light. She was shaking with rage. It took her three tries to speed-dial the governor.

———

Rob lay on a gurney with his eyes shut, so still that Meg felt a stab of pure terror. She must have gasped, because his eyes flickered open, and he turned his head.

"Hi. I guess Charlie called you."

"He did. I brought clothes. How do you feel?" She kissed Rob's forehead and felt grit on her lips. Someone had swabbed his face and hands, but he was remarkably dirty, covered in a coat of pale dust, his hair dim with volcanic ash. He wore a hospital gown, and a blanket covered him.

"I'll feel dopey but numb when the morphine kicks in."

"Morphine! What have you done to yourself?"

"Bad boy!" he mocked.

She was almost in tears. "What happened?"

"I bent down to lift a two-by-four and froze in place. Couldn't straighten up. Jeff and the rescue people carried me to a patrol car, and Thayer drove in with me lying sideways in the back seat. We have to do a better job of cleaning those cars. Smelled like vomit."

"You *are* doped."

"Some. Stuff to dissolve the bruise, muscle relaxants, or I wouldn't be lying on my back—"

"What bruise?"

"On my shoulders. It's a long story. What's going on, Meg? Everybody's tiptoeing around."

Oh God, he doesn't know.

"It's Mack, isn't it?" His eyes, direct and gray, held hers.

"I'm so sorry, love. He died about half an hour ago, on the operating table."

"Jesus!" His eyes clenched shut.

Meg took his hand, which was superficially clean but battered, cut, and bruised. She didn't say anything, and neither did Rob, for a long time. At last he sighed and scrubbed at his eyes with his free hand. "Well, it was in the cards. He looked bad when we found him."

"We?"

"Linda heard the baby. Jake brought the car jack. We got the baby out first, then Mack."

Meg had the feeling that wasn't the whole story.

His frown deepened. "Who's with Beth?"

"Their kids. I didn't intrude."

"That's good. What about Peggy?"

"I don't know, Rob. I'm sorry."

He brooded. "Charlie told me about Kayla."

"It's so sad. He's really torn up. I hope—" She broke off. She was going to say that she hoped the injuries wouldn't destroy Kayla's wonderful confidence, and perhaps Rob read her mind.

"She's going to be very upset that she couldn't save her patient. That will matter to her."

And her appearance won't? Meg didn't say anything.

He went on, "She's not as superficial as she seems. I hope Charlie's smart enough to see that."

If Rob felt protective of Kayla, Meg found that she had a strong need to defend Charlie. "And maybe he's not as besotted as *he* seems."

A smile tugged at his mouth. "Hey, lady, will you take me home?"

"They're not going to admit you?"

"Not if I have any say in the matter."

My home or yours? "The question is, do you want to lie for three days upstairs on my bed, or downstairs on the wonderful hide-a-bed?"

"Three days?"

"I once ruined my back lifting book cartons. The doctor made me lie flat for seventy-two interminable hours."

"Let's hope some magic pill shortens the sentence. I have a lot to do."

"And I didn't? Lucy was twelve when I threw out my back. She was in love with the pool maintenance guy at our apartment complex." Lucy was her daughter, a Stanford freshman. "That was before she took up physics."

He said very seriously, "I love you, Meg."

She felt tears rise again. She kissed him, this time on the mouth.

A care-giver bustled in. "I'm supposed to bathe you, Mr. Erm. Can't do it out here in the corridor."

Face burning, Meg scuttled away from the gurney. She had been raised to avoid public displays of emotion.

"Not a bath," Rob said. "A shower." The tips of his ears showed red through the caked ash.

The aide was a big woman with a stubborn jaw. Meg observed the power struggle. Somebody showed up with the clothes Meg had brought. A volunteer came bearing a plastic bag with Rob's

dirty belongings. Passersby gawked. It was a good show but no contest. Meg was unsurprised when Rob emerged from the shower room, clean, clothed, and almost upright.

The defeated aide slung him onto the empty bed nearest the shower room. Rob didn't look great, and he moved with effort, but he was a lot cleaner. He was still unshaven. At least his beard wasn't orange. The care-giver flounced off to report to her supervisor.

"Ah, there you are, Robert!" An elderly man with round glasses and a hearing aid sidled into the room.

"Judge Rosen. Why...I could have sent someone for the warrants." Rob struggled to sit up.

The judge made shooing motions with his small, neat hands. "Lie down. I talked to your sergeant. When he told me they'd taken you to the hospital, I came to see how you were doing. Well, from the look of things." His eyes twinkled. "This lady must be our new librarian." He held out his hand. "Nate Rosen, Ms. McLean."

"Your Honor." Meg shook hands.

"May I welcome you somewhat belatedly to our little community? We're fortunate to have so many talented people coming to us from California."

That was so kind, Meg almost burst into tears. She was also struck dumb. When local people heard she was from California, cold silence usually ensued—if they were polite.

Judge Rosen turned back to Rob. "I need hardly say the warrants should be executed as soon as possible."

"I can't call my sergeant till I'm released. No cell phones allowed in these rooms."

"Shall I call him for you?"

Rob frowned and glanced at Meg. "We need to confer."

"I'll go stand in the hall," Meg said.

He dug out the keys Meg had found among his dirty clothes—in a sealable bag with his wallet. "When you said you'd take me home, Meg, you meant to your house. Right?"

"Yes. You can't stay in that huge place of yours alone, Rob. Do not even consider it."

He smiled. "Thanks, I won't. It occurred to me while I was

under the shower that Beth might as well use my house. She needs a home base and space for all those grandkids."

"What a great idea! She told me they haven't sold the house in town yet, but it can't have much furniture."

"You're sure you won't mind?" He held up the house key with the others dangling.

"Don't be insulting." She took the keys, kissed his nose, and turned to Judge Rosen. "I hope to see you again under less trying conditions."

The judge made polite sounds, but his mind was clearly on his search warrants.

Meg left the room at a gallop. Waiting for the elevator calmed her enthusiasm. She hadn't spoken to any of the McCormicks yet, least of all Beth, and she dreaded the encounter. What on earth could she say? She'd had no time to know the sheriff, really, and what she knew she didn't always like. It was too late to know him better.

The group outside Beth's room had swollen to at least a dozen, half of them children, everybody crying.

Meg touched the nearest woman's arm. "Are you one of Beth's daughters?"

She sniffed. "I'm Danielle. Dany. If you're a reporter—"

"No, no, nothing like that. I'm Meg McLean. Rob Neill sent me up with the key to his house. He says you should use the place as long as you need to." She detached the key from the chain.

"The Guthrie house? Wow!" Dany had auburn hair and the sheriff's expressive mouth. She gave a shriek. "Hey, guys, Rob wants to lend us his house. Isn't that great!"

"There should be room for everybody." Meg wasn't sure of that. There were a lot of McCormicks. Still, Rob's Victorian had five bedrooms upstairs and one down, if you counted his office.

Everyone crowded around her, saying appreciative things and even smiling, and Meg started to relax a little.

"We can be together!" A dark man with Beth's eyes took Meg's hand. "Thanks. I'm John. Why didn't Rob come up himself?"

Meg explained.

John McCormick clucked his tongue. "I hope the back problem's not serious. We owe him a lot."

"Mom's life, for one thing." Dany's mouth trembled. "And he tried to save Dad."

"He did save Sophy." A ten-year-old girl grabbed Dany's elbow. "Sophy's going to be okay. You said so."

"Yes, she is, honey. I promise. Skip just took her off where it's quieter. She's fine."

"My grandpa died," the girl said to Meg.

"I'm very sorry," Meg said. "He was a good man. You should be proud of him."

"I am. I'm Beatie." She held out her hand.

Meg shook it. "I'm Meg."

The child considered. "Megan?"

"Margaret."

"Like Peggy."

"That's right." Meg looked at Dany. "How is your sister doing?"

Dany's face clouded. "Still unconscious. They have her in Intensive Care, but they think she'll come out of the coma eventually."

"That's good. Er, your mother—"

"She's sleeping."

"Not with all this racket going on." A nurse emerged from the room, scowling. "Off to the waiting room with you. Shoo!" She herded them down the hallway. After listening to a chorus of thanks, Meg made a graceful escape without seeing Beth. When she returned to the emergency area, Rob was sitting in a wheelchair with his sack of dirty laundry in his lap.

"Let's get out of here."

"What about the MRI?"

"I'm lucky I didn't herniate a bunch of discs. Some are bulging, but I should heal if I lie still—"

"For seventy-two hours," they said with one voice.

A care-giver appeared with documents, which Rob signed, while Meg ran out to the car and drove it to the entrance. He was wheeled to the car door and decanted with only a few groans. She fastened his seat belt, and he handed her a sheaf of papers.

"Prescriptions?"

"Painkillers, blood thinners, muscle relaxants."

"Sounds lethal. I'll fill them when you're on your back again." She drove home cautiously.

Two hours later, she returned from rearranging her own schedule, filling Rob's prescriptions, and tidying his house, where she ran into a sortie of McCormicks with suitcases. She locked Rob's home office because of the computer and left everything else to fate and chance.

When she returned, Rob lay on the hide-a-bed in conference with Jeff Fong and Jake Sorenson, who had seized the business records from Drinkwater's office and were about to go out to his house. Drinkwater was still missing. The department had issued an APB, and Rob was asking for an arrest warrant—he was emphatically still on duty. At least he was lying down. Flat.

Meg left the deputies to it and went off to the kitchen to cook. The phone rang as she was mixing biscuits. When caller ID showed Earl Minetti's name, she was tempted not to answer.

Minetti was brusque but not quite rude. He asked for Rob. She took the phone to the living room—Rob's cell phone sat on her counter recharging—and handed it to him. "It's the undersheriff."

"Neill," Rob said, just as brusque as his new boss.

"Yeah, I'm under doctor's orders to lie still for three days. You are? When? All right. No, Drinkwater hasn't responded. I started leaving messages for him before seven this morning. Must be out of town."

Minetti's voice went on at length.

Rob kept his face impassive. Meg had never heard him criticize Minetti in front of a department member. "Yes, sure, Earl. I'll do what I can. Right." He hit the Off button and handed Meg the phone. "Thanks. Earl is going to call in state investigators in the morning." That must have felt like a slap in the face.

Jeff and Jake groaned. One of them said, "Fuck."

"In the cards," Rob said without emotion. "The staties will take the Drinkwater case file, so copy it. See what you can find in his records by tomorrow. Look for evidence that somebody did him a large favor."

"Who?" Jeff asked. He looked puzzled.

Rob closed his eyes. He was gray in the face and not from ash. "A familiar name," he said heavily. "Somebody in county government. We can hope it was Hal Brandstetter." Commissioner Brandstetter was safely dead.

Jeff glanced at Meg.

Rob said, "And in case you're wondering, I swore Meg in as a reserve deputy last fall, remember?"

Jeff and Jake nodded.

"My lips are sealed." Meg spoke lightly but she meant it.

"Call Linda in and that kid Corky has working for him, the computer nerd. And Jake—"

"Yeah."

"Don't work all night. You had a heavy morning."

Jake said, "I'm not tired."

"Liar."

Meg was fond of Jake. His sister drove the bookmobile. He was technically in the uniform branch, but Rob borrowed him a lot. Now he looked more than tired. They had found the rest of the Gautier family—crushed and smothered in their beds—about the time Rob's back gave out.

Rob turned to Jeff. "You can use my office in the annex. Play this by the book every step of the way. I want a golden chain of evidence."

Jeff said, "What if Minetti sticks his nose in?"

"He won't. He's got other things to do. If he asks, tell him the truth. You have the records. You got them properly. You're preparing them for the state boys."

When the phone in Meg's hand rang, she almost dropped it. "Hello?"

"Meg, it's Beth McCormick."

"Oh, my dear, how are you? I'm so sorry about Mack."

"Thank you." Beth sounded as if she were speaking from the far end of a long, hollow tube. "I need to talk to Rob. Is he there?"

Puzzled, Meg handed him the phone. "It's Beth."

He took a long breath. "Hi, Beth. Not a problem. You're welcome to use the house as long as you like. Skip and the baby will

want to be near Peggy, too. I'll drop by for underwear from time to time when I'm allowed to move again. Oh. Okay. What, she what?" He sat bolt upright. "Ouch. Jesus, yes! The woman's a genius, and I damn near didn't vote for her."

Beth's voice went on for some time. She sounded agitated. Meg, Jake, and Jeff stared at Rob. A healthy color touched his cheek-bones, and his eyes sparkled.

At last he said, "I do not have a single doubt, Elizabeth. And you'll have help. Yes, well, you have more experience than he does, by a long shot. Remember that. If he gives you guff, I'll break his legs. Good-bye, honey. Thanks for telling me." He pushed the Off button and collapsed onto the pillows.

Jeff and Jake were staring.

"What!" Meg shouted.

Rob was sweating with pain, but he grinned. "The governor, bless her, just asked Beth to serve out Mack's term as sheriff of Latouche County."

Part II: Aftermath

In the burrows of the Nightmare
Where Justice naked is,
Time watches from the shadow
And coughs when you would kiss.

> —W.H. Auden,
> "As I Walked Out One Evening"

Chapter 7

BETH WAS FURIOUS. If she hadn't been—if she'd just been desperately unhappy and surrounded by her grieving children, if she'd just been in pain and beside herself with anxiety for Peggy—she would have told the governor to take a hike. But Beth was as angry as she had ever been in her life. She wanted to Do Something. So she said yes.

"Excellent," the governor said kindly. "I'll make an announcement tomorrow afternoon. Don't feel that you have to take up the reins immediately. I'm sending counsel from the attorney general's office to help the county with insurance issues, and a man from the disaster team."

A wave of advice swept over Beth. She lay back on her pillows and listened. The governor had been elected by the tiniest margin in the history of the state and had survived the recount. Beth had to admire her confidence.

Beth's eldest, John, was watching her with anxious eyes. The others had gone off to explore Rob's house. She managed a smile for John. She managed to thank the governor.

John took the receiver and replaced it on its cradle. "What was that?"

Beth told him.

His jaw dropped. "Good God!" He looked so blank, Beth's fury surged. Did he doubt she could do it?

"I need to talk to Rob. He's probably at Meg McLean's house. Find her number for me." She watched John's dazed face as he fumbled with the county phone directory.

Rob said the right things, or maybe he just listened. Beth poured out her reservations. Afterwards, she couldn't recall the content of their talk. The tone was enough. Rob didn't just welcome the appointment, he was delighted. Why? When she'd hung up, she remembered Earl Minetti.

She swore John to secrecy and sent him away, because she needed to think. It was a good twelve hours since the landslide. She was exhausted, grieving, and in some pain. When she had eaten a little of the tasteless hospital dinner and taken her medications, she fell asleep.

She did not wake when her children returned. They watched and whispered. She did not wake later, when they had gone off to Rob's house, and another patient was brought in from surgery. The nurse told Beth she had used a bedpan and been given more pain medication at three A.M., but she didn't remember. She finally woke at six, and everything came back to her in a waking nightmare. Mack and Peggy. Mack was gone. Frantic, she rang for the nurse, who assured her that her daughter was holding her own.

After the care-givers had attended to Beth's needs, and she had looked at breakfast, she finally got around to thinking. By that time, it was too late to turn back, and she found she didn't want to. Anger still burned close to the surface. She didn't try to damp it.

The phone rang—the superintendent of schools, extending condolences. He said nothing about her appointment as sheriff. Maybe he didn't know yet. She thanked him. The phone rang again—her principal. He was a kind man who had stood by her in difficult meetings with parents, of which she had seen a lot. He told her not to worry, that her colleagues were covering her tutorials and that the district had supplied a substitute for her classes. She told him he would have to find a permanent replacement and why. His congratulations sounded warm.

She hadn't yet told her other children. Her third caller—at barely half past nine—was John, who talked about making "arrangements." She winced at the word. John said he hadn't told the others about her appointment either. He thought she should tell them. He sounded forlorn.

"Your father wanted to be cremated." She wasn't sure how she felt about that, but Mack had been firm.

"Yes, Mom, I know. I need to talk to Father Martinez about the Requiem Mass."

"When?"

Silence at the other end. He cleared his throat. "Is Monday too soon for the funeral?" It was Thursday.

Beth forced herself to agree. He promised to notify the relatives—Mack had six brothers and sisters, all living, though his parents were dead. She would have to call her own mother and sisters soon.

"And I'll go to the bank and the credit union, stop your credit cards, look into insurance. Things like that."

"Oh, Johnny, honey, this is so much work for you."

"Well, it's my kind of work." He was the financial officer for a Portland firm.

He told her Skip and Dany were on their way to the hospital. Two neighborhood women had organized a play group for the younger grandchildren in Rob's living room. It was too wet for them to play outside. Beatie and Cieran, ages ten and twelve, were supposed to help. Beth sent up a prayer to St. Jude to protect Hazel Guthrie's furniture. She had known Rob's grandmother well.

And so it went. The daughters-in-law would take turns tending baby Sophy for Skip and sorting out the pies and casseroles flowing in from bereaved constituents. Beth's other sons, Jimmy and Mike, and Dany's husband, Peter, had had to drive back to Portland. They would return Saturday. Dany was organizing a rota, so somebody would sit at Peggy's bedside all the time until she regained consciousness. The family response was wonderful in its way. With all her heart, Beth wished it weren't necessary.

At last she remembered the governor's upcoming announcement and suggested that John warn the others. John agreed. He said he would come by the hospital later.

The phone rang again, Madeline Thomas asking about the funeral. Beth told her the tentative plans, and struck by a sudden insight, asked Maddie if she had called the governor.

"Yes. I hope you don't hate the idea, Beth. It seems logical to me. You'll do a good job. Nobody wants Minetti running things." She described the press conference.

"That was officious of him, but I suppose someone has to deal with the press." Beth paused for thought. "I told the governor yes."

Maddie made a noise that sounded like *whew*.

They talked awhile. Maddie said Beth ought to confront the press herself as soon as possible. Otherwise, Minetti would have time to build support, which might be awkward.

"I'll discuss it with my son."

Maddie ignored that. "I imagine the governor called the commissioners, but you'd better talk to Tergeson yourself—he's a Republican, you know, and won't like the governor interfering. Might as well call Hank Auclare, too, so he won't feel left out."

"Maybe Karl would like to make a statement to the media for me."

"You could ask him." Maddie sounded doubtful. "He might be flattered. He's a pompous old fart."

"I can't appear in public," Beth blurted. "I don't have any clothes!"

Maddie chuckled. "Then issue a press release." She wished Beth well and hung up.

It was literally true. Dany had bought Beth a nightgown in the gift shop. Otherwise, she was stripped of all belongings. It was a strange feeling. She had never thought herself acquisitive, but having nothing was disconcerting. She thought of Mack, and the black cloud of grief moved closer. She was angry enough still to push it aside, but she knew it would soon envelop her.

She asked an aide for paper and pen. By the time Dany showed up, Beth had talked to the commissioners, assuring them that she would serve the county faithfully, or words to that effect, and had prepared a shopping list for Dany headed Underwear.

"I don't have two cents," Beth confessed. "Not even a credit card."

"I'll keep the receipts, and you can pay me back when the insur-

ance money comes through. I really ought to go to Portland for you, Mom. There's not much choice in Klalo."

"Klalo will do." Beth did not want Dany turning her into a fashion statement. "Fred Meyer and that little shop on Pine Street. I need clothes now."

"You must feel better."

"The headache's gone, but the leg hurts." Her left leg was encased in a fiberglass cast from the knee down.

"Can you wear pantsuits with a broken leg?"

"No. Get me a long skirt. I hate skirts, but I'll wear one tonight if I have to."

"Tonight?"

It was time to tell Dany about the appointment. "I ought to make a public appearance," Beth fretted after she had confessed. "The county employees will be wondering where the buck stops."

It took Dany that long to get the message. She let out a gratifying whoop, startling Beth's poor roommate, and danced around the room. Shortly afterwards, she left with her list, murmuring "Sheriff Mom" as she went.

Beth drowsed. From long association, she knew the workings of county government. Mack had taken a lively interest in his deputies and had trained Corky and Rob well. The department could operate without constant interference from above. Juvenile Justice? Under control. The Library was in good hands. Parks and Recreation, too. Health Services needed money and a new clinic at Two Falls. She could talk to Maddie about that. Roads. Licensing—ah, liquor, hunting, construction…

"Mrs. McCormick?"

Beth's eyes snapped open. Her privacy curtain was drawn. She pressed the nurse's button and the button to elevate the bed. "Come in, Earl. I was expecting you."

He yanked the curtain aside with a rattle of rings. "I just heard… they told me…" Mack's protégé was white in the face and looked very young.

Pity disarmed her. "They told you the governor just appointed me to serve out my husband's term."

"It can't be true!"

"Why not?"

"I don't fucking believe it."

"I hope you'll continue as undersheriff," Beth murmured. "Mack thought well of you. He wanted you to gain experience outside the police function. You can start with the Chamber of Commerce meeting on Tuesday." Mack had always enjoyed C of C meetings, Beth couldn't imagine why.

"You're crazy!" Minetti roared. "You're no kind of cop. You have no right—"

"Please lower your voice," Beth said in best classroom mode. "My roommate—"

"The hell with her. Everybody said that woman was disaster." He must have meant the governor.

"*Everybody* didn't," Beth rejoined. Half the voters hadn't, plus forty-six or seventy-two or whatever the majority had been. "Are you going to calm down and communicate, Earl?"

He took a gulp of air. "Why did you say yes? You must know you have no qualifications, no experience."

"And you do?"

"I'm a good cop. I've been a cop for eight years. I have a degree in law enforcement."

"That might make sense if you were applying for Rob's job, or Corky's, but the sheriff is chief executive officer of the county. He or she is not just a cop."

"Just a cop? Fuck."

"You've lived in the county three years, Earl, and you haven't done much outside the department. I was born here, grew up here, lived here all my life. I know the people, good and bad." She knew she sounded defensive. "I've worked for twenty years in—"

"As a fucking English teacher."

"You damn well betcha," Beth snapped. "I understand you just got married. *I* was married more than forty years to a man who worked in county government his whole life. I've seen sheriffs come and go." She swallowed hard, swallowed outrage. "It was a good marriage. We talked things over. I know what Mack wanted

for the county and how he meant to get it. I think my credentials are good."

"You stupid bitch, I bet you never touched a gun."

Beth stared at him until his eyes dropped. "I grew up on a ranch potting rattlesnakes with my twenty-two. That has nothing to do with law enforcement. If you think it does, you're dumber than you sound, which is pretty dumb."

He raised his fist. She stared at it.

"What's going on here?" The duty nurse entered with a burly security man at her elbow.

"Mr. Minetti was just leaving. Chamber of Commerce," Beth said in the sweetest tones she could muster. "Tuesday, noon, at Logger Lover." Logger Lover was a steak house.

"Damn the Chamber of Commerce," Minetti shouted. "I quit!"

"I'll expect your resignation this afternoon in writing." She was proud that her voice sounded cool and pleased to have witnesses.

"You can expect my lawyer."

Beth wondered whether he had a case. Maybe. She wouldn't work with anyone who called her a bitch, but Earl didn't need to know that. If he hadn't resigned, she would have fired his ass.

———

The doorbell rang. Thanks to modern chemistry, Rob was sound asleep on Meg's hide-a-bed. She had gone to work. He decided to ignore the bell, tried to roll over, and thought better of it. He brought his left wrist up and blinked at his watch. Almost ten-thirty A.M. The bell rang again.

It couldn't be Jeff. Meg had given him a key. Heavy pounding rattled the glass in the old-fashioned front door.

"Keep your shirt on!" Rob set about getting to his feet. There had better be a major emergency. He edged over and slid off the bed onto his hands and knees. The jolt when he landed hurt his back but not as much as sitting up would have. The pounding went on.

He crept to a standing position inch by inch. Once he was up, it was all right. Barefoot and wearing only sweatpants, he made his way to the front door. Earl.

"Back off," Rob snarled, face against the glass.

Minetti took a hasty step backwards as Rob opened the door. "I have to talk to you."

"About the case?"

"The governor just appointed Elizabeth McCormick sheriff."

"And that surprises you?" Wet wind stabbed at Rob's chest. He wasn't the bare-chested type, but he hadn't wanted to squirm into a T-shirt. "Come in. It's cold."

Earl stepped in, and Rob shut the door.

"I have to pee. Pour yourself coffee in the kitchen." He plodded down the hall to the bathroom. Earl followed.

"That's one hell of a bruise."

"No shit." He shut the bathroom door in Earl's face.

When he came out, Earl was in the kitchen fiddling with a cup of coffee. He looked miserable.

"Bring your cup to the living room. I need major medication. We can talk when it kicks in."

But of course Earl talked anyway. Rob listened and gulped pills, then began the tortuous process of lying down.

"I screwed up," Earl admitted.

Flat on his back at last, Rob closed his eyes and waited. Breath in, breath out. The pain began to recede. "What did you say to Beth?"

"I lost my temper. I may have used bad language, but, shit, I was upset."

"This is not about you, Earl."

"What?"

"The woman just lost her husband of forty years in a disaster that could have been prevented. How do you think *she* feels?"

"Okay, yeah, I fucked up. I told you that."

Rob was silent.

"I shouldn't have yelled at her. I shouldn't have quit. I did a good job, though—"

"No."

"What!"

"You did an *adequate* job of organizing the rescue opera-

tion. Mack would have done better. You wasted time cultivating the Minetti image when we needed you to keep your mind focused."

"What do you mean?"

"Do you think I didn't hear about the press conferences?"

Silence extended between them. Rob felt sorry for Earl, but he felt sorry for a lot of people including himself. He felt very sorry for Beth. And Beth's kids. And Beth's grandchildren, who wouldn't get to know Mack the way they should have.

Earl heaved a sigh. "Guess I better start job-hunting."

"That makes sense."

"Uh, will you write me a reference?"

Rob opened his eyes and smiled. "Sure. Buddy. You're a good cop." Good but not great. "Who do you think told Mack you'd make a good undersheriff?"

Earl rubbed the back of his neck and gave a short laugh. "I guess I just got too ambitious too soon."

"Maybe. We all make mistakes."

"Even Mack?"

"Especially Mack," Rob said grimly. When Earl had gone, Rob sank back into drugged sleep. It occurred to him as he dozed off that Earl hadn't given the Drinkwater case two thoughts. Maybe he was not such a good cop after all.

Jeff came in around two and shook Rob's sore shoulder.

"Ow. I don't want to know," Rob grumbled. "Go away."

"We found Drinkwater."

He came awake fast. "And?"

"He's dead."

"Shit!" He started to sit up and lay back. "Suicide?"

"I don't know. Unattended death. I sent for the ME."

"He'll have to take up residence." The nearest state medical examiner was based in Vancouver and didn't like to drive up the Gorge in wet weather. "Maybe he'll do the autopsies here." There would have to be autopsies, six, no, seven, counting Kayla's elderly patient. Rob's mind raced, mostly in circles. "Tell me."

Jeff pulled a chair over so Rob wouldn't have to crane his neck.

"I'll make a better guess when I know the time of death. I think it's murder."

Rob felt a chill. Suicide made some sense. Murder didn't. "Where was he?"

"His place. Big house at Tyee Lake."

"He wasn't there yesterday when you seized the files?"

"No."

"Better trace his movements. Where'd you find him?"

"By the hot tub."

"By it?"

"Yeah, that bothers me. If he'd been in the tub, we might've figured he just stayed in too long."

"Happens a lot in cold weather," Rob murmured. "But he wasn't in the tub."

"No. He was naked, sitting in the pool room by the hot tub with a towel draped over him. Very neat. Like he just sat down on this upscale deck chair and died. Glass of something, orange juice or a mimosa, on the end table. The tub was whirling away. It stopped just after we got there—had a two-hour cycle, but that doesn't mean it ran the full two hours. You could set it for less."

"Maybe it turns on and off automatically."

"We're checking the manual. Also checking the mimosa."

Rob brooded. "He came in, turned on the whirlpool, sat, and died. Weapon?"

"Nothing like a weapon. No note. No visible marks on the body."

"Neighbors see anything? No, don't say it. There aren't any neighbors there on weekdays this time of year."

"We're checking."

Thanks to hydrocodone, Rob had trouble keeping his thoughts going in a straight line. "Fred was in his fifties. He looked healthy but may have had a heart problem, something like that."

"We're checking that, too."

Rob shifted gears again. "Any word from the state patrol? Earl meant to turn the investigation over to them." Apparently he hadn't.

"No. Earl's peeved. The governor just announced Beth's appointment." Jeff grinned. "Joy in Mudville."

"I talked to Minetti. He quit."

"Wow!" Jeff did not look distressed.

"You can spread the news, in case he starts claiming Beth fired him."

Jeff eyed him. "So what do you think?"

"About Minetti?"

"I know you like him, but—"

"It isn't possible to like him," Rob interrupted. "I thought he'd make a good politician when he learned to listen, and he was an efficient sergeant. I'm glad he resigned, but it leaves us shorthanded. Leaves *you* shorthanded, Jeff. I need two more days here in bed."

Jeff nodded. "Better take it easy. If your back's permanently damaged, you can't do martial arts."

Rob winced. Jeff was a little too perceptive. In fact, Rob was scared. He was almost forty-five and bound to slow down sooner rather than later. "I'm sure life would go on without karate." He cleared his throat. "If you think somebody killed Drinkwater, we need to dig into motives. The obvious one puts slide victims' friends and relatives in the frame, though they would have had to act fast."

"Very fast."

"The McCormicks, the Gautier heirs—we don't know anything about them. The house sitter who lost her cat." Rob had the feeling he was overlooking a victim or two.

"Hey, the slide was an act of God." Jeff rephrased, "A natural disaster."

Rob rubbed his forehead. "Drinkwater got a landslide hazard warning suppressed. I want to know how."

"Yeah, okay." He blinked.

Rob blinked back. "This dope is rotting my brain." Mack and I were too damned discreet, he thought. Self-disgust left a bad taste in his mouth. He tried to clear his mind. When his thoughts were in order, he gave Jeff a summary of Charlie's alarm and his own

understanding of the geological picture, finishing with his findings about Drinkwater's business interests. They were sparse.

"And the sheriff knew about the hazard warning?"

"For a few weeks." Rob hesitated. "He ordered me to drop the investigation," he added, reluctant. "I didn't."

Jeff looked appalled. "But that means—"

"We don't know what it means, but we'll find out. I was looking for a connection between Drinkwater and the courthouse, somebody with the opportunity to make the first LHA evaluation disappear."

"Not the sheriff!"

"Mack could have done it. Maybe he did, but I don't see him living at the foot of that hill if he knew it could slump at any moment. That does not make sense. He wouldn't do it to Beth." I hope, Rob added silently. "And he would not have endangered his children and grandchildren. That's my opinion, but we're not going to pay any heed to my opinion. We're going to go after the evidence, whether or not it incriminates Mack."

"Will Beth agree to that?"

"If she doesn't, I'll resign and send my cousin to talk to the state patrol." Charlie would want to do that anyway, after what had happened to Kayla.

"Were the Gautiers warned?"

"Mack or Beth may have called them." Rob explained Meg's chat with Beth the afternoon before the slide. "They didn't get *official* notification, and neither did the other owners. This is going to make a big stink, Jeff."

Jeff rubbed his hands over his face. "Other than survivors, isn't there an obvious suspect?"

Rob nodded. "The co-conspirator, covering his ass. Drinkwater couldn't have got at the first survey himself, and I'm inclined to believe the second geologist, Woodward, the one who said Prune Hill was stable, is just an opportunist. I don't doubt Drinkwater paid him well for his survey, but Woodward would have had a hard time stealing the original report. One of the commissioners could have, or Mack, or a clerk, for God's sake, or even a

janitor who knew what to look for. Somebody with access to the courthouse."

"Drinkwater sounds like an unappetizing guy," Jeff mused. "How about personal motives?"

"A courthouse insider's our best bet, but we should look into Fred's life." Rob's brain did a Vicodin leap. "Kayla!"

"What?"

"Kayla Graves, the nurse who was injured trying to save her patient from the flood surge."

"She's a suspect?"

"No. She knew Drinkwater." He wondered how much of Kayla's colorful doings Jeff needed to hear about. "She's, uh, a neighbor. My cousin's renting a room from her. She and Drinkwater had a relationship." Rob made a face. "Dumb word. They've had an on-again off-again affair going since Drinkwater moved here. She's a good observer, so it would be smart to interview her, but she's in bad shape right now, recovering from surgery in Portland. She lost an eye." His mind shied away from the thought.

"I could send Linda to talk to her."

Rob wasn't sure Kayla would confide in a strange woman. "Why don't we wait until my cousin gets back, find out what Kayla's condition is? Maybe we can just call her." An in-person interview was always better. Meg, he thought. Meg could talk to her.

"Okay." Jeff stood. "I'd better get cracking. Is it all right, me coming over here? I don't want to wear you out, but I've got a lot of questions."

Jeff wasn't the only one with questions. "It's your case, but you've got a house key, and I'm not going anywhere. Keep me up to date." Rob didn't insult Jeff by asking him to keep quiet about the court-house connection.

After his sergeant left, Rob lay still, staring at the ceiling and letting his mind drift through the fog of dope and guilt. Jeff was right. They needed to know everything about Fred Drinkwater. Maybe Kayla held the key.

Chapter 8

DARK. KAYLA SWAM in darkness. She reached out for him, touched him fleetingly, lost him. Her ears roared. Her lungs ached. She looked into his mild eyes as they widened with fright, as his fingers slipped from hers. Then darkness, whirling, roaring. She gasped for breath and drew in water. She began to thrash and choke.

"Is she coming around?"

"I think so."

"Chester! No-o-o-o!"

A warm, rough hand clasped hers. The touch comforted her a little. She gripped hard. That was what she had to do, hold on. She gulped air. Now—under again. She was losing him. She heard a high wail. "No!"

"Hush, love. You're all right."

But she wasn't all right. Her head hurt horribly, her body ached. Why couldn't they understand? Why couldn't he…? Her eye blinked open on the pale blur of a face. "Where is he? I lost him."

"It's Charlie, Kayla. You're all right."

But she wasn't. Why was he lying to her? She closed her eye. Darkness was better than knowing, better than pain, than loss. She felt a sharp jab and drifted back into comforting darkness, but it was a long time before her grip on the hand eased.

———

Meg and Rob watched the eleven o'clock news, which featured one and a half minutes of Beth McCormick's press conference.

Beth, who was sitting in a wheelchair with her leg sticking out

in a cast, looked calm but tired, a neat dressing just visible in her short silver hair. She wore a hunter green blazer over a pale blouse and a long tartan skirt. The commissioners and three of her children flanked her. Meg recognized Dany and John, Dany solemn and John dazed.

Beth spoke in a clear, flat voice. She thanked the commissioners and the governor. She intended to fulfill her husband's plans, so recently endorsed by the voters. She had confidence that Latouche County's employees would carry on with their duties like the skilled professionals they were. She would call on them all in the next few weeks to hear their ideas.

Deliberately bland, Meg thought. The wide-eyed newscaster seemed to think appointment of a female sheriff was a daring move on the governor's part. She gave statistics of the incidence of women in county government and went on to a story about a man knocked off a motor scooter at three A.M. by a hit-and-run driver.

"Daring," Meg muttered, blanking the screen. Not hardly, in a state with two female senators and a female governor. Meg didn't know what she thought about the appointment. It was one thing for women like Patty Murray or the California senators to win public office in open elections, but there was something vaguely medieval about a widow taking on her dead husband's role. Not a giant step for womankind. Still, Meg liked Beth and recognized a kindred intelligence behind the dumpling façade. Beth would probably do a good job.

Meg turned to Rob, who was drowsing again. "What do you think?"

"About Beth? She's mad as a hornet."

"As in crazy?"

"As in furious."

"Really? How on earth can you tell?"

"Voice, shoulders, fists. She's mad."

Meg thought he might be right. He knew a lot about anger. She heard a noise outside. Distracted, she stood and peered out the front window. Lights went on at Kayla's house, and she could make

out the bulk of Charlie's truck in the driveway. "Your cousin. I'm going to call him."

"Give the guy a break."

She shut the TV off, picked up her cell phone, and speed-dialed Kayla's house. Charlie answered on the third ring.

"How's Kayla?" she asked without preamble.

She heard him take a gulp of air. "Doped up. Confused. Upset that she lost her patient."

The poor kid. "How are *you*?" Meg ventured.

"Tired."

"Tired but wired?"

"Well, yeah."

"Come over. I'll feed you something hot and give you a drink. Then you'll be able to sleep."

"Uh, okay. Ten minutes." He hung up.

She looked at Rob. "Stop grinning." She was tired of being teased about feeding strays. She stomped to the kitchen, thawed soup from the freezer, cut bread, and poured a beer. By the time she returned to the living room with her tray, she could hear Charlie on the front porch. She opened the door before he got a chance to ring the bell and gave him a comprehensive hug. He looked worse than tired.

While Charlie ate soup and drank some beer, Meg and Rob brought him up to date on the day's happenings. He seemed bemused but didn't comment until Rob told him about the death of Fred Drinkwater.

"He what?" He was chewing bread.

"Jeff Fong thinks he was murdered."

Charlie stared and shook his head hard, shedding crumbs. "That does it. I'm going back to Pullman. All we have there are Wazoo freshmen getting drunk in Idaho and driving into bridge abutments on the way back." In Idaho the drinking age is eighteen. It's twenty-one in Washington.

Rob's mouth twisted in a grin. "And a few Aryan warriors." He'd met one that fall.

Charlie shrugged. "They're no problem. Spend all their time

going potty in the woods." He finished the beer in a single gulp and stood up.

Meg said, "What are you doing tomorrow?"

"Lectures at eight and eleven. Hospital afterwards."

"I have a library meeting in Vancouver at ten. I could drive you. Kayla's at the OHSU hospital, isn't she? I'd like to visit her. Will they have to do a bone graft?"

"On her cheekbone? Maybe. It's too soon to tell."

"Her family…"

Charlie grimaced. "Her mother's on a Caribbean cruise. I talked to the lady. She was ready to fly back, but I told her she ought to speak to Kayla first."

"What was she like?"

"Ditsy but nice. On her sixth honeymoon."

Meg digested that. It brought Kayla into focus. "I'll go see her tomorrow. Does she need anything from the house?" They talked a while. Charlie agreed to let Meg drive. Rob watched them.

When Charlie had left, Rob said, "You do know you'll have to break the news of Fred Drinkwater's death to her."

"Oh, no! Can I just not mention it?"

He watched her.

She plumped down on the armchair. "I'll have to, won't I? She'll hear about it on TV, or some fool will mention it in passing. How fond of him was she?"

"I don't know." He frowned. "I think Kayla avoids attachment. Fred took her places she enjoyed, gave her a chance to gussy up. She likes that, and she likes sex."

"Yes, but he can't have been much of a lover."

He cocked an eyebrow. "I'd better not comment."

"No. I expect he liked to be seen with her, but she wouldn't want to be any man's trophy." Meg sighed. "All the same, it's bound to be a blow to her. On top of everything else." She tidied the remains of Charlie's snack and carried the tray to the kitchen. She thought Rob would be asleep when she returned, but he wasn't.

Meg yawned and stretched. "Me for bed. Anything I can get you before I go upstairs?"

"You could come here, trophy."

"What!" She went to him.

"I like to be seen with you."

"Horrible man."

His smile faded. "Will you ask Kayla about Drinkwater, Meg? She knew him as well as anybody."

Meg sat with a thump on the edge of the hide-a-bed. "I can't believe you want me to interrogate a suspect."

"She's not a suspect. By the time he was killed she was already in the hospital."

"Even so."

"I know. It ain't nice. And she may not be in any condition to talk. Forget it. I'll send Linda to see her."

"Why don't you phone her yourself?"

"I probably will later. Maybe you could just explain that I'll need to talk to her about him." He shut his eyes, frowning again.

She kissed him between his eyebrows, and he pulled her down for a more intensive kiss that went nowhere near satisfying her.

By five-thirty, she was up, showered, and still arguing with herself. When she heard Rob stirring in the living room, she fixed toast and coffee for two, but he took a long time getting vertical and using the bathroom, which didn't have a shower. His toast was cold by the time he came into the kitchen, freshly shaven. He looked rotten.

"Going out?"

He ignored the sarcasm. "Two more boring days on my back."

"Boring?"

"Passive, then."

"I must admit I'm surprised you aren't charging around against doctor's orders."

"Like a true macho jerk?"

"Hey, I didn't mean it. Is the pain worse today?"

"No. That is, I cut back on the Vicodin, so it's worse in that sense. The pills gave me technicolor nightmares," he added when he saw her expression.

Some nightmares. She refrained from comment.

He poured coffee and stood by the counter while it cooled, as if sitting would be a bad idea. He ate the toast methodically. To her surprise he didn't say anything to her about questioning Kayla. Rob could be very shrewd.

Meg had meant to have a long talk with Charlie on the drive in to Vancouver, but he fell asleep almost as soon as the car was in motion. It was kinder not to wake him.

"Ready to navigate?" she asked when he straightened and blinked awake. "I don't know my way around."

"Take the I-205 exit north." He wriggled his shoulders. "Good thing I didn't drive myself." They chugged west past Camas with its paper mill billowing fumes. Rumor had it the plant was going to close.

The WSU branch campus was new and nicely landscaped. Meg dropped Charlie off, promised to return a little after noon, and headed south into Vancouver on Interstate 5. Her meeting at the Hilton Convention Center went well, and Charlie was waiting for her when she returned. They bought messy enchiladas at Muchas Gracias, ate them in the parking lot, and drove on across the Interstate Bridge.

Oregon Health Sciences University comprised a cluster of high rises on a bluff in Portland's west hills. The state was constructing an aerial tramway up to it. Meanwhile, parking was at a premium in the multi-story garage. Meg lucked out and found a space near the elevator.

Laden with Kayla's belongings and a sheaf of flowers Meg had bought near the Vancouver convention center, they entered the hospital, Meg following Charlie, since he knew the way. Some nice artwork hung on the walls.

He paused at a set of double doors. "I'm dreading this. She wasn't fully conscious last night, but she will be today." He pressed a square metal button, and the doors swung open.

"I hope her mother called her." Meg followed him down the corridor, noting the tense set of his shoulders under the professorial tweed jacket he wore over the usual jeans. His legs were so long she had to trot to keep up.

They found Kayla in a hospital gown being helped back from the bathroom. She gave a small shriek. "Tell me you brought me some clothes!" She looked strange—her dark hair tangled, half her face covered in bruises and bandages, the other half perfect as always. The bruises on both of her bare arms testified to the brutality of her ordeal.

Meg pointed to the small suitcase Charlie had packed.

Kayla snatched it. "Thank God. Good of you to come, Meg." She unzipped the carry-on, pulled out her wool robe, and groaned. "The brocade, Charlie. I'll swelter in this."

"Sorry." Charlie was grinning.

With relief, Meg guessed. She thought his relief was misplaced. Kayla's jauntiness seemed feverish.

The aide, a black woman with stylish oval glasses, frowned. "Time to lie down. And you can't wear that robe, Kayla. Doctor gonna want to install the drip again."

"I'll talk him out of it." She yanked the garment on and climbed up onto the bed with a lavish, unselfconscious display of leg and hip. Then she wilted against the pillows. "Head hurts."

"I expect it does," Meg murmured. "Did your mother call you?"

Kayla gave a soft hoot. "From the S.S. Matrimonia afloat in the azure Caribbean? You bet she did. We talked. Step-daddy will be mad when he sees the charges."

"Is she coming home?"

"Home? Home is Cabo San Lucas. She's coming to see me here. Next week. I told her no hurry, I'll be here forever." She rubbed the unbandaged side of her head, and her hand fell, limp, to the bedclothes. "I can hardly wait to see Mumsy's face when she sees little Kayla's face."

Charlie said softly, "Stop it, Kayla."

"What?"

"Stop playing the fool. You hurt, and your mother wants to help you. We do, too. We just don't know how."

A shudder shook her. "How can you help me? I deserve to hurt. I lost him. His hand was in mine, and I just let go. I lost him." Tears

streamed from her remaining eye, and she leaned back against the pillows, sobbing.

Charlie watched her, his face contorted with sympathy. That much Meg could see through her own tears, but she was unprepared when he roared, "That's enough. You're wallowing in self-pity, and it doesn't make a damned bit of sense. Stop sniveling."

Kayla choked on a sob and blinked at him.

Meg blinked, too.

His voice was hard and even. "Do you know what water weighs? Do you?"

Kayla sniffed. "It's heavy."

"Sixty-two point four pounds per cubic foot." He wiped his eyes with his sleeve. "You weigh maybe twice that. A ton of water fell on you, not to mention the tree branch that hit you. Of course you let go. You couldn't help it. For that matter, *he* let go. So stop whining about losing the man. You did your best."

"Well, my best wasn't good enough." She sounded almost petulant.

"That's right. It wasn't. Live with it."

Kayla's eye closed. She was still crying, but quietly. Meg went to her and held her. The aide had disappeared. Meg's bouquet had long since fallen to the floor.

When Kayla sniffed and sat up, Meg patted her shoulder and handed her a tissue. "There's bad news, I'm afraid."

Kayla blew her nose. "Better tell me."

"Mack died yesterday afternoon."

"Oh, poor Beth! She's not—"

"Apart from a broken leg, she's okay. The governor just appointed her sheriff."

"What!" Kayla gave a choke of startled laughter. "I love it. Sheriff Beth. Fred will have kittens."

"Uh, there's worse." Meg's throat closed. "It's about Fred Drinkwater, Kayla. Uh, he's dead."

"But he didn't live anywhere near the slide."

"They think he was murdered."

"They? Who?" Her voice rose.

"Jeff Fong. Rob. The police." Meg turned to Charlie who had composed himself. "Explain."

So Charlie did. Halfway through his concise account, to which Kayla listened with her mouth open, the aide bustled back accompanied by the duty nurse and a technician with an IV trolley. With a cluck of disapproval, the aide picked up the flowers and shooed Meg and Charlie out.

They promised Kayla they wouldn't leave. She sounded bewildered, as well she might, but not grieving, not even angry, except perhaps with Drinkwater.

When they returned, she had dressed in a buttercup yellow batiste nightgown and brushed her hair. The IV fed into a vein on her left arm, and she looked tired but alert, interested, no longer so focused on herself. That was good. Meg had decided to question Kayla after all.

Meg waited while Charlie finished his narrative.

"Let's see if I've got this straight. I lost my eye, and my patient lost his life, because Fred suppressed a landslide warning."

Charlie was fair-minded. "The slide would have happened anyway."

Kayla scowled. "Still, we should have been warned. The corporation that built Beaver Creek Retirement Village should have been notified, and the people in those houses near Prune Hill should have known the hill could slide."

"When was the nursing home built?" Meg interjected.

"Good question," Charlie said.

Kayla brooded. "About five years ago. *They* should have had a survey done, the bastards."

"I'm sure they did," Charlie said. "Rob will look into it."

"Rob will be looking into everything." Meg began to see ramifications. For one thing, Rob would have to double-check every geological survey issued to the county in the last ten years. She drew a breath. "He's going to want to talk to you, Kayla. He told me so."

"What about? Good God!" She chortled. "He can't imagine Fred and I chatted about landslide hazards."

Charlie flushed and looked at the floor. He was propped against the room's other bed, which was unoccupied.

Meg leapt into the breach. "What *did* Fred talk about? I got the impression his mind was mostly on business."

"True. Johnny One-Note. He was pretty boring." Kayla gave a harsh laugh. "Dull and Deadly, our Fred."

"Then why did you go out with him?"

"A good question." Kayla leaned back and closed her eye. "I'm thinking about it."

Meg said, "Do you know anything about his family or his business associates?"

"I met a couple of his investors. Also dull."

"Names?"

"I don't recall. California money. Fred was divorced. I don't mess with married men."

"Where does his ex-wife live?"

"Portland. She's married to a dentist now. Two kids, teenaged girls. They go to a private school. Fred was always complaining about their tuition. I don't think he was very interested in them, but he wasn't a deadbeat dad. I don't mess with scum like that either."

Meg let that ride. She wondered about Kayla's father. "Was Fred seeing other women?"

"Of course." She shot a glance at Charlie. He was still looking at the floor. "He liked being seen at all the watering holes. He liked to dance and party, liked good food. He was dull, but he was normal, for God's sake. What does this have to do with anything? Shouldn't Rob be looking for developers and bankers?"

"They don't know why Drinkwater was killed," Charlie offered. "Maybe a girlfriend got jealous."

"Wouldn't it be just a teensy coincidence if Darla Auclare shot him right after the landslide?"

"He wasn't shot. Uh, the commissioner's wife?"

"Daughter. Hank's wife has to be sixty. Fred liked younger women."

"A lot younger?"

"Not children," Kayla said flatly. "Younger like Darla and me. She's thirty-five. Divorced."

"The one who runs the supply shop for wind surfers?"

"Right. Tiffany—my former roommate—worked for her. I like Darla. We get together once in a while."

"Who else?"

"Who else what?"

"His girlfriends."

"You're barking up the wrong tree. Look, Fred's women were decoration. We knew we were."

"And didn't care?" Charlie's voice came out harsh.

Kayla gave him a wide, white-toothed grin. "Arm candy. Some men, especially businessmen, like to be seen in public places with expensive women hanging on their arms. It's a role I enjoy playing once in a while. I figure Fred wrote me off on his taxes. He was a bottom-line kind of guy." The devilment went out of her expression. "Rob should be looking into the good old bottom line. Fred thought that way. It simplified reality for him and made him boring."

"And dangerous," Meg murmured.

Kayla leaned back again, exhausted. "And very, very dangerous. The stupid shit."

They left shortly after that, both of them depressed, though for different reasons. Meg was aware that she had done a bad job of questioning Kayla. She hoped Charlie wasn't too disillusioned, but he wasn't a child. If he was going to be in love with Kayla, he ought to be in love with the real Kayla, not some Florence Nightingale caricature.

When she had negotiated the tangle of downtown traffic and headed the Accord east on I-84, she said, "You're brooding, Charlie. What's on your mind?"

"I wish I could afford arm candy."

Meg laughed. "No, you don't. She *said* it was a role. Are you in love with her?"

"Maybe. In lust, you bet."

"Then you ought to think about the missing eye."

"She's a beautiful woman, with or without two eyes, and I didn't fall for her face."

"That's noble. The disfigurement will change her."

"You don't believe me?"

Meg zipped around a slow semi and a Winnebago. "Kayla's physical perfection has been part of her personality her whole life. From what she said, I suspect her mother fed into it. The surgeons will sculpt a new cheekbone for her—"

"And pop a prosthetic eye into place."

"Exactly. And she'll look much as she always has. Beautiful. But she'll know she's no longer perfect. How she deals with that will tell you a lot more about her than you know now. I have confidence in her, but it's going to change her." Silence followed.

"Hey, you just drove past the I-205 exit."

"I always wanted to cross the Bridge of the Gods." Traffic began to thin out.

Meg glanced at the scenery. There was an outlet mall on the right. To the north, the towers of the old Troutdale aluminum plant rose with the river in the background. For once, it was not raining. The afternoon overcast was pleasant—no glare. She passed three semis of the sort that need half a block to turn on city streets. On the freeway they were no problem.

"Tell me about my cousin," Charlie said abruptly.

"I'm a biased witness."

"Okay, counselor, I'll be more specific. I was in town a year and a half ago, as you know, so I sent Robert an e-mail, just to say hello. I thought I was being polite. He didn't reply."

"The ultimate contemporary insult." A pickup on mega-wheels roared up behind Meg and passed. "Rob's attitude toward your family is not positive. He likes to pretend they don't exist."

"Why?"

"You really don't know? I guess that's possible. Ancient history."

"Jurassic? Pre-Cambrian? I am a geologist." Charlie sighed. "If my grandfather did something unspeakable—"

"Well, I think he did."

"Robert's father, my Uncle Charlie, was killed."

"Yes. Rob was eight. He idolized his father, who sounds like a nice man. Rob's mother died in a car wreck within the year."

Charlie whistled. "I didn't know that. That's tough."

"Yes. Fortunately, Rob was staying with his grandparents, his Guthrie grandparents, and they were able to comfort him a little, in spite of their own loss. He was starting to adjust when your grandfather sued for custody. Rob had never met him."

"The old bastard." Charlie relapsed into silence.

Meg drove past Rooster Rock and Multnomah Falls. They were now well into the Gorge Scenic Area. "I think Mr. O'Neill reckoned without the strength of community opinion. Robert Guthrie ran the local drug store, complete with soda fountain. Hazel Guthrie, well, she had my job and she was one of the great librarians." Meg wasn't kidding. Hazel Guthrie had developed a system remarkable for a rural county in that era and had gone on to institute policies that set a national model. "The Guthries won the court case easily, but to a child the suspense must have been appalling."

"I'm surprised Robert didn't toss me out into the ice storm."

Meg laughed. "He's not an idiot. He likes you well enough, just don't expect him to embrace your family."

"Except for Grandpa, they're good people, and the old man is safely dead."

They had reached Cascade Locks. Conversation languished while Meg found the narrow, very high bridge and drove across it. The view might be spectacular, but she wasn't about to take her eyes off the center line.

When they reached the other side and turned upriver, Charlie let out his breath in a long relieved *whoosh.*

Meg smiled. "Escaped with your life?"

"When I'm on a bridge like that I think about earthquakes." He returned to the subject at hand. "So Robert stayed in Klalo with his mother's people, and thirty-five years later, he's still there. Did he even leave to go to college?"

Meg bristled. "He got a TRS-80 Model I computer for Christmas when he was ten. When he graduated from high school, he

ran off to California, found work in the computer industry, and made good money."

Charlie whistled.

"You could do that without a degree in those days. Rob married and they had a daughter, divorced when the girl was six or seven. When his grandfather died, Rob came home and found his grandmother suffering from congestive heart failure. He sold out and came back for good. Sheriff McCormick hired him as a deputy, because Mack wanted to computerize the department. Rob decided he liked the job, so he's still here, though his grandmother died several years ago. As for college, he has a degree from Cal Poly, but I think he stumbled into it taking night classes."

"Hmm. What's his degree in?"

Meg glanced at him sideways. "Graphic design."

Charlie sat bolt upright. "As in comic books?"

"He was into website design. That was way back, remember. He came up with routines that are still used. He holds the rights."

"No kidding. Why in hell is he working as a cop?"

"Well, Charlie, why in hell am I a librarian? Why is Kayla a nurse?" She overtook a log truck that was laboring upward in the slow lane. "Why does Beth McCormick teach dyslexic teenagers to read? Do *you* plan on joining Halliburton in Dubai when you finish your doctorate?" He had told her he was studying hydrology because he thought finding potable water was going to be a major problem worldwide in the coming decades. Finding clean water was a lot less lucrative than finding oil.

"I get the point."

Meg wondered if he did. His generation was the first to grow up in the era of corporate triumphalism. Still, as a veteran of the first Gulf War, he must have an angle on profiteering, and by indirection, on Fred Drinkwater, whose beginning—and end—had to be profit.

Chapter 9

ROB TAPPED THE spreadsheet Jeff had printed for him. "I have the feeling it's all here, lost in a maze of phony corporate names." He was lying flat again and let the sheet fall on his stomach. "I need to talk to Beth."

Jeff nodded. "Funeral's tomorrow."

Rob shut his eyes. It was Sunday. He wasn't ready for Mack's funeral, and would be no more ready tomorrow. Beth had asked him to serve as an honorary pall bearer. At least there was no heavy lifting in prospect. Mack's body had been cremated. "Where is she?"

"They released her from the hospital. I think she's at your house. You're not going to walk there, are you?"

Rob levered himself up to a sitting position, swung his legs over the side of the hide-a-bed, and stood in one sharp jab of pain. The spreadsheet slid to the floor.

He had stopped taking the hydrocodone entirely after another bout of hideous dreams. Mack had figured in his nightmares, and the Gautiers, of course. As nightmares went, they were mundane recollection, but that didn't stop them being hideous.

Rob showed the sergeant out and made his way upstairs, a grim process. His legs felt weak. He took a long shower, shaved, and was struggling into jeans and a sweatshirt when Meg returned from the grocery store. She bawled him out while she pulled his socks on and tied his sneakers.

"I have to go see Beth."

"And it won't keep until tomorrow…" She cocked her head, eyes narrowed. "Tomorrow is the funeral with all that that entails."

He waited. One of the many good things about Meg was that she was reasonable.

"All right," she said. "I'll go with you."

"I need to talk to Beth alone."

Again, a considering pause. Rob confided in Meg, more than he should, properly speaking. She had acted on what he'd told her in confidence when she warned Beth about the landslide hazard, so she was capable of breaking faith. On the other hand, she had been right.

He could see that running through her mind, as it was going through his. Before she could protest, he added, "What I have to say will reflect on Mack. I think Beth will come around to my way of thinking, but I don't want to embarrass her in front of anyone, not even you."

"All right," she said again. "I'll walk over with you. While you talk to her, I'll go upstairs and get your uniform."

Rob groaned. He loathed uniforms, but Mack's funeral called for full dress.

Meg's eyes narrowed to fierce slits. "I don't regret warning her, and I'd do it again."

"It's okay," he said hastily.

Her face relaxed, and she smiled up at him. "I do understand where you're coming from."

Regretting that she was so short, he kissed the top of her head.

She gave him a swat on the seat of his Levis. "That bruise of yours is traveling south. It's also turning color. Do you realize you're going to have green cheeks?"

Beth sat on the living room sofa with her broken leg stretched out on a hassock. She was only marginally less miserable than she had been at the hospital and still very tired, but anger propped her up. The grandchildren had swarmed in and out for an hour after breakfast, which had cheered her a little. Then their mothers had carted them off to church, en masse to Mass, and fury had swept back over her.

The doorbell rang. She heard Dany trot down the hall to answer.

Meg's voice and Rob's. Beth went cold. She didn't want to see Meg. Meg was too sympathetic. Then she heard the women's voices retreating down the hall, Rob came in, and she remembered the reasons she didn't want to see him, either.

Perhaps he sensed that, for he didn't smile. "Sheriff?"

Mute, she nodded and watched him make his slow way across the living room. She had talked to him half a dozen times since the landslide, but the last time she had *seen* him, he'd been holding her hand and saying reassuring things as the EMTs shoved her into the ambulance. Then he had been covered with mud and sweat. Now he wasn't, but the toll he had paid in the rescue was written in his stiff bearing and on his face.

He came to a halt near her outstretched foot. "You'll have to excuse me for standing. I need to talk to you about these investigations."

"Plural?"

"You heard about Fred Drinkwater's death, didn't you?"

"I heard he was dead." And good riddance.

"He may have been murdered."

"Oh, my!" She sat up straight.

"Did you know him well?"

"You mean, did Mack know him well," she said flatly. She had been thinking about her quarrel with Mack the night before the slide. She had accused her husband of taking a bribe—the too-generous deal Drinkwater had given him on the house. She closed her eyes, because she wasn't going to cry in front of Rob, not again. "We didn't know Fred well. He was just another developer. Mack saw more of him than I did, as you might expect."

"What about Fred's personal life?"

"His women?"

"Anything."

"Well, Kayla, of course. Darla Auclare. And somebody suggested he was playing around with our wonderful county clerk, but that's probably just a rumor."

"Tergeson's daughter?"

"Inger Swets."

" 'No sweat with Swets,' " they chorused. Rob grinned.

Beth felt her neck muscles ease. "That slogan's like a lot of political language. Catchy but doesn't mean much. Not that I know anything bad about Inger. Mack thought she did a good job."

"She married Larry Swets, didn't she?" Rob had gone to school with Larry.

Beth nodded. "The barge captain—gone a lot on the river. No kids. I understand that's an issue for Karl." She thought about Fred's womanizing and shook her head. "A crime of passion seems so unlikely. Fred wasn't the kind of man who arouses grand passion."

"That's what Meg thinks."

"She's right."

"There's the ex-wife. Were they still together when he came here?"

"Five or six years ago? He was already divorced." Impatience coursed through her. "Look into his investors. Matt Akers, the contractor, put money into Fred's projects. They weren't partners, but I'm pretty sure Akers invested. Mack said there was California money to begin with, too."

"Where did Fred come from?"

"I don't know where he was from originally. Before he moved here, I think he worked in the Seattle area. I'm not the one you should be asking, Rob. I wish you'd sit." It felt as if he were towering over her, though he was an inch or so under six feet.

He gave her a crooked smile. "I could lie at your feet, Madam Sheriff, but not sit." He walked over to the mahogany mantel and touched it. "Somebody's been dusting."

"Probably my daughters-in-law. They're house-proud." She twisted sideways so she could read his expression.

He leaned both arms on the back of one of Hazel Guthrie's tall chairs. "Better? Less ominous?"

"Somewhat. You said investigations."

"Drinkwater's murder, and a close look at the process that led to approval of Drinkwater's development."

"That will put a strain on the department's resources."

"Minetti wanted to turn the second investigation over to the state."

Beth made a face. "What do *you* want to do?"

She watched him take a long breath. He walked back and stood in front of her again. "I hate to agree with Earl, but I think it would be best to call in the state right now, today. If we don't, pressure from the insurance companies, from victims like the Vander-brooks, and from the Gautiers' survivors, whoever they may be, will force the *commissioners* to call them in."

"And the commissioners are part of the problem."

"Exactly." He smiled at her. "If *you* ask the state to take over investigation of the missing LHA notice—"

"The what?"

He explained.

"Meg told me about that." Her mouth felt dry. He was saying she should put distance between herself and the commissioners. "Somebody with courthouse access suppressed the first notice—is that what you think?"

"I'm not positive, but the state has a record of the WSU survey, the first one. They have no record of the second survey, the one the commissioners accepted, the one Fred's geologist produced. That being so, the problem has to lie here—at the courthouse. If I do the investigation, I'll need to look at every document involved, of course, but I'll also need to look at procedures and board minutes. How does a geological survey get to the Records office? Who pre-pares the presentation when a developer's plans are on the agenda? And so on."

Beth interrupted him. "You could do it, Rob."

"I could, but it might not be wise."

"Because you're employed by the county? I see. You'd better tell me what to do. We can call now, can't we?"

"The sooner the better." He hesitated. "Everyone who was in a position to get at those records will come under scrutiny, includ-ing me. It's not going to be pleasant."

"Mack—"

He held up a hand. "I'm sure Mack had nothing to do with it."

"Why? Instinct?" Her voice shook.

Mack was probably in the clear because he was dead before Fred's murder. Rob didn't have to say that and didn't. "The state investigators will look into Mack's official records and into his personal finances."

Beth shivered.

He was watching her. "The real problem will lie with the commissioners. You've been sworn in, haven't you?"

She nodded. Karl Tergeson had administered the oath at the hospital the night before with John, Dany, and Beth's wide-eyed roommate watching. It had felt very strange.

"Then you have the authority to act. They can't stop you. Tergeson and Auclare will be under the gun. At the very least, they've been careless."

Beth's stomach churned. "What if they were all in on it? The commissioners, the clerks...Mack."

Rob met her eyes. "I talked to Maddie Thomas before the landslide, when Charlie told me about the first survey. If the corruption were that widespread, I think she would have picked up on it." He didn't say false gushing things about Mack's incorruptibility. He was assuming Mack's innocence, not making a big deal about it. That made Beth feel better.

She said abruptly, "When you said it wouldn't be wise for you to investigate the approval process, you didn't mean you were worried about your job, did you?"

His eyebrows shot up. "No!"

"Spell it out for me."

He stood still, head bent while he thought things over. At last he looked up. "Everybody knows Mack was my mentor, and sooner or later, someone will be charged with this crime."

"And with wrongful death?"

"Maybe. Definitely with fraud, and certainly with violating the state's procedures. When that happens, the defense lawyers will call the investigation into question. They'll claim I did a cover-up to protect Mack's reputation."

"Would you?"

"No, not even for Mack. I saw what happened to the Gautier family. I see it every time I close my eyes."

"And what happened to my family."

"Yes." He held up his hand, thumb and forefinger millimeters apart. "We came that close to losing Sophy. Linda had to *yank* her free."

Beth needed to thank Linda Ramos. Now she said, "But you should be in on it. You know the local scene better than a state officer based in Vancouver or Olympia."

"I do. I'll liaise with them, defer, make myself indispensable. And I intend to investigate the Drinkwater murder myself. It happened at Tyee Lake—an unincorporated piece of the county. Our jurisdiction."

"But—" She bit her lip.

"Since his accomplice probably killed him, we'll be coming at the culprit from two sides."

A long pause ensued. "Yes," Beth said at last. "Yes, go for it. One condition."

His eyebrows snapped together. "What?"

"I want you to replace Earl as undersheriff—listen to me." She spoke sharply to forestall his protest.

He was shaking his head. "Ask Corky Kononen."

"I did. He said no." Corky would retire in three years and did not want the hassle. "Listen," she repeated. "Mack chose Earl because he recognized another politician when he saw one. You were right to refuse Mack. You don't want to run for public office."

He said wryly, "I'd be unsuccessful running for public office. And I'd hate every minute of it."

"I know you would. I don't understand why, but I know it's true. I don't want to groom you to run for sheriff."

"Then what's the point?"

"When he was ranting at me, Earl said I was no kind of cop. He was right."

"You'll learn."

"Yes, if you'll teach me. I want you to run law enforcement for the county. You don't have to mess with the uniform branch.

Corky's a good lawman, and he likes and respects you. Run Investigations, as you do now, and stand between me and my own ignorance. That's all I'm asking. I'll attend the Chamber of Commerce meetings, deal with the press, meet with the Board." Any halfway competent woman could do that. "And I'll back you all the way, Rob."

He was rubbing his neck, eyes on the faded pattern of the carpet, cheeks flushed. Beth flashed on the first time she had noticed him, a small, skinny twelve-year-old at the dingy karate school, barefoot and clad in the white pajamas they all wore. Her son, Mike, who was Rob's age, was much larger. Rob had just thrown Mike over his shoulder. He had worn the same expression then as he did now—not gleeful, not even satisfied, just watchful. When Mike swarmed up from the mat, arms flailing, Rob threw him again.

Now he sighed and smiled at her. He had a nice smile, rueful and accepting. "Okay. On those terms."

Beth reached for her cell phone.

Maddie was thinking about land. Specifically, she was thinking about the prairie that now lay beneath the rubble of Prune Hill. She and Jack were sitting in a booth at Mona's awaiting the Hungry Logger breakfast, as they usually did on Sundays, Jack buried in the sports section of the *Oregonian*.

In the old days, the Klalos had used the open land for occasional encampment. The fishing had been good, but the soil was not wet enough to support camas, and the hill-cougar might leap down at any time, hungry for flesh. Land moved. That was one reason the idea of owning a piece of it didn't make sense. Once upon a time, the Burlington Northern had claimed to own the tip of Mount Saint Helens.

"You're looking cheerful, Chief Thomas."

"An illusion." She met Karl Tergeson's hostile gaze. "How are you, Commissioner? Jordis, good to see you."

Mrs. Tergeson gave her a timid smile. Like Maddie, the commissioner's wife was a big woman, but she didn't know how to dress. She looked like an expensive sofa cushion.

"Won't you be late for church?" Maddie said.

Tergeson explained that the Lutheran service didn't start until eleven. Maddie already knew that. She just wanted to make him nervous.

Jack crackled his sports page and looked up at the commissioner, who gave him a belated greeting. People like Karl sometimes ignored Maddie's husband. Jack didn't like it. Neither did she. She might have said something to make the commissioner even more nervous, but the waitress brought their meal, and Tergeson and his wife moved on to a table after a few more polite phrases. The waitress was Maddie's niece, Lena.

They had a family chat, nice but brief. The restaurant was busy and Lena conscientious. She poured coffee and was turning away when a woman rushed in and jostled her arm. Coffee splashed, staining the woman's sleeve.

"Why don't you watch where you're going?" the woman shrieked. It was Karl's and Jordis's daughter, Inger Swets, the county clerk. Maddie had not immediately recognized her.

"S-sorry," Lena stammered.

Maddie thrust out a handful of paper napkins. She hadn't recognized Inger, because Inger was dressed like her mother. The outcome was different. Maddie had once heard a guy say Inger was built like a brick shithouse. Still, the suit was dull, and Inger had pulled her glorious gold hair back in a bun.

Why was Inger in disguise? Ah, church. She was dressed for church. Interesting. Unusual. Lena was still apologizing, and Inger mopping and muttering.

"Your parents are over there," Maddie said kindly.

"Oh." Inger blinked at her. The taut features eased. She bared her teeth in a smile. "Oh, hi, Maddie. Thanks."

Lena scooped up the damp napkins and fled with her coffeepot. Inger was saying polite things about the funeral tomorrow. Maddie answered absently, her mind on the brick shithouse, which made about as much sense as owning land. If you were going to build a privy, surely you'd make it of light, inexpensive materials, so it could be taken down and moved.

As Inger went off to join her parents, Jack said, "Man, is that woman built!"

Maddie grinned and tucked into her hash browns.

They ate with leisurely enjoyment, not talking much because Jack wasn't a talker. The Tergesons ate and left in a rush. As they left, Hank and Yvonne Auclare came in from ten o'clock Mass. There was another flurry of greetings. If the Bjorks had come, too, it would have been a full turnout of the Board of Commissioners, but Maddie couldn't imagine Catherine Parrish Bjork eating at Mona's.

———

Meg would always remember Monday as the day the dog came home, even though it was also the day of Michael McCormick's funeral.

The dog in question was Towser, Tammy Brandstetter's Rhodesian ridgeback. Meg was fond of him. Tammy, who lived down the street, had taken time off from her work as a bookkeeper, six weeks at her sister's in Las Vegas, so she had missed the weather and its ghastly consequences. Meg brought her up to date over coffee while Towser looked the kitchen over. It was his first time inside her house. When he had sniffed everything, he settled down next to the table and thumped his tail on the ancient linoleum. At least he didn't lift his leg.

As for Tammy, she looked like a very merry widow. She hadn't overdone it, which surprised Meg, but her dim hair had been cleverly cut and highlighted, and her face shone with contentment and a hundred-buck makeover. Meg asked about Tammy's son, Tom, and Tammy asked about Rob's back, and they got all caught up.

Then Rob came down in uniform, set to leave for the funeral. There was a flurry of greeting, magnified by Towser's enthusiastic participation. He was bouncing, the way ridgebacks do, ready to jump on Rob, which would not have done Rob a world of good. Towser weighed upwards of a hundred pounds.

Tammy said, "Towser, sit!" Very firm, very calm.

Towser sat.

"Hey!" Rob gave her a wide grin. "What happened?"

"Obedience school." Tammy blushed. "I had to do something about him."

"Well, you done good."

Tammy smiled but her mind had drifted sideways. "Do you think I ought to go to the funeral?"

It was a good question. Her husband, the late commissioner, had died under a cloud, to say the least.

"Only if you want to," Rob said cautiously.

She shuddered. "Well, I don't. Give Beth my love. I suppose you're going, Meg?"

Meg sighed and nodded. She felt something of Tammy's reluctance, though for other reasons. She was still an outsider. However, she was also the head of a county agency. She knew her censorious subordinate, Marybeth Jackman, would be there, watching for her. And people would be curious about Meg's relationship with the new undersheriff, too. Better put a good face on it.

With another sigh she escorted Tammy to the door, gave her a hug and Towser a pat, and then it was time to go. Rob was unnaturally quiet. He had spent an hour with the man the state police had sent in to head the landslide investigation. Rob was not happy about that, and he was grieving for Mack, too, so he had plenty of reason to withdraw into himself, but she didn't like it when he went some place she couldn't go.

E TERNAL REST grant unto him, O Lord," Father Martinez intoned.

Obedient, the congregation replied, "And let perpetual light shine upon him."

Maddie listened with grave attention, as she always did to ritual, even Boston ritual. One of her grandmothers had been raised as a Catholic.

Maddie had a weakness for funerals, as long as she wasn't too close to the dead person. Her favorite funeral had been Hazel Guthrie's—Rob's grandmother's. It had combined the best features of Christian ceremony—Presbyterian, in Hazel's case—with the pleasures of a political rally, the library system being then under siege. The Celebration of Life part of the service had turned into a Library Testimonial. Five weeks later the levy passed. Maddie had enjoyed speaking up for the library.

Afterwards, Jack told her he thought Rob resented all the hoopla. Maybe so. Rob was a mystery to her, a very private man. She wasn't sure she liked him, but she came close to trusting him.

He sat up front with Corky Kononen and the other honorary pallbearers, who were, no surprise, Karl Tergeson and Hank Auclare. Rob looked strange in brown and tan, shrunken, diminished by the uniform, or maybe just by grief and a sense of failure. Jack said the sheriff had been like a father to Rob, whose real father was long dead, and Rob had not been able to save the sheriff's life.

Michael McCormick had been a father in the literal sense, too. His grown children, and their husbands and wives and offspring,

heads bowed, filled the first three rows of pews on the left. His elderly brothers and sisters, and Beth's two sisters, hunched in the front pew on the right.

Beth sat very still in the wheelchair, which rested beside the center aisle seat near her children. Maddie felt the tug of sympathy. Whatever his faults, Mack had been a devoted and affectionate husband, and Beth had been married to him forty years.

Maddie let herself rise and kneel and sit, as the ceremony seemed to demand, and gave herself over to surveying the mourners. Half the county had crammed into the tiny church. She saw a cluster of girls, some with nose studs, from the high school. They were there for Beth, and the two gangly boys whose underwear showed above low-slung pants were probably there for the girls. Deputies, in and out of uniform, shouldered well-dressed business people and less well-upholstered teachers and county employees. Maddie spotted her nephew Todd in uniform and Meg McLean with a clump of librarians. A good turn-out, someone was bound to say, but there were strange absences. She craned around but couldn't find the Bjorks or Matt Akers, the contractor.

It struck her that the funeral was not the orderly military affair everyone might have expected, with deputies forming an honor guard and a bagpiper tweedling away. Maddie had once seen a funeral for a police officer run over by a drunken driver. Massed motorcycle cops from all over the state had followed the hearse to the graveyard. She wondered why Beth had not wanted that kind of funeral for her husband. Mack probably would have enjoyed the motorcycles, and Maddie would have liked to hear a bagpipe again. The noise was profoundly odd, certainly more interesting than the organ that now wheezed out feeble phrases.

The priest, stumbling a little in English, had read the epistle and gospel selections. Time for the eulogy. At that point, the eldest brother rose from his pew and told a long, rambling, nearly inaudible story that provoked subdued laughter from the first few rows. Family stuff. Then the children spoke. They were a handsome, articulate bunch, and they said good things, warm and rather surprising, about their father. They thanked the rescuers and

asked everyone to pray for their sister's recovery. Peggy was still in a coma. At last the weedy young man who had helped serve Beth's dinner stood up—Skip Petrakis, the not quite son-in-law. He looked rumpled, short of sleep.

He sniffed, cleared his throat, and mumbled something. Voices prompted him to speak up. "S-sorry. I'm not much of a speaker. I am Aristides Petrakis." He cleared his throat again. "I just wanted you to meet someone." He stepped forward and took a squirming bundle from one of Beth's girls.

"This is my beautiful daughter, Sophia Agnes Petrakis. If her mother could be here—" His voice cracked, and he cleared his throat again. The baby looked up at him and tugged at his wispy beard. "We want to say thank you to Sophia's grandfather. He saved her life, and lost his own doing it. Thank you, Mack." Sophy gave a lusty yell, and everyone laughed and burst into tears including Maddie.

When push came to shove, Maddie reflected, slamming her eyes with a sodden Kleenex, there couldn't be a better tribute to Mack McCormick. Beside her, Jack sniffed and blew his nose.

After an interval, Beth's son John wheeled his mother around to face the congregation. She had been crying, too. Her nose was red, but she spoke with composure, her voice strengthening as the words came. She thanked the rescuers, mentioning Rob and Linda Ramos by name, and she thanked everyone for coming. Then she drew a long, sustaining breath.

"I just wanted to say I loved Mack." She paused, and people squirmed in their seats. "We met when we rode the school bus together to Klalo High School almost fifty years ago. I loved him then, and I love him now. He was—" She paused, then said with fierce intensity, "He was a *good* man. That's what counts. When my daughter Peggy is better and things have settled down, we're going to hold an old-fashioned wake for Mack. All of you have stories about him. Save them up." She gave Mack's constituents a big smile. "I want to hear every single one of them."

Amid shuffling and murmuring, she turned the chair, and her son pulled it back into place. The organ wheezed to life, and the

Mass droned on. As Maddie watched the family file up to receive communion, she found she was thinking hard about Sheriff Beth.

━━━

Rob spent the afternoon in his office, ostensibly reorganizing the Investigations staff but mostly staring out his window at the hill above the parking lot. Because Mack had been cremated, there was no burial service. Rob didn't want one, but the funeral had not brought a sense of closure. The only way to gain release would be to find out who had suppressed the landslide hazard warning. As of yesterday, that investigation was out of Rob's hands.

Try as he might, Rob could feel no urgency about Drinkwater's death, though it was probable the two cases were linked. Rob didn't care who had killed Fred, but he did care, a lot, about who had suppressed the warning. The irony of his situation did not escape him. He wondered what the state investigator was doing. With *his* case.

Outside an east wind shook the branches of the vine maples on the hillside. A cold, dry day.

Well, it wasn't his case. He thought of his cousin Charlie. Might as well say it was Charlie's case.

Brooding, Rob pushed the files on his desk around, shuffled them, piled them in reverse order. He had moved Jake Sorenson and Todd Welch from Corky's department to Investigations and bumped Linda Ramos up to acting sergeant, acting because she had not yet passed the sergeant's exam. Thayer Jones, who *had* passed, had refused the promotion. Thayer was a twenty-year veteran. Like Corky, he wanted to coast to retirement.

Rob had asked for Corky's computer nerd, too, but Corky balked at that. Rob could have ordered the move anyway, but he didn't want to antagonize Corky, who had been surprisingly cooperative over the loss of two good men. That could wait. Jeff Fong had computer savvy.

Impatient, Rob yanked out the folder marked DRINKWATER. Jeff would be calling in soon with preliminary results from the autopsy. Maybe Fred had died of chagrin. Rob extracted the crime scene photographs and put on his reading glasses.

"You've got to stop them!"

Rob's pulse jumped. "What the hell?" He shoved himself to his feet with a jab of pain.

Lorenz Swets, three hundred pounds of enraged barge captain, shook off the desk sergeant's restraining hand and glowered at Rob from the doorway.

Sergeant Howell was out of breath. "Sorry. He just bulled his way in."

Rob waved a hand. "It's okay. Come in and sit down, Larry. When did you get back?"

Huffing, red in the face, Larry sat in the visitor's chair. "This morning. Three weeks on the river, and I come home to this. Shit. Inger's spitting bullets." His voice took on a plaintive tone.

Rob appreciated the anticlimax. Inger was a strapping lass, but her husband weighed twice as much and out-topped her by half a foot. It was a tribute to the strength of her personality that she had him cowed.

"You've got to stop them," Larry said again, earnest.

"By them, I guess you mean the state investigators."

"They took her computers, mainframe and laptop, and hauled off all kinds of paper records. What are they after? I don't understand. The hill that slid, it was like a blob of Jell-O on a warm griddle. How can they blame Inger for a fucking landslide? You gotta stop 'em, Rob."

"I was the one who called them in."

"Inger told me Beth McCormick—"

"Beth okayed it. It was my idea."

Larry gaped.

"About the records." Rob maintained eye contact. "There was an irregularity in the county's approval process when those houses at Prune Hill were in the planning stage."

"Is that all?" Larry's voice squeaked.

Rob shrugged—and winced. Have to remember not to shrug. "If Inger has a beef, tell her to come to me. I want to talk to her anyway." But not about the state's investigation.

"About the mudslide?"

About her affair, if any, with Fred Drinkwater. "About the way

the county operates," Rob said smoothly. "We're in a muddle here because of Mack's death, and nobody knows the way things are supposed to work in the courthouse better than Inger. I'm ignorant. I always let Mack deal with the commissioners. Tell Inger I'll be calling her."

Larry was frowning, his eyes unfocused. "Uh, yeah, sure. Hey, what's the word about the developer, Drinkwater? I hear he's dead."

Watch it, Rob said to himself. "Unattended death. That means we have to look into it." After fifteen minutes of soothing obfuscation, Larry left looking less irate than when he showed up.

Rob riffled through the pile of photos and took another look at the death scene. Bizarre. Way too peaceful.

Drinkwater wasn't sitting, exactly. He was *lolling* on an upscale deck chair, legs extended on the footrest, towel draped chastely across his lap, arms limp. His head was turned to the right, his eyes were closed, and his mouth hung open a little as if he had just fallen asleep or passed out. A whisky glass half-full of some cloudy yellow liquid sat on a small table near his right hand. A second deck chair, empty and upright, angled toward him as if someone had been talking with him, but there was only one glass. A third deck chair was shoved back against the wall, perhaps stored there. The water in the spa shone unnaturally blue under the SOCO lights. Bizarre. And something was missing.

The phone rang. "Lieutenant Neill," he said, absently and inaccurately.

"Hey there, Undersheriff."

Word had got out. Rob grimaced. "Hi, Jeff. Did the ME have preliminary comments?"

"Unofficial ones. Hedged around with weasel words."

"Gotcha."

"Somebody used a choke hold on Drinkwater."

"No kidding?" Rob rubbed the skin between his eyebrows. "I don't buy it. Fred would have struggled."

"Maybe he did," Jeff said. "The body voided. There's minor postmortem bruising, too, as if it was rearranged."

"Even so."

"Doc thinks he was probably out cold."

"Drunk?" That made some sense. If I'd just killed half a dozen people in the name of profit I'd head for the bottle, Rob reflected. Or a bridge to jump off.

Jeff was giving the blood alcohol level. High but not paralytic. "He may also have been drugged. We'll have to wait for toxicology."

Rob sighed. "Time of death?"

Jeff chuckled.

"What?" The ME was notorious for refusing to commit himself on the time of death.

"The evening after the mudslide. Sometime."

That was apparently as useful as the ME was going to be, lacking the rigorous analyses the lab would conduct. Patience, Rob told himself, signing off.

It was getting dark out. He finally left an hour later, having e-mailed everyone their reassignments and touched base with the state investigator. Then he went home to Meg. Halfway there, what was missing from the death scene photographs came to him. Nude or fully clothed, Fred Drinkwater would not have been caught dead without his cell phone. It should have been lying on the small table alongside the hypothetical second glass. Somebody had rearranged things, all right.

———

Kayla drifted in and out of doped sleep. The plastic surgeons had harvested a segment of bone from the iliac crest of her pelvis the previous day. They would use it to reconstruct her cheekbone, but they thought she ought to heal a bit before they performed the first of what would be several surgeries on her face. She had wanted them to go in and get it all over with, but that wasn't likely to happen. How long, she wondered—when she was able to wonder. Mostly she just drifted.

The pain in her pelvis more or less balanced the pain in her cheekbone, leaving her, she thought dopily, suspended over a pit of pain. Something wrong with that image.

Image. "Have to change my image," she muttered.

"No shit? What do you have in mind?"

She blinked her good eye—her remaining eye. "Charlie."

"That's me." He was eating something. "Would you like a French fry?"

"That stuff'll kill you." Her mouth watered. The surgeons didn't want her to chew yet.

"Naw. I'll suffocate under a pile of student lab reports first." He popped another fry into his mouth. "I brought your mail."

"Mm. Snail mail?"

"And e-mail. I printed the e-mail up for you. Lots of good wishes. I zapped the penis enhancers and the Christian debt removers first. What the hell is Christian debt? Forgive us our trespasses?"

"Ow. Don't wanna laugh."

"Okay." He chewed peacefully.

That was the good thing about Charlie. One of the good things. If you didn't want to talk, he didn't force conversation. Her eye closed, and she sank into comforting darkness. She woke to nightmare again, drowning, reaching out.

"Hey, Kayla."

"H-hold me." It was amazing that she didn't mind it when Charlie saw her cry. And he didn't try to sweep her into his arms and carry her off on his white horse either—just let her grip his hand hard. The vision of Charlie as a White Knight tickled her, and she gave a watery giggle.

"That's better. Okay now? It'll fade."

A lot you know. The resentful thought surfaced, but she was grateful.

He looked at his watch. "I have to leave. Your mom will be here tomorrow, right?"

"I don't want to see her."

"Sure you do. Tell her you need a new television—digital, big flat plasma screen, satellite dish."

That did make her laugh. Kayla never watched TV. She saw too many old people anesthetized by *Jeopardy!* and the soaps. The thing was, Charlie didn't watch the tube either. Too busy with his

precious rocks. "Oh God, your dissertation! Weren't you supposed to defend it this week?"

"Tonight."

It was five P.M. according to the big wall clock. She stared at him. "Are you out of your mind? Get out of here. Go read a book or recite your mantra, or whatever you do to prepare for intellectual crises. I may be a self-absorbed bitch, but I'm not that greedy for attention."

He stared back. His eyes were an utterly dazzling blue and never mind that they were shadowed with sleep-deprivation.

"Go away. Now. And call me," she said, "as soon as you know."

He didn't say anything, but the smile he gave her took her mind off her misery for the next three hours. That was when he called.

Though Meg did her best with dinner, it was a glum and mostly silent affair. Rob made a stab at helping with the dishes but wasn't up to their usual banter. She suppressed her irritation. He had a right to gloom.

At ten she sent him upstairs to lie flat, which he promised to do, though she could hear him talking on his cell. Maybe he was calling his daughter. That thought reminded her to call her own child. When she did, though, she found that Lucy was studying for a big examination—all her exams were big these days. Meg clicked her phone off and went to make sure the front door was locked, an urban habit she was unable to shake. She saw a light come on across the street and took the phone from her pants pocket.

"Hey, Charlie, you're home early." He usually got in around eleven.

"Oh, hi, Meg. How are you?" He sounded odd, as if he were at the bottom of a well or floating in space.

"Fine. How's Kayla?" Maybe something had gone wrong with the bone harvest.

"Uh, sore and grumpy. Uh. I think she'll be okay."

"Want a cookie?" Meg had baked in anticipation of cop swarms in her kitchen. The swarms hadn't materialized yet, but they would. Rob's new investigation team was meeting next day.

"Sure. I'm hungry." He sounded surprised.

"Come when you're ready."

"With you in ten."

Charlie was definitely spaced, Meg decided. Probably tired—that was a long drive, especially with side trips to the hospital. She started a pot of coffee and heaped a small plate with cookies. She could hear creaking noises upstairs. Rob pacing the floor. Maybe it helped him think, but it wouldn't improve his back.

Oh stop fussing, she told herself and went to the kitchen to await Charlie.

He took longer than he said he would.

"It doesn't matter." She waved his apology away. "Coffee?"

"Uh, sure. I, uh, had to call my dad."

She poured a mug full and went to the fridge for milk. "You look dazed. What's the matter?"

He rubbed the back of his neck, grinning. "I guess I don't believe it's over. They accepted my dissertation. I don't even have to revise it."

Meg gasped. "What? They made you defend it tonight? Oh, Charlie!" She gave his shoulders an impulsive hug, and the coffee on the table slopped. "That's wonderful, in spite of the lousy timing."

"Hey!" Laughing, he grabbed a paper napkin and mopped. "Dad was pleased. Jealous, too. He has a master's in education, but he always wanted to go for a science degree. Started a family too soon, I guess."

"And your mother?"

"Well, it's a little hard to tell." He looked at Meg over the rim of his cup. "She had a stroke when I was in high school, so she doesn't speak much, but she made rah-rah noises and hummed the Wisconsin fight song."

Meg was shocked. She forced a smile.

"For some reason she's always been able to remember tunes." Charlie shook his head. "The brain's a funny thing."

"It is," Meg said gently, "and there's obviously nothing wrong with yours."

Charlie's ears turned red, but he grinned and saluted her with his cup. "Cheers."

"What *am* I thinking?" Meg darted to the liquor cupboard. "This calls for single malt."

"Scotch?" Charlie drooped, wistful. "You mean you don't have Jameson's?"

"What's the occasion?" Rob stood in the doorway wearing the white karate outfit that always reminded Meg of pajamas. "Hi, Charlie."

Charlie lifted his glass. "*Sláinte.*"

Meg explained, watching Rob's face. His eyebrows shot up. Then he looked blank. After a moment, he smiled. "That's good news. Congratulations, Dr. Neill."

Charlie took a swallow. "It's Dr. *O'*Neill, thanks."

The two men stared at each other.

Rob burst into laughter. "I can't believe I said that."

"Maybe you just adopted him," Meg said helpfully and poured Rob a very small glass of whisky.

THE WOMAN WHO entered Meg's office at the library the next afternoon was the kind who always set Meg's nerves on edge. Everything about her *matched*, from the crown of her exquisitely tinted hair to the soles of her spectator pumps, so retro and so right, they defined retrocity. She wore a raw silk pantsuit in a subtle shade that couldn't be called beige, and her beautifully preserved and manicured hand—extended for a genteel handshake—bore a ring with a stone not quite as big as the Ritz.

Meg pressed the flesh. It was warm.

"I'm so glad to meet you, Mrs. McLean." People often made that mistake. Meg had never married. The woman's voice fluted—a bit high, a bit girlish. "I'm Dede Marquez, Kayla's mother."

"I hope Kayla's bone graft is going well," Meg ventured.

"Ah, it's early days. I consulted her surgeons, of course. It will be some weeks before they do the actual graft." Unbidden, Mrs. Marquez sank onto the patron chair beside Meg's desk. "I wanted to thank you in person for visiting my poor girl at the hospital. I had no idea it was so far from Klalo."

"Neighbors sticking together," Meg murmured.

Mrs. Marquez looked at her as if she had said something quaint but smiled graciously. "You took pity on my child, so I thought you might take pity on me, too. I'm staying across the river at the Columbia Gorge Hotel. Will you have dinner with me tonight? Otherwise I'm doomed to a book and room service." A fate worse than death.

Meg's mind raced. She was a little tired of accommodating Rob's

non-schedule. She could leave stew in the oven and a message on his voice mail. What the hell?

Three hours later, suitably rigged out, she drove her Accord upriver. The low, narrow span over the Columbia to Hood River made her nervous. Like the Bridge of the Gods at Cascade Locks, it was a two-lane toll bridge. None of it was elevated, fortunately, but the roadbed was a steel grate, open meshwork through which you could see the water if you were so inclined.

The car's tires hummed one note on the approach and a higher pitched sound where the drawbridge crossed the main channel. Though they didn't skid, the tires felt as if they might. There was little traffic. Sullen gray beneath the grate, heavy with snowmelt, the Columbia powered its way west. The tollbooths with their metal bars blocking the exits lay on the Oregon side. Meg handed over three quarters, waited for the bar to lift, and made her way along the freeway to the small resort hotel, which was notable for its food and its view of the river.

It was a pity she and Dede Marquez had nothing in common other than gender and a certain willingness to be pleased. In the course of the evening, Meg came to understand that Kayla's mother had made a lucrative career of marriage, that she never read anything other than fashion rags and *People* magazine, and that she loved her only child without the least understanding of what made Kayla tick. At least she was trying. She wept a little about the damage to Kayla's face, but she had faith in cosmetic surgery, so she wasn't inconsolable.

About halfway through the entrée, Dede dropped her fork onto her plate with a delicate clatter. "Oh, my word, it can't be."

Meg craned. Cate Bjork had just entered with a casually dressed couple of about her own age, both of whom looked sullen. The man was shorter than both women.

"I wondered where Katie wound up."

"Katie?"

"Now what is her surname? She married that banker."

"Bjork."

"Goodness, do you know her?" Dede beamed at Meg as if she

had just passed a social test. "Whatshisname is such a dull man, almost as dull as my ex. I married an investment banker, too. Very wealthy, very boring—the longest five years of my life. You have no idea. Katie and I suffered together. A dear, dear friend."

But not in touch.

Dede rose. "Forgive me, Meg. I won't be a minute." And she strode across the room to the table where the maître d' was seating the commissioner and her guests.

Meg ate slowly and watched body language. Dede was gone more than one minute and less than ten. Meg thought she met with a cool reception. When she returned her cheeks were flushed, but she didn't say anything negative.

She picked up her fork and toyed with a morsel of veal fricandeau. "Just imagine. Katie tells me she's a county commissioner now. What in the world is that?"

Meg explained. Briefly.

"Ah. Sounds dire." Dede took a gulp of a wine that should have been savored. "Well, it will give her something to do with her time while she sorts out her family troubles. Apparently Lars has Alzheimer's. He's nearly eighty, you know. Much older than she is."

Meg thought that over. She hadn't had much contact with the elderly man at Beth's dinner.

"Lars's son Warren has locked horns with her before. That's Warren with his wife at Katie's table. Lars's children blamed her for their parents' divorce. Kids do that." Dede chewed and sipped, then added, with relish, "*She* has power of attorney, though, so my money's on her. It was shrewd of her to move Lars north."

"Did she move him, or did he move her? Alzheimer's progresses fairly slowly in the early stages."

Dede's eyes narrowed. "Good question. No offence, but I have a hard time imagining Katie choosing Klalo. Seattle, yes. How long have they lived here?"

"Five or six years," Meg said. "She's been active in Gorge preservation groups and environmental causes. She was elected to the Board of Commissioners in December."

"She was big in the Sierra Club at home." Dede gave a girlish giggle. "Home! Listen to me. Home is Los Cabos now." And she

gave Meg a detailed picture of just how wonderful it was to live in Baja and what a lovely condo her new husband had bought for them to retire to.

Meg listened with what she hoped was a sympathetic expression on her face and watched the commissioner quarrel with her middle-aged stepson. Or rather, since nothing about Cate Bjork betrayed either tension or hostility, Meg watched the stepson quarrel with Cate.

━━━━

Rob ate his solitary dinner around eight, tidied the dishes, and settled down at the kitchen table to brood over photocopies of Fred Drinkwater's financial records and Linda's report on them. Every few minutes he found he had to walk around to ease the cramps between his shoulders, so he gave up in disgust and walked to the municipal pool for a swim. Swimming was about the only form of physical exertion his doctor had not warned him against.

He didn't swim laps. He tested assorted muscles with three breast strokes here, one butterfly there, half a lap on his back with his legs doing most of the work. The crawl was too wrenching.

The Olympic-sized pool, gift of a philanthropic lumber baron shortly before the last planer mill closed, boasted times set aside for family swims, youth training, senior aquatics, and so on. Nine P.M. was the hour Mack had claimed for his deputies' fitness program, and two rookies from the uniform branch were dutifully plowing their way up and down the far lanes. Otherwise the vast expanse of water was empty of life. Cops were more likely to use a gym. Rob made a mental note to remind his people the pool existed. Then he gave himself over to wallowing, which was symbolically appropriate.

He thought about Mack, trying to say good-bye, but it was too soon to sink into that black pool. His mind drifted to Meg. They were going to have to resolve something. He loved her, and she said she loved him. There was a logical solution, but neither of them viewed the institution of marriage with enthusiasm. Still, Rob felt at home in Meg's kitchen, not to mention her bedroom, as he had never felt in his grandmother's huge house, or anywhere else.

He took three lazy sidestrokes and flipped over. He had no

trouble at all with the idea of spending the rest of his life in Meg's company, but he wasn't sure she felt the same. And there were their daughters. He hadn't yet met Lucy. After Christmas, when Meg returned from a lightning trip to Palo Alto to see her daughter, she had met Rob's daughter, Willow, and they had dealt with each other politely. Willow had good manners. She was almost always polite.

He flipped to his back and stared up at the tiles on the distant ceiling. Polite was not good enough for Meg. She deserved better. Well, there was time. Willow was sixteen, with other things on her mind. Boys, the SATs, boys, an upcoming study tour in France, boys, her too-long hair and too-brittle fingernails, the Amazon rainforest (she wanted to save it), boys, the deficiencies of her iPod, boys. Maybe Willow would stumble across a nice French convent on her study tour.

He flipped to his stomach and tried the breast stroke, which was almost tolerable if he pushed the water hard with his legs. He was no kind of jock, but the fact that he might have to give up karate troubled him. Karate was too much a part of what kept him steady, central to the path he had walked when he stopped being Bobby all those years ago and began to learn how to be Robert. His father had changed his name, too, when he changed his life.

His thoughts slid sideways to Charlie. Calling his cousin Dr. Neill had been a dumb mistake. Rob wondered whether he was trying to create a virtual Clan Neill in the murky depths of his subconscious mind. He'd invited Charlie to join, and Charlie had declined. Fair enough.

He heard a crescendo of splashing as the other men left the pool. They shouted something, probably to him, and he raised an arm in farewell. Then he wallowed some more. He got out only when the manager dimmed the lights.

On the short walk home, he was still testing his muscles, and his mind was still adrift, so he didn't see the attack coming. He had taken Fifth Avenue to Oak, because Fifth was well-lit. Oak was a residential street with handsome Craftsman houses. Half-way along, an overgrown hedge hung out over the sidewalk in the shadow between two streetlights. A muted shuffle from behind

and a quiver in the hedge were the only warning he had of the attack, but his body took over.

He jumped right, bounced off a parked car, and whirled with his left arm swinging up. He thought he probably shouted. Something stung his arm, but his defensive swing knocked a knife from the first man's hand. Both attackers crouched together, facing him, wide-eyed and unarmed. They were young and not very big. A growl rumbled from his throat. He leapt forward, slashing at the shorter kid's nose with the edge of his right hand. He made contact with a satisfying crunch.

Blood spurted. The boy let out a screech in Spanish, and both of them fled along Oak Street, running flat out. They dodged left into the alley that led to the back sides of half the shops in town. Rob slid to a stop, groped for his cell phone, and hit the button to call 911. Behind him, lights had come on in the smug Craftsman houses.

He stood still, panting a little, feeling the flow of adrenaline as the dispatcher's calm voice pried answers from him. By the time Wade Hug, Klalo's veteran police chief, rolled up in the newer of the city's two police cars, reaction had begun to set in.

Three citizens, two wearing jackets over pajamas, collected around Rob, gabbling. He said something to calm them as Wade got out.

"You okay?"

"Uh."

"He's bleeding." An indignant voice, almost accusatory. It was the teacher, Bat Masterson. No, Bat Quinn, the one who had led the search and rescue team at Prune Hill. Bat wore blue pajamas with a print of small white sailboats under all-weather Gore-Tex.

Rob looked at his left arm, which had begun to sting. He saw a long slash on the sleeve of his jacket. Blood trickled down over his fingers.

"Let's get help." Wade stuck his head back in the car and keyed the radio. He asked for the EMTs over Rob's muted protest, muted because Rob was starting to feel weird. Wade yanked open the door on the passenger side of the patrol car. "Better sit down."

"Uh, no." Sitting was a bad idea. As the adrenaline seeped away,

every muscle in Rob's body began to seize up. If he sat he would be sitting for the next forty-eight hours. He leaned against the patrol car and tried to explain. He also pointed out that the attackers were getting well away. A county car pulled up behind Wade's. The blue light revolved as Jake Sorenson jumped out. A siren wailed, coming closer. A circus, and I am the resident clown, Rob thought, woozy.

When he reached home some minutes before midnight, stitched and bandaged, his clan awaited him—Meg and Charlie.

Beth held court in the living room of Rob's house, since she couldn't deal with the courthouse yet, physically or emotionally. It was ten A.M. on Wednesday. Dany was upstairs baby-sitting Sophy, and Skip had gone to the hospital where Peggy showed hopeful signs of waking. The rest of the McCormicks had left. Beth already missed the grandchildren. They would all return on the weekend.

She had heard of the attack on Rob shortly after it happened and been seething ever since.

"You do realize," she said in carefully measured tones, "that a lone woman strolling home late at night on a dark street would be blamed for putting herself in harm's way? Whereas Rob Neill is hailed as a hero by friend and foe alike for doing the same dumb thing."

"Sorry," Rob said. The tips of his ears were red.

He sounded cross and impatient and looked awful. He deserved it.

"Sit down."

"If I sit I won't be able to get up."

Beth sighed. "If you had to go swimming in the middle of the night, Rob, why didn't you drive to the pool?"

"I needed to walk." He rubbed the back of his neck with his good hand. The other arm reposed in a bright blue sling. "I needed to think."

Beth made a rude noise. "Precisely my point. Think."

He gave a rueful grin. "Okay, okay. But with thirty-plus years of martial arts training I sort of assume I can walk the mean streets of Klalo."

"If they'd had guns—"

"Yeah, I know. If they'd had guns I'd be dead. If they'd strapped dynamite to their bodies all three of us would be dead. We live in a perilous society." He walked over to the fireplace and leaned against the mantel. "It's okay, Beth. I didn't even do much damage to my back. And next time I'll carry a can of pepper spray."

She suppressed a smile. "Sheriffing is almost as nerve-wracking as teaching remedial English. So tell me what the mugging means."

"Somebody panicked."

"Drinkwater's killer?"

He straightened and started pacing. "I'll tell you my best guess, but you have to remember it's just a guess."

"I *am* the sheriff."

"Yes." He stopped his restless meandering and leaned against the back of one of the tall armchairs. "It's a relief to know I can speculate freely with somebody. I talk to Meg, of course, but it wouldn't be right to burden her with a load of unfounded suspicion. She has to deal with these folks in a wider context."

"Folks?"

"People who have money and/or clout. She's working up to a levy. She has to do her own kind of politicking, and she needs to be comfortable doing it."

"True. Who are your suspects?"

"In general or for the mugging?"

"In general."

Perhaps he read her impatience. "Matt Akers. Larry and Inger Swets. Karl Tergeson. Hank Auclare. Maybe even our brand new commissioner. Her husband was one of Fred's investors."

Beth whistled. "That's a lot of suspicion. Tell me the rest. Why Matt Akers? I know he's an investor, but there are others."

"A lot of reasons. For one thing, he was Hal Brandstetter's good buddy. He could have pushed Hal to suppress the warning notice. It's exactly the kind of thing Hal would have done."

Beth nodded. She had known the late, unlamented commissioner, the man Cate Bjork had replaced. How convenient to be able to blame Hal for the disaster. Her mind shied away from

thinking about the mudslide. "Uh, what else do you have against Matt?"

"He went to the top of my list last night. Those kids who jumped me were laborers, probably illegals, the kind of workers Matt hires cheap when he can."

"I thought he was the classic true-blue patriot."

"He huffs and puffs about rounding up aliens, but he's been using undocumented workers for years. I looked into Fred's backers. I know now that Matt invested heavily in at least three of Fred's projects, besides doing most of the construction. He subcontracts with plumbers and electricians and so on, but his people do the rest. It's probable that Fred owed Matt money for the construction work, and Matt wants to be able to collect it from the estate and the insurance companies. That's over and above his initial investment. Matt's a blowhard."

Beth heard the contempt in his tone.

His lip curled. "The kind who panic and slash out at anybody who gets in their way. Jeff's bringing Akers in for an interview this morning."

"While your deputies comb the county for the two muggers?"

"If they're smart, those kids are halfway to Mexico by now." He sighed. "But they're not smart, and they're scared. And old Matt probably owes them money."

"You sound sure."

He made an impatient sound. "I'm not sure. I'm guessing. The other suspect who could have found desperados-for-hire is Larry Swets. He came to see me the day before yesterday. The state investigator has to be looking seriously at Inger."

"They think she suppressed the hazard warning?"

"She's the record keeper. She could have done it easier than anyone else, easier even than Hal Brandstetter, but Fred could have paid someone else to substitute his geologist's survey for the one Charlie worked on. All it took was access."

Beth winced. It was an uncomfortable thought, familiar but uncomfortable.

Rob straightened and rubbed his injured arm. "While I can see

Larry panicking, Inger strikes me as a woman with a cool head. I don't think she would have hired anyone to attack me. She knows that investigation is out of my hands."

"But Larry might have?"

"Only without her knowledge." Rob walked to the window and looked out at the yard. The sun was shining for once. "You mentioned rumors that Inger had an affair with Fred, and I've heard that from other people, too. If it's true, all bets are off."

Beth thought of a thousand bad films. "You mean she may have killed Fred in a fit of passion?"

Rob turned. "Or Larry may have, in a fit of jealousy."

Beth didn't know Larry at all. She knew Inger's parents better than she knew the county clerk, but Inger was very much her father's protégée. Beth tried to imagine Karl condoning an extramarital affair. She said slowly, "What if Inger was sleeping with Drinkwater, and Karl had just found out about it?"

"Katy bar the door."

"One of your grandmother's famous expressions?"

He grinned. "Grandfather's." The smile faded. He walked back to the chair and leaned on it. "I can imagine Karl killing Fred to avenge his daughter's honor, but I have trouble believing he could find and hire muggers. He's pretty naïve." He shook his head. "He probably wouldn't know how to use a choke hold, and it wouldn't be his kind of killing anyway. He'd take a horsewhip to Fred in front of the courthouse, not seduce him to death beside a hot tub."

"Is that what happened?"

"I don't *know* what happened. The ME believes Fred was drunk and that somebody killed him while he was out cold. Doesn't sound like Karl. Hell, it doesn't sound like Inger either, even if she was a woman scorned. And Fred did get around. Kayla. Darla Auclare."

Beth flopped back against the wheelchair. "I refuse to imagine *Hank Auclare* avenging his daughter's honor."

"Unlikely," Rob said crisply. "If Hank killed, it would be over money."

Beth was thinking of Mack's reaction to Skip Petrakis. Mack hadn't killed Skip or even threatened to, but horsewhipping would

have suited her husband. Her loss swept over her. She had to look away so Rob wouldn't see her tears. Why were men such idiots, and why did women love them? She cleared her throat. "What are you going to do now?"

"Research. We're checking the record of calls to Fred's telephones, landline and cell. That should be enlightening. And we're looking into our suspects' lives."

"Trying to figure out who could have used the choke hold?"

He nodded. "Who could have done it physically and who might have had reasons to do it. Linda's leading the hunt for my muggers."

"Doing your footwork."

He grimaced. "Right. She's part of the Latino community. Jeff and Linda are inexperienced, but they're both sharp. I'll be working the computer and the telephone. I need to talk to Kayla myself. And to Matt's foremen. But the main thing I'll have to do is establish some kind of rapport with the state investigator."

"Who is it?"

"Ed Prentiss. Lieutenant Prentiss. He's a cold bastard but efficient."

"Will he listen to you?"

He gave a crooked grin. "I'll have to see that he does, won't I?"

"Let me know if I can help." She eyed him, cautious but curious. "Will you tell me something, Rob?"

"If I can."

"Why did you come back to Klalo?" She waved her hand. "Oh, I know—your grandmother was sick. But you stayed. Mack was afraid you'd leave when she died."

He was silent a long minute, frowning. "I guess I wanted to come home for good." The frown eased. "I spent the first ten years of my working life wrestling with Southern California traffic. Here I can walk to work." He grinned. "And to the swimming pool."

Beth thought that was only part of the story, but she let it go.

Chapter 12

"WHAT'S HAPPENING?" CHARLIE took the glass of pinot grigio Meg offered and sat at the kitchen table. It was not yet set for dinner, though cooking scents perfumed the air.

"Since last night, you mean?" Meg perched across from him with her own glass. They were waiting for Rob. Again. In five minutes she was going to stick the salmon in the oven whether Rob came home or not. He was in the safety of his office doing police-like things, so she wasn't worried, just impatient.

"How's Kayla today?"

Charlie smiled. "Fighting with her mother."

"I wish I could listen in."

He gave an exaggerated shudder. "I lay low myself."

"Coward." She sipped the wine. It was not wonderful but it was local. "What are you going to do with yourself now, Dr. O'Neill?"

He shrugged. "Look around for a job. Meanwhile I'll teach my classes and check on Kayla. I still have to pass the licensing exam. I've been ready to take it for three years, though, so it's not much of an obstacle."

"Do you enjoy teaching?"

"Up to the point when lab reports start sifting in."

"Sifting—as in flour?"

"As in silt settling to the bottom of a pond."

Meg laughed. The likelihood that she would have had to grade student writing had kept her firmly in librarian mode her whole adult life. She wouldn't have minded reading student work, but she

would have found grading it disheartening. And overdue books were one thing, overdue term papers something else.

The two of them were deep in a discussion of the perils of teaching when Rob showed up. She had forgotten to put the salmon in the oven. A flurry ensued. Charlie set the table. Fortunately the filet didn't take long to bake. Conversation languished while they ate.

"Man, is that good." Charlie speared a last bit of salmon, chewed, and rolled his eyes in pantomime ecstasy. He was easy to cook for.

"Is this a piece of Jack's fish?" Rob had kept pace with Charlie, even one-handed. He twitched the blue sling as if it annoyed him, a good sign.

Meg nodded. Jack Redfern was grateful to Rob for saving Madeline's life the previous fall. Being a man of few words, Jack expressed himself in material ways, the enormous fish being an example. It was not jack salmon, as a matter of fact, not even coho, but Chinook, the king salmon. Meg saved the filets for special occasions. She thought Charlie deserved salmon. Rob, too. Maybe.

"Wild salmon always tastes better than the farmed stuff," Rob said. He'd looked half-dead when he came in the door, but the magical fish revived him.

Meg poured coffee and set out a plate of the cop-cookies. "Any progress?"

"We took my assailants into custody."

"Rob!"

"Thanks to Linda's connections. Now the trick is to persuade them to talk about who hired them. As for the murder investigation..." Rob made a face. "Facts are trickling in."

"And?"

He frowned.

"I'm a reserve deputy, remember." Meg was proud of her calm, unaccusing tone of voice, but Rob's fits of reticence maddened her. Imagine not telling her immediately that the muggers had been found. She drew a breath, seeking patience. "God knows *Charlie* has a legitimate interest in your investigation."

"In Ed Prentiss's, anyway." Rob turned to Charlie. "Prentiss is

the state investigator. He's shrewd and thorough, and he has access to all kinds of information I'd have a hard time getting to."

"So you handed over to him. Makes sense." Charlie nabbed another cookie.

"Yeah. I just wish I didn't have to go through a marking-of-territory ritual every time he shows up. Fortunately I had the files copied before I gave them to him."

Meg was disappointed. "So you had to waste a lot of time with bureaucratic shuffling. Pity. Tell me a fact."

He cocked an eyebrow.

"You said facts were trickling in."

"Okay. One of Fred's investors was Lars Bjork."

"Wow. When did he pony up?"

"I'm not sure. Three or four years ago at least. I imagine our green commissioner isn't all that happy to be tied to a developer, even indirectly."

Meg started clearing the table. Thanks to the previous evening's melodrama, she had not had a chance to tell Rob the details of her dinner at the Columbia Gorge Hotel. "Would it make any difference that Mr. Bjork has Alzheimer's?"

Rob stared. "Where did you hear that?"

Meg explained. It took a while, because she was scraping and stacking dishes and because Charlie kept asking irrelevant questions about Kayla's mother. He seemed to find Dede diverting.

"So Catherine Bjork has power of attorney." Rob swallowed coffee.

"She does now. Or so Mrs. Marquez said."

"And the son is at odds with his stepmother?"

"Ready to dish the dirt," Meg said amiably.

Charlie grinned.

"If there is any dirt. Is he staying at his father's house?"

"No idea. I doubt it. I could see there was a lot of tension." Meg frowned. "Maybe he and his wife are staying at the hotel. That didn't occur to me."

"I'll check it out. Thanks, Meg."

"So this how real detectives work," Charlie said.

Rob raised his coffee cup in ironic salute. "Stumbling around bumping into choice bits of information by accident? Absolutely."

"The old guy can't be too far along if he's still able to go out to dinner parties."

"He was quiet. I assumed he was shy around strangers." Meg ran water into the mashed potato pan. "Ask Beth what she thinks. She sat next to him at her dinner."

Rob winced. "I'm afraid to call her. Beth raked me over the coals this morning. I'd rather face Mack in a rage any day." And he regaled them with an account of the dressing down Beth had given him. Charlie found his clowning amusing. Meg's sympathies lay with Beth.

When Rob mentioned pepper spray, Meg said, "You could scream and run away next time. That was what I was told to do by a police sergeant when I tried to take a self-defense class."

Charlie snorted. "Did you follow his advice?"

"I dropped the class." She removed his cup and Rob's, ran a sink full of soapy water, and handed Rob a scrub brush. "See you later." As she slipped off to her home office, she could hear the two men discussing who was going to wash. She almost had them trained.

When she had checked her e-mail, she went out for a stroll and met Tammy walking Towser. He bounced while they chatted. By the time Meg returned to the house, Charlie had gone home and Rob had gone up to bed. She'd neglected to ask him who else had invested in Drinkwater's scams.

━━━

Charlie left when he finished washing up. After Rob shelved the dishes, he called Beth. She confirmed Meg's rumor, so he called the hotel, too, while he was at it. Warren Bjork was registered. He answered the phone as if he were expecting an important call. When Rob identified himself, the man sounded hostile but agreed to come to Rob's office the next day around three.

A day of solid interviews to come—Inger Swets and Matt Akers in the morning, Warren Bjork in the afternoon. It was time to expand Sergeant Ramos's horizons. Linda was good at interrogation, but she wasn't used to mixing with the rich and infamous.

Yawning, Rob shut down his cell phone and went up to bed. It occurred to him that his back was feeling better. Or maybe it was all those muscle relaxants. Or Jack's salmon. He was asleep before Meg came in.

And gone before she woke up the next morning. The Roads crew had uncovered another slide victim at Prune Hill, the driver of a blue lowrider, a young man whose mother-of-pearl rosary lay smashed in the rubble. There had been no missing persons reported the day of the slide and none since, yet there he was.

Sickened by the sight—and smell—of the crushed remains, Rob came in late for his interview with Matt Akers. Matt fumed and spluttered, but Rob was in no mood to put up with bluster.

"Sit." He jabbed a finger at the visitor chair, the one he reserved for people he disliked. Light from the window hit the sitter in the face.

Matt sat. He was a big, red-faced man whose strong suit was not subtlety. When Linda entered, bearing a recorder and notebook, he leered but not with any real interest. "That your secretary?"

"Sergeant Ramos will assist me." Rob nodded to Linda, and she set the recorder on his desk. When she was settled on the other chair, the comfortable one with armrests, he turned back to Akers. "I hope you don't object to the recorder. It's standard procedure."

Matt objected. He huffed and threatened to call his lawyer. Rob shoved the phone toward him, and he subsided. He had come, he said, from a long interview with Ed Prentiss. "And I suppose you'll cover the same ground."

"Lieutenant Prentiss is investigating another matter."

Akers frowned. "Isn't this about the Prune Hill development?"

Rob said, "I'm looking into the death of Fred Drinkwater."

Akers stared. "I thought Fred had a heart attack." There had been no public statement regarding Drinkwater's death.

Rob suppressed his skepticism with an effort. In a town the size of Klalo word should have got out. "The medical examiner believes he was murdered."

Akers jolted upright. If he was faking it, he was doing a good job. "Murdered!"

"That's right. Tell me about your involvement with Drinkwater. I know he threw a lot of business your way."

Akers looked blank. "He was a good idea man."

Wonderful. "And?"

"I worked for him. He owes...owed me a lot of money."

"I hear you invested in his projects."

The contractor took out a blue bandanna and mopped his forehead. "We've worked together a couple-three years now. Look, Neill, shouldn't you Mirandize me or something? I mean murder, that's serious."

"I'm not charging you with a crime at the moment. I'm looking for information about Drinkwater."

"Then you should look somewhere else. We was strictly business, me and Fred. I didn't socialize with the guy. Too fancy for me." He snorted. "Him and his fancy women."

"We don't know why Drinkwater was killed," Rob said. "Might have been strictly business."

Akers mopped his forehead again. Linda adjusted the recorder and flipped a page in her notebook. She was not writing down what Akers said, just how he said it. She was good at that. She was capable of coming up with unexpected, insightful questions, too.

"You suggested I look at Drinkwater's women," Rob said. "Who?"

"You know who."

"I know he enjoyed the night scene here and across the river."

"And out at Tyee Lake," Akers sneered. "Had himself a real love nest out there."

"So who are we talking about?"

"Darla Auclare, for one. That little cunt, Kayla Graves."

Rob deduced that Kayla had turned Matt down. He was divorced. "And?"

But Akers' mouth set in a hard line. "I dunno. He talked big."

Rob decided Akers didn't know much about Drinkwater's social life. If Inger had been playing around with the developer, she had been discreet. Well, I knew that, he told himself. Shift gears. "You say you invested in Drinkwater's projects. Did that include Prune Hill?"

"No! That was straight contract work. He bought the land. He chose the architect. Back when I invested, we was buying land in the north county, near the national forest. And I put money in the senior condos east of Two Falls. I built those for Fred."

"On the edge of the Klalo trust lands." Madeline Thomas had objected to the construction. Linda raised her eyebrows. Rob nodded, so she watched Akers closely, eyes narrowed.

The contractor was sweating again. "We didn't build on Indian land, and we didn't mess around in the Gorge Scenic Area either. We bought the old Patterson place. It was free and clear. The commissioners approved."

"That would be Tergeson, Auclare, and Hal Brandstetter."

"Yeah, Hal."

"He was a good friend of yours, as I recall."

"So? Hal fooled a lot of people, me included." Akers looked at Linda. "Can she keep her mouth shut?"

Linda gave him a dazzling smile. *"¿Señor?"*

He muttered something about Mexicans.

Rob said, "That reminds me. Do you know two young men, casual laborers, by the name of Chavez and Santos? What were their full names, Linda?"

"Jorge Chavez and Manuel Santos-Rivera."

Akers paled. "I dunno. I hire some Mexican workers."

"These young men were taken into custody yesterday morning. Sergeant Ramos has been talking to them, getting to know them, you could say. They're illegals. They claim you hired them to attack me."

"No!"

"That so? One of your regular crew says you pulled them off the job the day I was knifed and had a long conversation with them. They drove off together in their pickup."

"Who? Who said that? I want a lawyer. Now."

Annoyed with himself for jumping the gun, Rob read Akers his rights. He could have pried more information from the man, but there was time.

It took a while to charge and process Akers. Rob figured the

contractor would be out on bail within the hour and didn't intend to object. He despised Akers for a racist, sexist jerk and an old-fashioned bully but didn't think he had killed Fred Drinkwater. And Matt was unlikely to run. He had too much invested in Latouche County to want to leave it.

If Inger Swets had been on time for her appointment Rob would have had to keep her waiting half an hour because of the Akers paperwork. She entered his office just as he and Linda returned.

Rob stood. "Ah, Inger, thank you for coming. Do you know Sergeant Ramos?"

Inger didn't smile but she gave Linda a stiff half bow. "Larry said you wanted to talk to me about courthouse procedure."

"Have a chair. Do you mind if we record this?"

Inger sat on the edge of the chair Matt Akers had vacated. "I don't object, but I don't know what I could tell you—"

"That's the tale I spun for Larry," Rob said. "In case he doesn't know."

"Know what?"

Rob sat. He twitched the blue sling for effect. It didn't do much for his arm but it was a great prop. "I'm looking into Fred Drinkwater's death."

"So?" Inger had gone pale but her tone was as cool as a glacial breeze.

Rob kept his face blank. "Your name keeps coming up. Among Fred's many, er, romantic entanglements. Were you having an affair with him, Inger?"

"No, I was not, and I resent the question."

He thought she was lying but she was cool, very cool. She was also beautiful in a tall, full-bodied way that was timeless rather than fashionable. If you put Inger beside Cate Bjork, Rob reflected, the stylishly lean commissioner would look like a *memento mori*.

Now why did I think of that, he wondered as he waited, silent, for Inger to start babbling. But Inger was not a babbler. Linda Ramos sat very still.

At last he said, "Your husband is away a lot. Who could blame you for wanting a little companionship?"

She gave a harsh bark of laughter. "Who? Every voter in La-touche County, not to mention my father the commissioner. Use your head, Rob. I'm not a moron, and I like my job."

"You were seen—"

"I don't doubt that some busybody saw Fred and me at the Red Hat. He took me out for drinks a couple of times. That was it. He was not my l-lover." She choked on the word, whether from grief or amusement Rob could not have said. She stood up. "Is that all, or do you want a quick lesson in how to apply for a building permit?"

"That's it, Inger. Thanks."

She swept out like a tall ship under full sail.

"*¡Qué cosa!*"

Rob grinned. "She was on the girls' double-A volleyball team the year they won the state championship. I think I just got spiked."

Linda said seriously, "I would not allow that woman to come anywhere near my boyfriend."

Rob decided he'd better not comment. Linda's boyfriend was a small, cheerful man. Rob thought he was devoted to her. "Hey, I wanted to give you a turn with the questions. Did you come up with any?"

She nodded. "Who cuts her hair?"

Both of them were laughing when the phone rang. The desk sergeant said Karl Tergeson wanted to see Rob immediately. Rob gave Linda a chance to escape before he let Karl come in.

The county commissioner looked old and ill, Rob thought as they shook hands. Karl talked for awhile about Mack and how much everyone was going to miss him. Rob agreed. Then Karl congratulated Rob on the promotion. He'd already done that at the funeral. Rob asked after Jordis. She was well.

At last Rob said, "Is there something I can do for you, Commissioner?"

Karl ran the tip of his tongue over his lips. "My daughter...I understand she's in trouble with that state patrol detective."

Rob explained that anyone with access to the records would come under suspicion.

"Can't you talk to him, tell him she's innocent? Jordis and I, we raised our kids right." They had three sons but Inger was Karl's favorite. "No child of mine would take a bribe from a developer."

"I'm sure that will come out in the investigation."

Karl stared at him from under bushy eyebrows. "And these rumors…"

Rob kept still.

"She's not…she's a good girl. Faithful to her husband. He's not worth much, Larry, but she's true to her vows. I know it."

After a moment, Rob said carefully, "I'm sure Inger is everything you and Jordis want her to be. She certainly won re-election by a good margin. The voters like her."

That did not seem to console Inger's father, but at least he left the office. Rob wondered why he'd come. One thing for sure: Karl Tergeson was a frightened man.

Chapter 13

COMMISSIONER BJORK called on Maddie early that afternoon. Cate had made the appointment at Mack's funeral. Maddie was ready for her, or as ready as possible given the tentative state of planning for the Klalos' casino.

As in other states, tribal councils in Washington had opened casinos on reservation or trust land. Federal and state laws that limited gambling didn't operate there. The same was true of Oregon, where two successful casinos had opened to appeal to coast-bound travelers.

Casinos brought money to the tribe as a whole and jobs for tribal members. That there were problems associated with large-scale gambling Maddie knew very well, not least the possibility of Mob intrusion. And, in descending order, gambling addiction, traffic, rivalry with other Indian enterprises in the area, and the petty crimes associated with any large-scale tourist magnet.

Some people in the county had religious scruples about games of chance, and because of the National Scenic Area, the feds were bound to raise objections, too. Every time Maddie had mentioned the word *casino* in Mack's presence he had spluttered and gone red in the face. That was partly because he disliked change, but some of his objections made sense.

Maddie was not set on building a casino. There were other possibilities. She was prepared to discuss the alternatives with Cate Bjork, but she was not prepared to be patronized, especially not by a woman who had moved to the area a scant five years ago. If Maddie agreed not to push the casino, she intended to see to it that the

county compensate the Klalos for the loss of revenue and prestige. In some ways, threatening to build a casino was as satisfying as building it.

Cate had agreed to come out to Two Falls. Maddie set the scene with care. She met the commissioner in the large room she had created for the tribal council. It was attached to the double-wide mobile home she and Jack lived in, and she had designed it to suggest warmth and collective action.

She had furnished it simply, with an open central hearth (a good gas-fired fake), a dun-colored outdoor carpet suggesting rammed earth, and built-in benches along the walls, but the chief extravagance was wood. She wanted nothing to detract from the wood used on the walls and benches and in the display area.

Klalo culture used wood with exceptional brilliance. Maddie meant to remind the council of their own carpenter heritage, and much of the cedar, alder, pine, fir, spruce, and birch used in the room had been donated and shaped by tribal artisans. She did not encourage clutter, just perfect joinery. Above all, because of the cedar-paneled walls, the room smelled good.

Having restrained herself in the room's design, Maddie indulged in an orgy of display. Every art and craft that had been passed down from grandmother to granddaughter, from grandfather to grandson, had its day. Pine needle baskets, cedar bark baskets and reed mats, elkskin headbands and robes, cradle boards, bentwood boxes, button-ornamented blankets, sleek obsidian knives, masks and drums for the dancing—she gave each traditional art its time and place. As the seasons wore on, she returned the beautiful things to the families that had created them and asked for others.

The council room had many uses. Maddie met there with the young people Rob Neill called her "troops" and with the elders, most recently for an oral history project. Her favorite use, though, was story-telling. Her grandmothers had been splendid singers and story-tellers. They would have loved her council room. She set aside times when artists could teach their skills, too, but it wasn't the ideal space for that.

Maddie wanted a true craft center to support the traditional

arts. That would take money if it were done right—with a big, un-cluttered shop, proper lighting, and computer marketing, so artists could make a living from their work. The casino could finance such a center, and other important things like scholarships and a decent, convenient health clinic. She did not think the commissioners would share her passion for Klalo culture to the point of welcoming a casino, even so.

She considered greeting Cate in a traditional manner, but it was too early in their acquaintance for that, so she dressed plainly and when Cate got there, offered the woman a cup of Earl Grey and a plate of shortbread, nothing to alarm her.

Cate gave the room a cursory glance, settled on the bench, and accepted a cup of steaming tea, no sugar. She declined the short-bread as Maddie had thought she might. They exchanged comments on the weather and asked after each other's husbands in a verbal sarabande of the kind Maddie usually enjoyed. She could feel the other woman's impatience, however, so she avoided elaboration.

Cate bared her perfect teeth in a smile. "No doubt you're wondering why I wanted to talk to you privately, Ms. Thomas."

"Chief Thomas." Maddie took a sip of her own tea to mask her irritation.

"Oh, of course." The smile dimmed.

"I assume you want to talk about the role of the Klalo people in county affairs."

"Well, yes. Since I'm new on the board—"

"You campaigned on an environmentally sensitive platform, so I think we share some ideas. You mentioned clear-cutting at Beth's dinner party."

"I oppose clear-cuts. They're an abomination."

Logging, at least as the Bostons practiced it, was an abomination. Maddie sipped Earl Grey. "And you want to protect wetlands." "Wetlands" was a locally sensitive flashword Maddie found amusing. The whole county was wet land as far east as Two Falls. After that, as if someone had drawn a north/south line, it was very dry land. "Did you know that your house sits on a camas meadow?"

Cate looked blank.

"Camas," Maddie repeated. "The botanists used to say it was a lily, but it has its own classification now. It has lovely purple flowers, like lupine or phlox. The bulb was a staple food." It tasted like sweet potato when it was baked and could be pounded down to a flour. Maddie didn't think Cate would find that interesting.

"We are preserving local flora."

Except for camas. Maddie said, "You'll have trouble getting the zoning laws you talked about during your campaign. Hank Auclare is a real estate agent."

"It will be an uphill battle," Cate conceded. "Perhaps Mr. Tergeson—"

"As far as Karl is concerned, property is sacred." Maddie was pleased she remembered that platitude of the many Karl was fond of. "He resents the government's limits on building in the Scenic Area, so he's not likely to want more restrictions outside the reserve. And I will say for Karl that he's consistent."

"May I ask you something, Madeline?"

"Maybe."

"Why do you live here?"

Maddie set her cup on the bench beside her. "Why do I live here instead of in a seven-thousand-square-foot house in the middle of a camas meadow, or why do I live in Two Falls?"

Cate bit her lip. "Two Falls. Instead of Klalo."

"Well, I'm hereditary chief of the Two Falls band, so I live in Two Falls. There are three bands. I was *elected* principal chief by all three."

"I see."

"Three times," Maddie added. "Shall we talk about the casino?"

Cate set her own cup down and stood. "I'll listen to your plans, of course." She strolled to the nearest display cabinet. It held pine needle baskets. "But I have to tell you up front that I'll oppose building a casino in Latouche County."

That was pretty much what Maddie had been expecting since the night of Beth's dinner party. She said nothing, but she was thinking hard.

Cate moved on. She looked at the knives, but they must not

have interested her. The big cedar bark baskets were another mat-
ter. Maddie was glad for the glass-enclosed display case. Other-
wise, the commissioner might have felt free to finger the baskets,
some of which were a hundred years old.

At last Maddie said, "Why?"

"These are really beautiful."

"Thank you. Why are you opposed to a casino? Do you object
to gambling for religious reasons?"

Cate gave a short startled laugh, almost a whinny. "Heavens,
no." She paused and frowned. "No. Latouche County is pristine,
untouched. It needs to be nurtured. Your casino would bring Japa-
nese tourists, busloads of retirees, and who knows what riffraff—
cars full of rowdies from Portland dumping beer cans."

Maddie chuckled. "Untouched! Our fishing grounds and all
three of our villages were drowned by Bonneville Dam. Power-
lines cut gashes in the hillsides. Orchardists ripped out the old
growth. The railroad goes right along the river. And there's log-
ging. A flume built in the 1890s runs down to the Choteau, down
below the falls." She gestured with her right arm. "How can you say
Latouche County is untouched?"

Cate sniffed. "You know what I mean."

"I know you want to preserve your equity," Maddie said wick-
edly. "Right now there's no law to say some contractor can't buy
up land around you and build condos. So you want zoning. You've
been here what, five years?"

"Almost six. I've seen what unrestricted building has done to
California. It's time to draw the line here, or we'll wind up looking
like Tahoe."

Maddie clucked her tongue. "And our casino would do that?
Who'da thunk it?"

After a moment, Cate smiled her wintry smile. "I can see we're
at loggerheads. Shall we agree to disagree?"

"As long as you understand one thing."

"What's that?"

"If we decide to build a casino, it will be erected on tribal
land, outside the county's governance. You can lay on all kinds of

restrictions having to do with drainage and traffic, highway access, policing, protection of endangered species." Her mouth curved in an answering smile. "But you can't prevent us from building a casino."

"We'll see about that." Cate turned back to the cabinet. "How much is that large basket in the back, the one with the tweed-like pattern? It would look wonderful on my hearth."

Ice gripped Maddie's stomach and her fingers itched. When she could control her voice, she said, "It's not for sale."

"I pay museum prices."

Maddie had gathered berries in that basket when she was five years old. Her maternal grandmother had woven it of long strands of cedar bark, overlapping the strands with plaited bear grass. It was irreplaceable. Strictly speaking, she ought to *give* the basket to the commissioner. That was what custom demanded. No way would Catherine Parrish Bjork have understood the gesture. Maddie was proud that she didn't smack the woman in the face with her clenched fist.

After another silence, Maddie said, "Nothing in this room has a price."

———

"John! I thought you weren't coming until the weekend." Beth hitched herself higher in the shabby recliner that had belonged to Rob's grandfather. The day before, when she attended the Chamber of Commerce meeting, she had abandoned the wheelchair and used a walker. The doctors promised a walking cast in two weeks. She could hardly wait.

Her eldest son plunked down on an armchair. "I have some news I needed to discuss with you in person. I talked to the insurance people."

"About the house at Prune Hill?" Beth's stomach churned. Even with the deal Drinkwater had given Mack, that horrible place had cost half a million dollars. If the insurance companies weaseled out of a settlement, she'd be paying on the debt when she turned ninety.

"Dad had a policy that pays off the mortgage when one of the

partners in the marriage dies. He took it out a long time ago on the old house, and he transferred it to the new house when you moved."

"Oh thank God." She covered her face with hands that trembled.

"Yes." John beamed at her. "And the other company, your ordinary house insurance, is supposed to pay replacement value. That will take a while, but my attorney thinks they'll settle."

She wiped her eyes with a Kleenex and said, almost at random, "I suppose that's good, too."

"Very good." He hesitated. "I didn't want to say it to Dad, but I didn't like the mortgage arrangement that developer made."

"Me either," Beth muttered.

"The house price wasn't out of line, and the guy—"

"Drinkwater."

"Yeah. Odd name. He was generous on the down, but it was a variable rate deal. He could have upped the interest, and it was high to begin with. So you're well out of it."

"That's a relief." I'm into *meiosis*, Beth thought, a little dazed.

"So what do you want to do, Mom? I can put the old house on the market for you. With that and the insurance settlement, you can buy one of those condos that look upriver, no problem."

"Ugh. Condo."

He smiled. "I thought that's what you'd say."

Her head whirled. "Can I go back to the old place?"

"Sure!" He turned his head. "Hey, Dany!"

Her daughter came in from the kitchen, drying her hands on a dish towel. The baby was asleep. "Did I win the bet?"

John's smile widened to a grin. "*I* did. She wants the old house."

Dany threw down the towel. "Oh, Mom, you know it's too big for you."

Beth said, "It's not too big for me and the family. I like company. If I bought a condo, even one with three bedrooms, you'd visit me in relays. I want you—any of you, all of you—to be able to drop in with your kids when you feel like it. And I like having us all to-

gether. I want to have a room where everybody can sit down at the dinner table on holidays." Except that the table was gone, smashed to kindling. "It's a big house to furnish, but I don't need to do it all at once."

"Of course not." Dany sounded reasonable.

"I can close off the rooms I won't be using to save on gas." The old house had a gas furnace.

"Well, if you're sure it's what you want." Dany sat up straight. "I'll go have a look at the furniture that's still there. Who has the key?"

Beth racked her brain trying to remember who might have an extra key. Since she and Mack hadn't yet handed the old house over to a real estate agent, that meant friends and neighbors, but all she could recall was that the wife of the principal of the high school, a fellow teacher and a good friend of hers, had a useless key to the Prune Hill house. John and Dany tossed other names back and forth.

Beth's cell phone rang. Rob, reporting in. His description of Inger's lofty departure from his office amused Beth, but she didn't like the sound of Karl's anxiety. If Karl even suspected his daughter of malfeasance, the odds were good she had done something. Not, surely, murder. As for Matt Akers, Beth was willing to believe almost anything of him, but he had always struck her as a blusterer, too open and direct to sneak around suborning commissioners, if that was the right term. He might have killed Fred Drinkwater in a fit of rage, but he wouldn't have done it neatly.

When Rob wound down, she told him her decision about the old house.

"That's a good idea." His voice warmed. "It's a great house, but you'll need to furnish it. There's some good stuff in my attic. Help yourself, and take your time moving home, Beth. I'm happy where I am."

"What are you going to do with this house?"

A pause. "Damned if I know. I can't bring myself to sell it. Willow loves it, for one thing."

"Do you?"

Another pause. "I guess I have mixed feelings."

"Talk to Meg."

He chuckled. "That's part of the problem. She mixes my feelings." He said good-bye and hung up.

She clicked her phone off. Memory stirred. Clara Jenkins next door had a key to the old house. Clara always spent the winter with her daughter in Florida. Her house sitter wouldn't know where the key was. Beth's mind cringed away from calling. Clara would not have heard of Mack's death.

As she was explaining the situation to Dany and John, the landline phone rang in the hall. John jumped up and went for it.

"What's Clara's number?" Dany asked. "I could call her for you and explain."

"Oh, darling, would you? It's Coral Gables. Her daughter is listed."

Dany wrote down the daughter's married name.

Beth hated to be so feeble and dependent, but she didn't like Clara. The woman was a talker. She'd gush sympathy, and Beth had had enough sympathy to last a lifetime. What she wanted was Mack.

John returned almost at once. "That was Skip. He couldn't get through on your cell phone, so he looked up Rob's home phone. Peggy's awake. She recognized him. She wants to see Sophy."

Too much joy. Too much confusion. Beth burst into tears.

━━━

Warren Bjork turned up on the dot of three. Rob went out to meet him. Since it wasn't a formal interview, Rob didn't call on Linda to take notes nor did he use the recorder.

Bjork was a short, petulant man with a recent hair transplant. Since bald was fashionable Rob wondered why the transplant but admitted to himself that, so far at least, baldness was a problem he hadn't had to deal with. He'd been short, though, all the way through school, and defensive about it. Now he was sort of medium. He'd started to shoot up taller his senior year at Klalo High, but he remembered agonizing over his stature, especially when he was in love with the captain of the girls' basketball team. She had

topped six feet at the age of thirteen. She'd agonized, too, or so he discovered many years later.

Bjork was looking the office over, lip curled. "I can't imagine what you want with me, Deputy. I know nothing about Latouche County, and I'm a busy man."

Rob waved him to the chair with armrests. "Sorry to inconvenience you, sir. What do you do?"

Bjork stared. "Do?" He slammed down into the seat.

"You said you were busy." Rob sat.

He gave a bark of laughter. "Busy trying to settle my father's estate. As for what I *do*, I'm CEO of a charitable trust in California."

Settle the estate? Rob frowned. "I met your father in January. He seemed well enough then."

"My father's not dead. He has Alzheimer's Disease."

"I'm sorry to hear that." But not surprised, thanks to Meg.

The man's mouth set in a thin line. "He was diagnosed more than a year ago, but I wasn't informed until last week. I dropped everything and came north at once."

"You're a devoted son."

"If you're being sarcastic I don't appreciate it. The old bastard turned his back on his family fifteen years ago when he traded my mother in for the current model. I'm here to protect my own interests. And my sister's."

"Hmm." Rob steepled his fingers. "And you were what, twenty, at the time? An undergraduate?"

"I was thirty-two!" Bjork half shouted.

That made him some years older than Rob, probably about the same age as Catherine Parrish Bjork. "I guess I don't understand," Rob murmured. "Divorce is always unpleasant, but it's a fact of life for a lot of people. At thirty-two you may have been unhappy about your parents' split, but it shouldn't have been a major trauma."

"My father is a wealthy man," Bjork said, as if that explained anything.

"And?"

"She...Cate signed a pre-nup. The divorce settlement granted my sister and me...Fuck it, my family history is none of your

damned business. Suffice it to say, I have a legitimate interest in what that woman does with Dad's money."

"Washington is a community property state," Rob mused, "like California. Your stepmother is a competent and mature woman. No doubt she has power of attorney and can arrange for care-givers."

Bjork had the grace to look embarrassed. "I talked to his doctors. Dad's still at home. He has full-time attendants, and he's getting decent care." He ran a hand through his hair. "He didn't recognize me, hasn't seen me in a couple of years."

"It's a terrible disease." Rob felt a moment of compassion for this short, unappealing man. Whatever Bjork's feelings about his father, he must know that Alzheimer's could run in families. He had to be worried about that as well as about money.

"So what do you want with me?" Bjork asked.

"I'm investigating the death of Fred Drinkwater."

Bjork frowned. "Oh, the developer. Cate mentioned that some of his houses were destroyed by a mudslide."

"Yes. It seems your father invested in Drinkwater's projects."

"What of it?"

"There are only a handful of motives for murder."

"It was murder?"

"Probably. As I was saying, people are killed for a limited number of reasons—anger, sexual jealousy, revenge, and greed top the list. Drinkwater was a womanizer, so we're looking into his relationships."

Bjork's lip curled. "Then look into Cate."

An interesting thought. "Does she sleep around?"

Bjork's scowl deepened. "I've never been able to prove it."

Rob decided not to press the matter. The idea of the classy commissioner with a two-bit Lothario like Drinkwater had to be absurd. "We're also following the money trail. The mudslide represented a major setback to Drinkwater's enterprises. His financial partners were bound to be upset. There you have it. Two sets of motives." Rob was editing freely.

"Believe it, my father is uninterested in Drinkwater's problems."

"What do you know of the other investors?"

"Nothing at all. Look, whatever Dad put into Drinkwater's schemes, the money was chump change to him."

"When did your stepmother take over his affairs? Could she have talked him into the investment?"

Bjork's eyes narrowed. He leaned forward. "I don't know, but I'll find out." The flash of interest faded. "I doubt it. When Dad was functioning, he made his own decisions. They moved up here almost six years ago, and he was still in charge then. At the bank, before he retired, he was notorious for playing his cards close to his chest. He spoiled Cate, gave her whatever she wanted, but he wouldn't have *consulted* her in a business matter. When she worked for him, she was just his social secretary, not a colleague."

"What's her background?"

Bjork snorted. "She doesn't have any. Nobody from nowhere, that's our Cate. Parrish was her first husband's name. He was an actor or musician, died of an overdose."

In fact, Cate had gotten mileage out of her first husband's death when she ran for office. She had strong ideas about expanding the county's drug abuse programs.

"She has a P.E. degree from some state college," Bjork drawled. He had a Wharton MBA. Rob had checked. Cate's degree was from UC Santa Barbara, hardly a backwater institution but certainly state-funded. Of the two, Cate struck Rob as being the more intelligent. Her stepson's stupidity was beginning to annoy him.

"She worked as an aerobics instructor. When Dad met her she was a personal trainer." Warren Bjork's voice put the term in quotation marks. "His assistant was having health problems, so Cate started keeping track of Dad's social engagements, and the next thing we knew she'd replaced Mrs. Schulz. I don't think my mother even noticed Cate. I sure didn't. I still don't understand the attraction. Cate was no great beauty, just another skinny blonde. She must have made Dad feel young or something."

Rob wondered if the first Mrs. Bjork had been a great beauty. He thought he might look into that if he had time. Right now he didn't. "So there was a divorce and a property settlement."

"Had to be," Bjork said with some complacence. "My mother's family owns a chunk of Orange County. She has good lawyers."

Rob said mildly, "Then your grievance against the present Mrs. Bjork seems a little overblown."

Caution shuttered Warren Bjork's eyes. "I don't know that I have a grievance. I don't like her, and I don't trust her an inch, but I can't prove anything against her. So far." He rose. "I also don't see how I can help your investigation. If that's all?"

Rob considered. "If you uncover financial improprieties that touch on the investment your father made with Drinkwater, I want to know about them."

Bjork looked mulish.

"I mean it," Rob said. "This is a murder investigation."

Bjork shrugged. "Okay. Whatever."

"You'll be at the hotel?"

"As long as I have a reason to stay. I've asked to look at Dad's financial records. The lawyers are talking it over."

Rob shook hands, and the man left. Rob had learned very little, or rather he'd learned very little that could help his investigation of Drinkwater's death. What he'd learned about Cate Bjork made him more sympathetic to her than he had been. He didn't know why he had bothered checking up on her. He'd never suspected her of Drinkwater's murder, but her husband's connection to Fred's business affairs puzzled him.

If what Warren Bjork said was true, the amount Lars invested with Fred, though large, would have seemed trivial to the retired banker. Still, Lars could have been involved, at least in the beginning, in suppression of the hazard warning. If so, Ed Prentiss would find out. That left Rob with two chief murder suspects, Akers and Inger Swets, plus Darla Auclare. Of them, his money was on Inger. Still, he was a long way from proving anything, and he had yet to interview Darla. Or talk to Kayla about Fred. He reached for the phone.

Chapter 14

KAYLA TALKED TO Rob briefly on the phone before he was called away on another matter. That frustrated her. She didn't think she had anything significant to tell him about Fred, certainly not about Fred's finances, but she enjoyed hearing Rob's voice. She was rather hurt that he hadn't called her sooner.

The next morning, after visits from flitting surgeons who were working up to the bone graft, she distracted herself by gossiping with three aides from her own care facility. They had made a special trip to Portland to see her on their day off, which touched her, and they brought her up to date on Patrick Wessel's latest atrocities. She sent them off to shop at Nordy's and thought about work. She wasn't sure she could stand to go back, even if they'd have her.

She drank a milkshake for lunch. Chewing hurt. Then her mother descended. Dede brought her a peach-colored frou-frou bedjacket Kayla wouldn't have been caught dead wearing. She thanked her mother like a good girl and sent *her* off to Saks. She gave the bedjacket to her favorite aide, who regarded it with wondering eye. Then she read a nursing journal and tried to start a paperback romance her friend, Barbara Olsen, had brought. The opening chapter gave her the giggles.

A long time ago, Kayla had decided she wasn't a romantic. She liked sex. She liked to party. She liked most men some and some men a lot. But the steroidal dude on the cover of the romance embodied the author's vision of a man women would want, not Kayla's. What Kayla wanted at that moment was conversation. She settled down to wait for Charlie.

He finally showed up after her lonesome puréed dinner. He looked strange.

"You got a haircut."

He nodded.

"And you're wearing a suit."

"Please!" He sounded insulted.

"Well, a sports jacket and what, slacks? Is that a necktie I see peeking from your breast pocket? What's the matter? Did you have to attend a funeral?" In fact, she thought he looked handsome, though not in the bloated style of the cover model.

"Very funny. Job interviews." He plunked down on the visitor chair. He looked so depressed her heart went out to him.

"Never mind. Someone's bound to hire you soon."

His mouth twisted in a wry grin. "I've had three offers so far."

"Three! Then I don't see the problem. What do you want, Charlie?"

He didn't answer at once and frowned when he did. "I won't work in Saudi. I turned that one down flat. I'm thinking about the other two." He rubbed the back of his neck. "I don't want to leave the area right now."

Kayla stiffened. She recognized the signs. He was going to fling himself onto his knees, declare his undying passion for her, and demand marriage. And she didn't know how to let him down gently. He was going to ruin everything.

He glanced at her. "Er, my cousin's tangled in the murder investigation. He needs backup. Did I tell you they found the kids who attacked him?"

Kayla's neck muscles relaxed. "Yes. So did Rob. He called." She felt relief and an unaccountable twinge of disappointment.

"Ah. Then he probably told you the county clerk has gone missing."

"Inger? Good grief, no. Tell me."

"I don't know much. Meg said Inger Swets apparently upped and left town. Her car's missing. When she didn't show for an appointment at the courthouse yesterday, the state detective called Rob, and Rob called her husband."

"And Larry didn't know where she was either?"

"You know him?"

"I know who he is. Big guy. I know Inger a little. Was Larry out on his barge?"

"He had a trip down the river as far as Portland, and she was gone when he got back. When she does that, she usually leaves him a note. Not this time."

"And she isn't answering her cell?"

He shrugged. "I just know what Meg said. Hey, are they going to let you go home for a while before they do the graft?" That was one of the issues her surgeons had been dealing with. They didn't agree.

Kayla told Charlie all about it. She got a little emotional, but he listened without too much sympathy. She found his matter-of-fact attitude comforting. He offered to take her to Klalo whenever she was allowed to leave.

"In your ghastly pickup? No way." An idea struck her. "You should be driving my car. I bet that old junker of yours slurps gas."

He blinked at her like a startled owl. "It does."

"Well, I'm not using the Civic. Go ahead. There's an extra set of keys in the drawer by the kitchen sink." She reached for the bed-side table. "I forgot. There's a set here, too. Barb brought it this morning." Barb had rescued Kayla's purse from her locker at the Beaver Creek Retirement Village.

"I can't borrow your car. What about insurance?"

Kayla scrabbled in her purse. "Mine covers any driver with a valid license. Tiffany used the Civic all the time. She put a couple of dings in it." One reason Tiffany was an ex-roommate. Kayla was fond of her little car. She could trust Charlie's driving, though. She held out the keys. "The extra one is for the house."

Charlie hesitated but took them. "Thanks."

Kayla sucked in a sharp breath. "I just thought. What if they won't let me drive anymore? Oh, God!"

He said, "Your right eye's gone, Kayla. The left is the one you need for driving."

That was true. She thought about it, panic ebbing. "I won't be able to drive in England."

He laughed. After a moment, she did too. Sobering, she said, "Things are going to change, aren't they?"

He said gently, "They're bound to. They always do."

———

Early that morning, Nancy Hoover, Beth's dyslexic student and Maddie's favorite lieutenant, found Inger's car parked at a turnaround that overlooked the Choteau River above Two Falls. Ordinarily Nancy would not have stopped at the turnaround, car or no car, but she was on her way to school and in no hurry about it. Besides, local radio news had just reported Inger missing, and everybody knew the county clerk drove a vintage green Volvo. It was kind of a joke, that car. It was empty, no sign of the driver.

As a good lieutenant should, Nancy called Maddie. Maddie told her to stay where she was, phoned Rob at home, and rang the high school office to explain Nancy's absence. Nancy had a small problem with truancy. Jack was off fishing with a buddy, so Maddie hopped in the pickup and drove upriver.

Anywhere else, the Choteau would have been considered a major river. Here it was just another tributary of the Columbia. Maddie loved every inch of it. It was in spate and roared cheerfully along the slope of the mountain, spray flashing in the morning light.

Inger had parked at a spot with a great view of the water across a field of sword ferns. The turnaround overlooked the first of the two cascades that gave the town its name. It was tribal land but not true wilderness. A few fishing shacks clung to the rocks along the streambed. Maddie could see the Redfern place upriver—Jack and his brother Leon shared it—where the stream swept a wide curve. No lights showed in the cabin, not even the security light.

She parked on the shoulder some distance from the graveled area in case the turnaround was a crime scene. As she got out, Nancy jumped from her battered Toyota and trotted over, cell phone in hand.

"Hi, Maddie. What did Rob say?"

"Sit and wait."

Nancy groaned. Patience was not her strong point. "I peeked in the car."

"You didn't open the doors, did you?"

Nancy looked injured. "You told me not to. Besides, they're locked."

Maddie studied the girl's broad, good-natured face as Nancy backed out of the phone conversation with which she had whiled away the fourteen minutes it had taken Maddie to get there. Everybody used cell phones now, though reception in the Gorge was spotty. She wouldn't have parted with her own phone, but she wondered how much of the natural world kids would notice if they were constantly wired. Well, Nancy had noticed the Volvo.

"Come and sit with me. Tell me all about it."

So Nancy did.

Maddie listened to Nancy's adventure and administered praise. That took time. Then she asked after brother Ben from whom Nancy had inherited the Toyota when he joined the army. Ben had just enlisted. Maybe the war would be over before he finished basic training. Fat chance.

The first cop car drove up and parked beyond Maddie's pickup. Rob got out of the passenger side. His left arm hung in a sling, and he was still moving stiffly. Jake Sorenson had driven him. Maddie liked Jake. He had been her nephew Todd's partner when they were both in uniform.

She introduced Nancy, and Rob and Jake shook hands with her. Rob called her Miss Hoover and thanked her for being alert and conscientious, but Maddie stood beside the girl and listened carefully all the same. It was not in her to give her full trust to any policeman, though she didn't expect Rob to bully Nancy—he let her go after only a few questions. Maddie thought Nancy was disappointed, but she chugged off toward school and was on the cell phone again before she had driven ten yards.

By that time the incident van had showed up, and after it, the state patrol officer who was investigating the missing landslide hazard warning. Maddie found the police consultations boring and began to cast about for an excuse to leave.

One of the technicians was placing crime-scene tape around the graveled area. When Lt. Prentiss joined the others at the Volvo, she edged over to where Rob stood alone.

"So what does it mean?"

"I don't know."

"Come on, Rob. Nancy found the car out here on tribal land. That makes it my business."

He smiled a little. "It's a county road."

"Don't be picky," she snapped. The tribal council could have contracted with the Yakama, who had a good-sized police force, but, for now at least, the county provided police services. The Klalo Nation was too small to field a full-time officer. Elected constables took care of minor problems and "attended" the deputies in domestic calls, but the disappearance of a white woman from a county highway was a county matter. Maddie didn't intend to dispute that.

She took the offensive. "I bet you were looking for Inger's car somewhere else. Portland airport, for instance."

Rob didn't answer her immediately. At last he said, "Prentiss sent out an APB. All police jurisdictions were looking for it. This road isn't patrolled very often, partly because of your well-known distaste for police presence in your territory—"

"Hey!"

He held up his good hand. "And mostly because we're short-staffed."

Maddie let that go. "If you'd found the car at the airport, you'd have known what to think, right? Admission of guilt. Flight to avoid prosecution."

"Been watching TV?"

Maddie growled.

Rob sighed. "Shrewd of you. Way out here, the car's ambiguous. I don't know what it means."

"Ha! Ambiguous? Inger committed suicide. If she threw herself in the river, she wouldn't be the first." At least three tribal members Maddie knew of had drowned in that stretch of river under circumstances that suggested suicide.

Rob said wryly, "Or that's what I'm supposed to think. Maybe Inger had a rendezvous here."

Maddie's hackles went up. "Not with me she didn't. I had no personal contact with Inger Swets. I voted for her. That's it."

"You wanted me to speculate. The truth is, I don't know what finding the car here means. I'm surprised. Blind-sided. I need to talk to Larry again." He turned away from her as Prentiss came up.

Prentiss acknowledged Maddie with a nod. "So what do you say, Neill? Suicide? We'll have one hell of a time finding the body. That water's high and fast. She could be in the Columbia already. Hell, she could be halfway to Astoria."

"Or hung up at Bonneville Dam," Maddie said sweetly.

Prentiss shot her a hostile glance. "Or that."

Rob frowned. "Where's Jack?"

"Out on the Columbia fishing." Maddie didn't elaborate. The commercial salmon season hadn't opened yet.

Rob wasn't interested in Jack's freewheeling attitude toward fishing restrictions. He turned to Prentiss. "Jack Redfern has to know every pool and eddy on the Choteau."

"I could call him," Maddie offered. "He may be home by now." Jack hadn't intended to make a day of it. He just wanted to see how the salmon run was shaping up. She flipped her cell phone open and speed-dialed home.

Jack answered with his mouth full. Breakfast. She could hear his friend Will in the background clanking pans. "Maddie," Jack said to Will. To her he said, "Where's the truck?"

She explained what had happened in some detail. Jack listened without comment the way he usually did.

"That's not good," he muttered when she wound down.

"No. Here's Rob Neill. He wants to talk to you." She handed Rob the phone.

Rob explained that they had to look where a body might come ashore, listened to Jack's response, and said, "Okay. I appreciate the offer." He handed the phone back to Maddie. "His friend will drive him over. Thank you, Chief Thomas." He was being formal in the presence of the state detective. "You can leave now if you want to."

Maddie said, "If Jack's going to take police onto trust land, I'm coming."

"*I'm* not." Rob twitched the blue sling. "I'll leave the search to Jack. Prentiss and Jake can go with him. No need to call in Search and Rescue until they've checked the likely spots." He meant the places between the first cascade and the second where a body was apt to wash up.

It was not raining but it had rained. The sword ferns would ooze water over anyone walking through them. Maddie decided to go home. She left Rob peering in the windows of the Volvo as the SOCO crew worked over Inger's car. Maddie wondered whether they'd find a suicide note.

————

There was no clue in the car as to what had happened to Inger Swets. When Jack didn't find a body, Rob set a full search of the west bank of the river in motion. He got back to his office in the courthouse annex well after noon and found a message waiting for him from Meg, and a list of Drinkwater's telephone calls, courtesy of Jeff, who was now working the financial angle.

Rob rang Meg at the library. She announced that she was about to do battle with her insubordinate assistant, Marybeth Jackman, an unsuccessful rival for headship of the library system. Jackman had been doing her best to undermine Meg's authority since Meg's arrival last fall. It was time to confront her.

"Buy me dinner," Meg said in fade-away tones. "I won't have the energy to cook."

"Six-thirty at the Red Hat?"

"No need to get fancy. I'm in the mood for Mona's hamburgers."

"Nature red in tooth and claw," Rob said admiringly. "You'll wipe the floor with Jackman."

Meg sighed. "Probably, but I hate close combat. Oops, incoming call. See you at Mona's." She hung up.

Rob replaced his own receiver, smiling, and drew the list of names closer.

Meg liked to cook. She had raised her daughter on the salary

of a librarian, so she didn't have the habit of eating out, and she didn't waste money on fast food either. Rob knew he took advantage of that. He was a fairly good cook himself but a little apt to eat Cheerios when he was dining alone. Pure laziness.

Cooking for one was no fun. Meg didn't cook for one. She cooked for four and froze the leftovers. She had one of those devices that suck the air from heavy-weight plastic bags and seal them. When she was in a hurry she could toss the bag with the frozen meal in it into a pot of boiling water, whip up a salad, and have a decent meal in half an hour. She saved bundles of money and the food was tasty. Sometimes she wanted a break from cooking, though.

He resigned himself to dinner at Mona's and began to sift through the list of names. Jeff had annotated it with whatever information he could come up with from police records, the Internet, and Sgt. Howell, equally informative sources, but unlike Jeff, Rob had lived in Klalo most of his life, so he brought that perspective to the list. For what it was worth.

There were few surprises. The day before the mudslide, Drinkwater had spoken at length with his ex-wife, with his banker briefly, with Darla Auclare, Inger Swets, Matt Akers, and half a dozen people who were just names. Immediately after the slide, however, the calls flooded in, including a large number from media representatives. Rob had called Drinkwater himself during the rescue, trying in vain to get through to him about the layout of the development, the names of owners, and the number of people living there.

Drinkwater had put both phones on voice mail almost at once, returning very few calls. It was to those that Rob turned his attention. Who had Fred been willing to talk to in the aftermath of the disaster? He had probably gone out twice. The patrol cars had missed him both times. Rob wondered where he'd gone. So far no one claimed to have seen him, and his Lexus was not distinctive enough to be immediately noticeable, unlike Inger's green Volvo.

Somewhere around six in the afternoon Drinkwater had stopped returning calls entirely. The ME thought he had died after seven, but it was not clear when he had returned to the house at Tyee Lake. He had eaten very little but corn chips all day and

drunk quite a lot—vodka and orange juice, an odd choice. Whether or not Drinkwater had been at home, the calls had continued to flood in.

Exasperated, Rob culled the list, removing police numbers and the media, and asked Jeff to come in.

When Jeff had settled into the comfortable chair, Rob shoved the amended list toward him. "Let's brainstorm. He talked to most of our suspects the day before the slide, notably Matt and Inger, but what are these other names?"

"I called all of them and left messages, got two return calls. One of them is a plumber Drinkwater owed for repairs to the hot tub. We can eliminate him. The other is an insurance agent. He said he and Drinkwater talked about car insurance. The rest haven't got back to me yet. This Maury Schwenk has a couple of unpaid parking tickets in Portland. Otherwise they're clean." He meant they had no police records. Jeff was thorough.

Rob nodded. "Good work." There were two unidentified names. "I don't recognize them. They're probably innocent bystanders, like the plumber."

"Well, these two he talked to twice for longer than usual."

"Hmm. Reo and Olsen. Okay, let's see if we can eliminate them, too. That'll leave us clear to pull in Matt and Darla for a little sweat session."

"Akers is out on bail?"

"Yes, and he's lawyered up. I doubt that Darla will have much to say, either, but I could be wrong." He picked up the phone and asked Sgt. Howell to reach Darla.

Jeff rubbed his neck. "This Schwenk guy, the name's unusual around here. I thought it sounded like somebody I'd maybe met once. Keiko and I don't socialize much outside the soccer league parents, so I called her." Jeff's wife, a physician's assistant, worked at the county hospital. "She said Schwenk sometimes worked at the hospital. He's free-lance, not with the agency."

A two-county agency supplied care-givers to health care facilities and private patients. Some care-givers preferred not to pay the agency its hefty cut of their wages. They developed their own lists

of clients, and the hospital called on the reliable ones in emergencies. For the most part, these free-lancers were licensed practical nurses or nurses' aides. There were also a couple of medical assistants and a few RNs and technicians who were new to the area.

A care-giver. Drinkwater had spoken with him twice. Maybe Fred had had a medical problem. No, the ME said he was healthy as a horse. A puzzle. Rob was tired of puzzles. He was even more tired when the hospital personnel director told him the two people Drinkwater had talked to twice were also free-lance care-givers.

At that point the phone rang.

"Undersheriff Neill." He was finally getting his new rank right.

"Hi, Rob, it's Darla. You wanted to talk to me?"

"Thanks for calling. Jeff Fong is here with me. Is it okay to turn on the speaker phone?"

"Sure. I guess." She sounded doubtful. "Hello, Sergeant Fong."

"Ms. Auclare."

"You know I'm investigating Fred Drinkwater's death," Rob said when he had recited the usual interview formula.

"Yes."

"I understand you knew him fairly well."

"We had an ongoing relationship. I was fond of him." Darla cleared her throat. "It was cooling down, though. He had somebody else."

"Who?"

She gave a short laugh, half sob. "I don't know."

"Inger Swets?"

She sniffed. "No, of course not. That was over last summer. It was just a fling anyway. Have you found Inger? Larry called me. I've been worried about her. It's not like her to just take off without a word to anybody."

"You're friends?"

"Sure. We run together a couple of times a week."

Rob drew a breath. "Where do you run? Out in the country?"

"Around the high school track usually. Once in a while we take a jog in the country—when the weather's good. It hasn't been lately."

"Did you ever run out beyond Two Falls on County Road 3?"

"Never," she said promptly. "Why?"

He supposed the location of Inger's car would be public property fairly soon. "We found her car there."

"Her car but not her?"

"Not so far. Maybe she went for a run alone."

"I doubt it. Neither of us likes to run alone."

"Okay. That's good information. What does she wear when she goes for a run?"

Darla described Inger's running suits and her shoes—not the fragile kind used on indoor tracks but sturdier sneakers. Rob decided he'd better have Search and Rescue check along the road, too, in case Inger had been hit by a passing car while running on the shoulder.

He shifted gears and went back to the murder of Fred Drinkwater. Darla knew nothing about Fred's finances. He talked about money but she never listened, she admitted with a disarming laugh. Apparently she had spent the afternoon and evening of the day Drinkwater was killed on a shopping-and-dinner expedition to Portland with a girlfriend. She gave the friend's name and phone number.

When Rob hung up, he sent Jeff off to check what sounded like a decent alibi and called Jake to widen the search for Inger. Then he went back to brooding over his puzzle. It was a two-parter. Why were the callers medical workers, and why had they called Fred? No, there were three parts. Why had Fred returned their calls on a day when his financial world was crashing around his ears?

A sharp rap on the door. Jake Sorenson stuck his head in. "Busy?"

"Busy running in circles. Come in, Jake. Did you find her?"

"No. No sign of Inger. I left the second team of searchers combing the shoulder of the road upstream from the turnaround, the way you suggested. We did find this downstream, along with plastic grocery bags and assorted pop bottles." He held out a damp paper evidence bag.

Rob shook its contents onto the desk—a white sneaker, not

new, with fluorescent green laces. "Looks like it's been in the water awhile."

"Probably leftover from last summer."

"No, I'm afraid it's Inger's. I just had a description of the shoes she ran in." He tapped the lace with the cap end of his pen. "Green laces. Darla thinks she wears size nine or ten." He peered inside the shoe. "Nine and a half wide. Okay, let's show it to Larry." He thought of Meg. "Do *you* have time to show it to Larry? I've got a dinner date in fifteen minutes."

"Meg making chili these days?" Jake was a connoisseur of Meg's chili. "Sure, I'll run it by him. Should I give you a call on your cell?"

Rob grinned. "Better just leave a message. I am taking the lady out on the town."

"Wow. Is that a wise precedent?"

Rob thanked Jake and left, reflecting that it was pretty bad when his friends thought he was too cheap to take Meg out to dinner. His momentary amusement faded. Inger Swets was probably dead.

Chapter 15

ON FRIDAY BETH made herself enter the courthouse for the first time since Mack's death. Because John had gone back to Portland, Rob took her in his pickup. At the door to Mack's office in the annex, he made a vague offer of help, which she declined. She also thanked Mack's longtime secretary, Ramona Flynn, for *her* offer of help and shook her head no. With massive tact, Ramona brought her a roll of plastic garbage bags and went off. Beth had to deal with the sorting herself.

Nobody had touched Mack's office since his death, except to dust and retrieve necessary files, so the experience was wonderful and horrible, and ultimately, because Mack had been a packrat, exhausting. Beth was torn between tossing everything into a Dumpster and keeping everything, including random scraps of paper with incomprehensible scribbles and half-used rolls of antacid mints. Grimly determined, she set about cleaning out the clutter. She would have to make Mack's office her own, as she had made Mack's work.

She salvaged all the photographs, whether framed or curling at the corners, from the walls and the desktop, because most of them were of family. She'd lost the best of her photos in the mudslide. She was looking through the pile, tears pricking her eyes, when Ramona announced, "Commissioner Bjork" from the doorway and stood aside for Cate Bjork.

Beth blinked hard and shoved the stack of snapshots away along with the memories they provoked. She didn't try to rise. Her cast rested on an upended drawer, her walker in a corner of the room. "How nice to see you, Commissioner. Have a chair."

Cate smiled and sat. She wore a Donna Karan suit, unusual but not too pretentious for Klalo, and carried a huge pistachio handbag. "I came to apologize for my absence from your husband's funeral."

Beth murmured something forgiving. She hadn't noticed the Bjorks' absence.

"It's Lars, you see. He has Alzheimer's."

Beth made a polite sound of sympathy.

"We were hoping to keep his condition to ourselves, but it had to come out sooner or later, I suppose. Some days he's quiet and calm, as he was the night of your dinner, and other times he's… difficult."

"That must be stressful."

"Oh, I have plenty of help, but I don't like to go out when he's in that state. Who knows what might happen? He used to wander off—"

"How frightening for you, Cate. Do you have competent caregivers? It's hard to find good people."

"I've been lucky so far."

"You're younger than he is."

"Twenty-five years," Cate murmured. "He was so vigorous and interesting when we met. Old age is a terrible thing."

But so much better than the alternative, Beth thought and was instantly ashamed of herself.

"And how is your daughter?"

"Conscious," Beth said. "She's weak, though, and she doesn't remember anything about the mudslide." She cleared her throat. "The doctors are worried that she may suffer grand mal seizures. There was brain damage."

"I am so sorry," Cate murmured, polite and correct.

Beth wondered why she couldn't warm to the woman. "We may be able to bring Peggy home next week, but of course we'll need professional help."

"There's an agency—"

"Yes, we called them, and Skip will be interviewing people over the weekend. They're expensive, though. Skip and Peggy are

graduate students, for heaven's sake." Something else to worry about.

Cate rose. "Let me know if I can help." She held out her hand, and Beth shook it.

When Beth was growing up, women never shook hands. The custom came from back East or maybe from Europe. Handshaking revealed whether a man was carrying a weapon, according to Beth's father. She had pointed out that women could carry weapons, too, but her father had just laughed.

Rob intruded as Beth was sorting through a file marked PERSONAL. It was quite large. It included every school photograph of Beth since she began teaching, as well as pictures of all the children and most of the grandchildren. She cried a little over Mack's secret stash, until she saw the ominous bank statements, a row of well-thumbed envelopes. Her heart sank. When Rob's knock came, she shoved the drawer of the file cabinet closed with a smack.

"Come in."

He slid into the chair Cate had vacated. "How's it going?"

"Slowly."

"I can imagine." He handed her a fax sheet. "The toxicology report just came in on Fred Drinkwater. There's not much doubt he was murdered. That's a copy. I gave one to the prosecutor, too. We can go into high gear now."

"You don't sound enthusiastic."

He shoved his good hand through his forelock. He needed a haircut. "I can't say I'm burning to avenge Drinkwater's death, and I'm distracted by Inger's disappearance." He told her about the sneaker that had washed up.

She nodded, trying to look wise, which was hard with her thoughts on what might be hidden in Mack's bank records. So she told Rob about the commissioner's visit in more detail than he probably wanted to hear. He had the knack of looking as if he were interested in what you said, a major asset in interrogation, Beth reflected.

"We'll probably bring Peggy home to your house next week," she finished. "I hope you don't mind."

"No. It's a pity I took the wheelchair ramp down when Gran died. If Skip wants to resurrect it, I stashed the lumber from it in the garage."

"That's a good idea, if you don't mind—"

"Beth," he interrupted, smiling, "I really *really* don't mind. And if you need good LPNs, I can give you several names." He had been responsible for his grandmother's care in her last years.

She thanked him warmly and took down the names. They were all on the agency list, he said.

He stood up. "The drug that was used on Drinkwater, quetiapine, is not a common street drug. It was found in the glass beside him as well as in his bloodstream." He gave her the proprietary name, which she didn't recognize and wouldn't remember. "An anti-psychotic medication, sometimes used for anxiety or insomnia."

"That's weird. Did Fred have a prescription for it?"

"Not from his primary care physician." He made a face. "I'm getting old. I can remember when a doctor was called doctor."

Beth smiled. "Or Doc."

"Or that." Rob sighed. "If it weren't for the state's HIPPA Act, we could start asking pharmacists who on our suspect list is taking the stuff. Unfortunately, we'll need more evidence before we can get a court order."

"Frustrating," Beth said.

"Yes. Almost as frustrating as financial stuff." Rob glanced at her and at his watch. "You look tired. Do you want to go home?"

"I…uh, yes. Give me half an hour and I'll have most of the personal things sorted."

"No problem."

When he left, Beth locked the door and began stuffing the bank records into a garbage bag. She set the stack of photos on top of them and, for good measure, Mack's awards, of which there were many. She twisted the wire tape in place and felt safer. Then she unlocked the door and waited for Rob, busying herself by tossing out the paper scraps, the indigestion remedies, and a hideous artificial poinsettia that no one had removed after Christmas.

Towser bounced beside Meg's Accord as she set the brake. Because the garage door had not yet been repaired, she had taken to parking in the short concrete driveway. Towser treated it like a trampoline. She cracked the car door, grabbed her briefcase, and looked around for Tammy, who trotted up, smiling.

"Towser, sit!" He did that.

Meg slid out and locked her door. "A miracle," she murmured. "What's happening, Tammy?" She held her hand low, palm down, for the dog to sniff. He did that, too.

"I'm back at work. Well, I got a lot done through the Internet while I was in Las Vegas, but I'm back at work in my office. Feels good." She worked from home.

"Did you lose clients?" Meg scratched Towser behind the ears, and he gave a small, ecstatic bounce.

"Not a single one," Tammy said with justifiable pride. She was a bookkeeper/accountant and had worried about leaving town in the run-up to tax day, but here she was, back in time for frantic last-minute filers.

They talked awhile about the heartwarming loyalty of Tammy's clients, and Tammy reported that her son was going to graduate from cooking school at the end of April. He already had a job lined up.

Meg congratulated her and agreed to go for a walk. "Let me dump my briefcase first and change my shoes."

It never ceased to surprise her that she and Tammy had become friends in the few short months she had lived in Klalo. Tammy was a recovering alcoholic, an abused wife, now a widow, and uninterested in the library. Being loyal herself, she would support the levy, but she wasn't sure what a levy involved. Her late husband, a Libertarian, had opposed all levies on principle, insofar as he had had principles.

In LA, Meg's carefully chosen friends had shared all kinds of things—profession, taste, social attitudes, political affiliation. Here you took your friends where you found them, down the block in Tammy's case. It was an interesting change for Meg. Later, over dinner, she meditated on the luck of finding friends down the

block and across the street, and a lover next door. She wondered what she'd missed in LA.

She hadn't missed Marybeth Jackman. Marybeth was an all-too-familiar type. At one time she must have been a good librarian, but disappointment at home and work had soured her disposition. She enjoyed inflaming conflicts, even when the sparks burnt her. Marybeth was on her way out, one way or another. She didn't have friends, just cronies, fortunately for Meg.

"She threatened to out us," Meg said darkly.

Rob stared at her over the rim of his coffee cup. He looked as if his mind had been a million miles away. "Who? What?"

"Marybeth. Our fornicating ways."

"Ah."

"I laughed. I told her that blackmail is a two-way street, that *she'd* better not have any secrets."

Rob set his cup down. "Marry me."

Her turn to stare. "Are you running for public office?"

"No way."

"Then I don't see why."

"I love you."

"Prove it."

His grin started in his eyes. "I might just rise to that."

Well, it had been a problem, what with his bad back and slashed arm and all his medications, not to mention the overall gloom. She was glad he felt better.

Very glad, she decided, somewhat later. They lay abed upstairs in a peaceful tangle, both of them drowsing but not asleep. Downstairs, all the lights in the house were still on. Scandalous. She thought of Marybeth and snickered.

"What?"

She reached over and tweaked a nipple. "Marriage. Not necessary."

"You don't like the idea?"

"I don't know what I feel." She rose up on one elbow, looked at him, and said, very serious, "I'll take it under advisement."

His mouth relaxed in a smile that was at once tender and languorous. "We don't want to scandalize the librarians."

"Or our daughters."

They drifted downstairs after another interlude. Meg made another pot of coffee.

She turned off most of the lights. "Feel like telling me about it?"

"About what?"

"Your investigation."

"Jesus, Meg."

She poured two shots of single malt and set the tiny glasses on the kitchen table beside their coffee cups. "Maybe if you talk about it you won't thrash around so much in the middle of the night."

"Have I been doing that?" He looked sheepish. "I'm sorry."

"You did propose marriage. This would be an issue."

He didn't respond. His eyes darkened.

"Openness," she said. "Either I'm trustworthy, or I'm not. I would never betray you, and I certainly wouldn't blab sensitive information to the media or my friends. True, I told Beth about the landslide hazard, but that was an extreme situation."

"But why—"

"I believe in words. Talking things over is a way of understanding, oh, everything, not just this case, but who you are, and who I am, and what kind of community I find myself in. If something is so awful you can't bring yourself to talk about it, just say so. That I can understand. So how about it?" To cover her uneasiness, she took a tiny sip of scotch.

He sat down slowly, opposite her, and raised the shot glass. To her surprise his hand was not steady. "I'm afraid. Superstitious."

She turned that over in her mind. "You're afraid that Inger may be dead."

"I'm pretty sure she's dead." He tossed off half the whisky. "I'm afraid she was murdered."

"But I thought—" She bit her lip. "Okay, yes. I see. Saying it may make it so."

"Sounds stupid." He set the glass down with care.

"Word-magic is a primeval thing. We all use it."

"Thank you." He made a wry face. "I'm afraid she was killed, and afraid I won't be able to prove who did it."

"But you think you know."

"Yes." He toyed with the shot glass, then met her eyes. "I won't give you the name. It wouldn't be fair."

"Not fair to the killer?"

"Not fair to you, Meg. You'd look at the suspect differently. Believe me."

She did see. What a burden. "All right. I understand. What are you going to do? Do you have leads?"

"I have some facts." He told her about the phone calls from care-givers and the drug that had made Fred Drinkwater helpless to resist his killer, half-drunk as he was after a day of guilt and vodka. He told her about Inger's friendship with Darla, Matt's truculence, Karl's nervousness, Warren Bjork's spite, even about the shoe that washed up on the bank of the Choteau.

She had asked for it, so she poured more coffee and tried to sort through the spate of information, looking for patterns. "Care-givers, anxiety medication."

"Right." He blew on his hot coffee. "But the only notably anxious soul around—apart from Beth and Larry, of course—is Karl Tergeson."

"He's a commissioner. If he was the one who suppressed the hazard warning, he's bound to be anxious."

"He's worried about his daughter. No sign that he's thinking about the trouble the county's in."

"He's a dentist," Meg persisted. "Wouldn't he have access to drugs like that?"

"That's a point to ponder." Rob savored his scotch.

Karl might have killed Fred, but he would surely not have harmed his daughter. Meg's mind skittered. "Care-givers." She shook her head. "That just doesn't make sense."

"Try thinking of them as telephones."

"Oh, you mean somebody used their phones?"

"Maybe. That would eliminate one absurdity at least. It's touchy figuring out who they're working for, and yes, we have asked. They tell me about the nursing homes, the hospital, hospice, even the small foster-care facilities, but they're cagey about naming private patients."

"Nursing homes," Meg interrupted. "Kayla!"

"She's not a suspect."

"I know, but I bet she ran into these people. She could ask around and find out who they're working for." She saw doubt on his face. "Okay, there are privacy issues as far as the law is concerned. *I* could ask her to find out."

"Or I could get Beth to interview them, ask them for references," Rob mused. "She's looking for somebody to take care of Peggy."

"Hah!"

He smiled and raised his coffee cup in salute.

"You already know this." She felt an absurd degree of disappointment.

"That I need to find out who these people are working for, yes. It will take time. Linda's on it already, so don't call Kayla in. She has enough on her plate without cross-examining her friends. You might ask her how easy it would be for someone to use a caregiver's private cell phone, though. Nobody uses mine. It's on my belt or in the charger...." His voice trailed.

"I imagine some employers would ask care-givers not to make personal calls while they're on duty. A kindly employer could volunteer to charge the cell phone while it wasn't in use. Most people would never notice that the phone had been borrowed. Do you check every number on your monthly statement?"

"Sounds plausible."

Meg brooded. "Have you found out who could have done it? Administered the choke hold, I mean. I gather it's a police thing."

"The proper term is neck hold or stranglehold."

"Ugh."

"I could do it," Rob said mildly. "So could any of the deputies I've trained. It's a standard submission hold in most martial arts. Some police departments prohibit it, because it's damned dangerous when the victim struggles, but it's easy enough to do. A relatively small person can apply the hold successfully."

"Especially if the victim is already unconscious."

"Or even groggy. You could put a big man like Larry Swets out cold in less than ten seconds."

Meg shuddered. "Choking somebody."

"No, it's a blood hold. You compress the carotid arteries, cut off the supply of blood to the brain. The person in the hold passes out immediately—within five seconds. If he takes five seconds to pass out, it will be ten seconds before he comes to." He stood up and walked around the table. "Shall I show you?"

"Uh, sure."

"I'll just use my right arm. I would put my arm around the neck like this."

She felt his warmth and scent, the soft fabric of the shirt he'd put on when he came downstairs. His arm closed on her neck.

"Then I grab my own hand with the left and pull back, compressing your...you okay, Meg?"

She blinked black spots from her vision. "I...yes, but that's enough. I see what you mean."

He backed off, walked around the table, and sat down. His face was gentle, his eyes dark with concern. "All right?"

She gulped and nodded.

He finished off the shot of whisky. She took a snort of her own. She needed it. She knew he was a trained and effective martial arts practitioner, but she hadn't really taken in what that meant. In his own way, Rob was a very dangerous man.

That night Rob slept like a lamb. It was Meg who thrashed around, and her mind was not on marriage.

Chapter 16

JACK REDFERN CALLED on Rob's cell phone at half past seven the next morning. Damp from the shower, Rob stood in his boxers looking out the back window. Meg was still asleep. As he spoke, she stirred and turned over.

"You got to come out here." Jack sounded upset, almost disoriented. "Somebody's been messing around at my fishing shack. You know the place—upriver from that turnaround where Nancy found the Volvo."

"Okay. Warn Maddie."

"Already did."

"I'll have Jake Sorenson drive me. Give me forty-five minutes."

Rob could have driven himself, but he always wanted backup when he faced an encounter with Maddie. He was down in the kitchen chewing toast by the time Jake arrived with the blue lights revolving. It was a dim morning. An hour earlier, when Jack must have made his discovery, it would still have been dark out.

Rob took a gulp of coffee and left the kitchen in a mess. At least he'd made a pot of coffee. Upstairs, Meg said something. He called a good-bye.

Across the street, his cousin watched from the driveway. It almost looked as if Charlie meant to take Kayla's Civic to work. Rob waved as Jake pulled away, and Charlie waved back. On impulse Rob had Jake stop at a convenience store on the way out of town. He ducked in and bought a pack of cigarettes.

"Gonna take up smoking?" Jake peeled out and headed for Highway 14.

"No. We're dealing with Jack and Maddie."

"Oh, yeah, the peace pipe."

Rob smiled. "Something like that."

"Todd says it's a ritual they have."

"Several rituals, I think."

Jake nodded.

Todd Welch had been Jake's partner, the other deputy Rob had transferred from the uniform branch when he reorganized the department. Todd was also Maddie's nephew, her sister's son. Rob wasn't clear about Klalo relationships, but sister's sons apparently had a special role in the scheme of things. He probably ought to have called on Todd, but Jake drove well and fast, and unlike Todd, didn't chatter.

Rob let his mind drift back to the abandoned Volvo and the missing county clerk. A striking woman, Inger, intelligent and assertive. Nevertheless, she had never left home. She had commuted to college in Vancouver and married a local man. If she owed her position to her father's influence with the voters, she kept it because she did a good job.

Everything Rob knew about Inger indicated she was exactly what she appeared to be, an able public servant, committed to serving the community. Clearly she liked being a large frog in a small pond. What in the world had driven her to collude with Fred Drinkwater? Passion? Rob could see Inger as Freya or one of the Valkyries. She was undeniably Wagnerian. He did not see her in the role of Isolde, however, and Drinkwater was no Tristan.

What if she was innocent? Then who?

Mack? Of meddling with the geologists' reports maybe, but not of murder.

Rob groaned.

"You okay?"

"Sure. Just expressing my feelings."

"My ex-wife used to tell me to do that, but when I did she got mad."

Rob gave a matey laugh and focused on the landscape as they passed Two Falls and headed up the Choteau. They found Maddie

and Jack huddled together in the pickup, waiting. Even seen through the foggy windshield, Jack looked miserable and Maddie angry.

"Peace pipe time," Jake chortled. Rob left him in the car.

As Rob approached the pickup, Jack slid out the driver's side and Maddie got out, too. Jack nodded but didn't speak. He led Rob on wet grass to the river's edge, avoiding the rough path around the cedar cabin. As they neared the place, an outdoor light came on. Motion-sensitive, Rob assumed. It cast odd shadows on the gray morning. The Choteau was roaring so loud they couldn't carry on a conversation without shouting. Rob didn't even try to talk. He held out the opened pack.

Jack's eyes widened and Maddie's narrowed, but both of them took cigarettes. As Rob raised his to his mouth, he remembered he should have asked the clerk for matches. Fortunately, Jack whipped out an ancient Zippo of the kind sailors used to use in a high gale. Even with that, it took a while to light all three cigarettes. Rob did not disgrace himself by coughing, though he felt like it.

They stood silent, smoking, and looked at the river. Rob stared downstream, along the bank they had not searched because he'd been so sure Inger had gone into the river at the turnaround a mile further down. Salal and Himalayan blackberry grew down to the water. He couldn't see anything but brush along the shore, but that didn't mean nothing was there. The light was still not good.

At last, mercifully, Jack flicked his cigarette butt into the torrent, and Rob followed suit. Maddie kept on smoking, while Jack pointed out what he had brought Rob around to see. About five yards upstream from where they stood, someone had dragged something from the shack to the water. It was not obvious, though the security light made the signs clearer. Rob might not have spotted them if he hadn't been looking for them—broken grass blades and twigs, turned stones, patches of bare earth where the mast of leaves and needles had been scraped away. A bootprint showed at the edge of the drag area.

Jack pointed to the print. "Mine."

"Okay." Rob gestured at the door of the shack, which opened to the river, and raised his voice to be heard. "Do you lock it?"

Jack shook his head no and led them back to the road where it was possible to talk without shouting. "We lock it summers and hunting season."

Rob nodded. "Drunks."

"They get a load on, they'll steal whatever isn't nailed down. It's not locked now. Wasn't locked. I come over for an old creel."

"Is anything missing?"

"I dunno. I saw the bottle and backed out. Figured I shouldn't touch anything."

Rob nodded. "Smart. Bottle?"

They eyed each other, and Maddie watched them both.

Jack sighed and rubbed the back of his neck. He was looking easier. "In there, on the floor. Plastic bottle rolled under the trash burner. It's a sports drink, the kind runners take with them. I seen it advertised on TV. Hell, they stock it at Safeway. I don't drink that shit and neither does Leon." Leon was his brother. "You said Inger Swets is a runner."

"She is."

"Somebody tried to frame my husband." Maddie, her voice tight with fury.

"Well, it didn't work," Rob said. "Shall I send for the incident van?"

"You're asking me?" Her mouth was still set. She tossed the butt of her cigarette.

"You're the chief."

Silence. All of a sudden, Maddie began to laugh. "My God, Rob, unfiltered Camels?" Then all three of them were laughing. It cleared the air. Jake peered at them from the patrol car.

━━━━

The doctors let Kayla go. If she hadn't been an RN, they would not have permitted her to leave at all because of the danger of infection, especially in her sinuses. They made her sign releases, loaded her up with antibiotics and pain pills, and demanded that she return by ten A.M. Tuesday.

It was Saturday, and Charlie had a long morning lab to teach, so she was dressed and packed, and had signed out, by the time he got to the hospital. The only fly in her ointment—of which she had a lot—was that she would have to stay at the hotel with her mother and spend most of the time lying down. Since Dede had taken a suite with two queen-sized beds, she would not have to rent another room.

When Kayla called, her mother was still in bed but would have driven in to Portland at once if Kayla hadn't forbidden her to come. Kayla explained all that to Charlie, babbling as he helped her into the Civic.

He set her suitcase and a sack of medications in the hatchback beside his box of tutelary rocks, closed the back of the car, inserted his long legs into the driver's side, settled behind the wheel, and leaned over to fasten her seat belt. "Shut up," he said amiably. "You'll give yourself a jaw ache."

She was so happy to leave she kissed him on the nose. She was aiming for the mouth.

He rubbed his nose and his intensely blue eyes met hers. "Don't do that unless you mean it."

"Okay." She subsided onto the passenger seat as he dealt with the sparse Saturday traffic.

Since the hotel was in Hood River, Charlie drove on the Oregon side. It was a misty day. The mammoth basalt formations of the Gorge, hazed now with spring green, receded from vision like the landscape in a Chinese watercolor. There was plenty to look at. Someone had once counted twenty waterfalls on I-84 between the Sandy River, the western entrance to the Gorge, and Hood River.

"I don't want to leave either."

"What?" Charlie pulled around a semi with two long trailers. Road scum sprayed the windshield.

"I like Klalo. I want to stay, but I won't go back to Beaver Creek as long as Patrick is running things."

Charlie squirted wiper fluid on the windshield. "Good. You can teach me how to wind surf."

"If they'll let *me* wind surf."

"Who's going to stop you?"

"Oh Charlie, I love you."

After an increasingly uncomfortable silence he said, "And don't say *that* unless you mean it."

━━━

Beth spent the day clearing out Mack's office and doing the paperwork of a real sheriff. There was quite a lot of it. She consulted Ramona when she wasn't sure of what she was signing but would have preferred to talk to Rob. He wasn't there, unfortunately.

He had called her to say evidence had turned up in Two Falls that meant another organized search. Lt. Prentiss had agreed to facilitate a quick analysis of the sports-drink bottle Jack Redfern had found. "Quick" probably meant two or three days. Beth could see that thorough investigation involved maddening delays. Rob sounded resigned to the wait, at least for the analysis. The search was taking place as Beth sorted her husband's belongings.

Since Rob had not been around to drive her to the courthouse, Dany did. They made a quick visit to the hospital first. Peggy looked much better and was feeding Sophy with a bottle while Skip watched. It was a touching sight and somehow very private. Beth kissed Peggy and the baby, and Skip for good measure. Then she and Dany took themselves off.

Dany helped her to Mack's office and left with a box of odds and ends. Beth locked the door and sat at the desk, brooding. The previous night she had read through the bank statements—ten years' worth—without enlightenment. It was a savings account in a bank they'd never patronized. Mack had been squirreling money away at the rate of about a hundred dollars a month during that time. There were a few larger deposits, but the largest amount was $250. On two occasions he had taken money out, the bigger withdrawal being $840. That was an odd sum. She wracked her brain but couldn't remember anything they'd acquired that had cost that exact amount. The withdrawal had occurred five years ago. Was that when they'd replaced the television?

Money talks. Beth wished this money would. She decided she'd have to show John the statements and ask for his expert opinion,

even if it meant his father had taken regular tiny bribes. Having reached that unhappy conclusion, she unlocked the door, notified Ramona that she was open for business, and went on with her sorting.

At midday Ramona brought her a pastrami sandwich and a Coke, neither of which Beth liked. She ate them meekly, used her walker to find the ladies' rest room, and settled back into the badger den. She only discovered she had worked a full day when Ramona stuck her head in the door at five o'clock and said Dany was waiting.

From long maternal acquaintance, Beth knew Dany was up to mischief. She was sure of it when she found her granddaughter Beatie sitting in the back seat of Dany's car. Beatie had returned to Portland with her father after the funeral.

"What's going on?" Beth asked sharply.

Dany grinned. "Do you mind if we swing by the old house?"

"I'm very tired."

"Come on, Mom. It won't take long."

"Okay," Beth grumbled. "How are you, Beatrice darling? You're wearing your bubble gum shoes." Beth despised the little-girl fashion of Pepto-Bismol–pink costuming, but Beatie was proud of her pink plastic shoes. "And a tiara. Very regalitarian."

Beatie laughed and bounced forward to kiss her grandmother. Then she had to be induced to refasten her seat belt. The child was verbally precocious but abnormally normal in her tastes. She told Beth in detail how well she had taken care of her father and sister while Mom was staying in Klalo. By the time she wound down, Dany had parked in the driveway of the old house. A suspicious number of familiar cars littered the curbside. The house was lit from basement to attic.

"What?" Beth demanded.

Dany winked. "A little surprise."

After Dany and Beatie had helped her up the steps and in the front door, a wave of greeting swept over Beth. All three of her sons were there with their wives and younger children, and Dany's husband and smaller daughter. Only John's two teenagers had stayed

home in Portland. There was as much hugging and kissing as there would have been if Beth had not seen them in months.

The interior of the house looked suspiciously different. In December, before they moved out, Beth had started to prepare the place so it could be put on the market. She had shampooed the old carpet and given away as much of the furniture as the family wanted. Now she was torn between laughing and crying. She had tried for years to get rid of that furniture. It was back in place, polished and even reupholstered.

A sofa she didn't recognize sat across from the fireplace. Her daughters-in-law had hung new drapes. Beth wasn't sure she liked the fabric, and the swag was a tad pretentious, but the curtains gave the big living room a fresh look. She eyed a reupholstered chair and decided she wasn't the kind of woman whose belongings matched anyway. When she collected her wits, she said how delighted she was, but that wasn't enough.

"Come on, Mom. You have to see this." John's wife, Lindsey, took her arm.

"Let the sheriff use her walker," John murmured.

Beth smiled at him. He had always been the most empathic of the three boys. She lurched the few steps to the dining room, and there it was, a huge, circular oak table of the kind her parents had had at the ranch. She had been looking for one before Mack took it into his head to buy the plastic palace.

"Oh, yes," she said. "Oh."

"I found it at an estate sale," Lindsey boasted.

"But you'll want it for your own house," Beth protested. John and Lindsey had bought a great old Victorian off Thurman in Portland and were slowly filling it with period furniture.

"We need something with knobs and gargoyles," Lindsey said breezily. "Oak fits *this* house."

"Does it have a leaf?"

"Two!" Lindsey crowed. "And enough chairs for all the grown-ups."

Beth kissed her. "I love it."

"Look at the rest!"

The rest comprised a heavy oak sideboard and china cupboard, the latter filled with what looked like a service for twelve in Blue Willow. In the mudslide Beth had lost her favorite Franciscan ware and the everyday Mikasa. She could get used to Blue Willow.

"All this stuff—it must have cost a fortune."

John said, "Insurance will cover it, Mom. I'm going to see if I can salvage your silver when the inspectors are through sifting the ruins. For now we found a good set of stainless."

"And a raft of glasses at that estate sale," Lindsey said happily. "They're in here." She led Beth into the kitchen, which was the same crummy old room it had been, except that the girls had cleaned and polished everything. They had stuffed the cupboards with cookware and utensils, probably taken from their own kitchens, and a boring set of everyday china she recognized. Someone had given it to Jimmy's wife when she married, and she'd been trying to get rid of it ever since. A new coffeemaker gleamed beside the old gas range. A nice little breakfast table and chairs sat in the nook that overlooked the backyard.

The sight of her old kitchen ought to have depressed Beth, but didn't. It was wonderfully familiar. The counters sagged beneath a family feast, casseroles and salads and pies and a huge ham. Clearly her offspring expected to sit down at the oak table then and there, with a couple of card tables set up elsewhere for the kids.

Beth took a deep breath. She wanted to slink back to Rob's house and go to bed, but that wouldn't do. She looked around, catching their eyes, Jimmy and Mike and John, Dany and her daughters-in-law and Dany's sweet husband. She smiled. "I love you all very much. Thank you, and let's eat."

A good two hours later Dany drove her back to Rob's house. "Tired?"

"Yes," Beth admitted. "Very tired. Where are they staying?" At that moment the idea of all those wonderful people swarming into Rob's place was intolerable.

"At your house."

"But there aren't any beds upstairs!" They had set up a temporary bedroom for her downstairs in what had been the office/library,

originally a second parlor, though everybody understood that she wasn't ready to come back yet. When she and Mack had moved house, the beds upstairs had either been shifted to the basement level of the Prune Hill house, or in the case of the four battered, swaybacked twin beds from the big sleeping porch, taken to the dump. Beth had not inspected the second story of the old house at all, not wanting to tackle the stairs. "What have they done?"

Dany laughed. "Nothing very startling. Each of us furnished a bedroom. Lindsey did two."

"But you did it so fast!"

"Two days," Dany said with an air of understandable self-congratulation. "Lindsey bought the dining room set and the drapes yesterday after I measured things. We all had extra beds, mostly doubles. The boys rented the truck last night, drove to each house, and loaded up. They got here by eleven this morning."

"Wow." It amused Beth to think of the extra beds. The fashion now was for queens and kings. Beth supposed the kids had been married long enough to want to discard the original bedroom sets from long-abandoned apartments and starter homes.

"Four different styles, all of them, uh, somewhat the worse for wear." Dany got the giggles. "I made the guys promise to replace the mattresses, so the beds should be comfortable enough. What the hey, Mom, you believe in recycling. The stuff is usable, it doesn't cost you anything, and my set even comes with its own coverlet and curtains. When you get tired of your 'new' furniture you can call Goodwill with a clear conscience."

"St. Vincent de Paul," Beth corrected. She had to laugh, too.

"The kids had a great time this afternoon clearing a play space in the attic."

Beth groaned. She'd meant to go through the attic before they moved but hadn't had time. God only knew what was up there. "My grandmother's armoire!"

"It's okay. Genie was with them." Genie was Mike's wife. "The kids will use the sleeping porch, too, of course." The sleeping porch had been the boys' dormitory when they were young, with a spare bed for whatever friend wanted to stay the night.

When Beth and Mack had bought the house, the porch had been open to the elements. They had glassed it in and insulated it. It ran the width of the house and was just about large enough for three active boys. Beth supposed half a dozen smaller grandchildren would fit into it nicely. She didn't want to know how it was furnished—bunk beds?—so she didn't ask. And the attic would transform into a game room, no doubt, with computers and all the impedimenta of modern child-life. It was a good idea. Maybe the grandchildren would come more often than just for holiday dinners. Maybe they could spend the summer…Good God, she thought, I've taken leave of my senses.

When she got home and collapsed onto Robert Guthrie's recliner, it occurred to Beth that she had forgotten to tell John about the bank statements. Dany was off in the kitchen making tea. Beth reached for her cell phone, saw that she had messages, and called the first number, which she didn't recognize.

It was Karl Tergeson.

Beth said, "It's Elizabeth McCormick, Karl. You called me."

"It's not true. It can't be. Not my little girl, not Inger."

"Karl, I don't—"

"They found her. They're saying she killed herself." He began to sob, the terrible wrenching sound of a man who was unaccustomed to crying. "You have to stop them saying that. It's not decent."

Beth cleared her throat. "I'm sorry, Karl. I've been out of touch for a couple of hours. I hadn't heard."

"Call yourself a sheriff?" Karl broke the connection.

Beth phoned Rob. "Karl Tergeson just told me Inger's body had been found," she said without preamble.

"That's right." Rob's voice was flat and the connection wasn't good. She heard odd whooshing noises. "I just came from telling the Tergesons. We found her about two hours ago on the east bank of the Choteau, just below the turnaround where the car was abandoned—on the other side of the river. Jack Redfern thought the current might take her there if she went in farther upstream. I left a message on your voice mail."

"I'm sorry, Rob."

"Me, too. Christ, Jake, watch the fucking road."

"Did she commit suicide?"

There was a crackling pause. Rob's voice came through stronger when he finally spoke. "You know I can't say what caused her death at this point. We don't even know for sure that she died from drowning." He drew an audible breath and added, wearily, "The body was battered. Lots of rocks in the Choteau. We found a piece of paper in one of the zip pockets of her track suit. It's probably illegible. May be a suicide note."

"Karl is terribly upset that somebody is saying she committed suicide."

Another pause. Rob cleared his throat. "If you think Karl is upset, you should see Larry. We had to get the medics to sedate him. I'm on my way home. Shall I stop in and brief you?"

"If it's not too much trouble," Beth said. "Thank you, Rob. I'm sorry you had to break the news."

"Me, too."

Chapter 17

ROB SHOWED UP less than half an hour later. Dany brought him in to Beth and left them to their talk. He didn't sit.

"You're in pain," Beth said sharply.

"I went off without a supply of pills this morning, and it's been a long day." He took up his post behind the high-backed chair, leaning on his good arm. "Don't concern yourself, Beth. I stopped off and took a Vicodin before I came here. It'll knock me out in the next half hour, so let's get this over with."

"All right. I'm listening."

"We found Inger's body about six-thirty." He fiddled with the blue sling, avoiding her eyes. "*Jack* found her—washed up in an eddy on the far shore—after we'd searched every inch of the west bank."

"I see. Karl said—"

"Prentiss is convinced that she killed herself sooner than face arrest. He had already asked Judge Rosen for a warrant. Now he's trying to decipher the note we found in her track suit."

"A warrant for murder?"

Rob shook his head. "Prentiss isn't investigating murder. He meant to charge Inger with suppressing the hazard warning. She may have done that. I don't know. I'm pretty sure she didn't kill Drinkwater, or jump in the river and drown. I'm gambling that the postmortem will show she was dead, or at least doped, when she went into the water."

"And?"

"Who killed her? I can't give you the name." He shut his eyes,

forced them open. "I don't have a shred of proof. I should be getting some early next week. Lab results, financial records." He drew a ragged breath. "Goddamn, I hate weekends. I hate—"

"I'm sorry."

He stared at her. Tears glazed his eyes.

"You are not to blame yourself for failing to make an arrest before she disappeared, whatever foolishness Larry and Karl may be saying in their grief."

"But—"

"Listen to me."

He buried his head in his sleeve. She could see his hand cramp on the back of the chair.

"Listen," she repeated. "You don't know what was going on in Inger's life, what chances she was taking, who she trusted and should not have. She was a remarkable woman, in some ways, and perfectly ordinary in others."

He didn't reply, but she thought he was listening.

"I never taught her," Beth mused. "She had finished high school before I started teaching, but even then she was visible, a personality. And beautiful, of course. If you think she was good-looking at forty, as a teenager she was a goddess."

He raised his head, his face pale but composed. "I'm five years older. I was out of high school, and out of town, before she appeared on the radar."

Beth nodded. "The boys swarmed. In spite of that, she always had female friends."

"And she married Larry Swets." Rob frowned. His hand still gripped the chair as if he might fall over.

"Inger's father was protective and conventional. Utterly conventional." Rather like Mack, she thought.

He straightened up and stared at her.

"I've no idea whether Inger was a lesbian," she said mildly. "I doubt it. I wouldn't be surprised if she was bisexual, but I don't know if she ever acted on it. With Larry on the river, she was alone a lot of the time. I'm just saying that she was not necessarily as conventional as Karl wanted her to be."

"She was scornful when I asked if she'd had an affair with Fred."

"What did she say?"

"That the voters wouldn't forgive her if she played around." Both of them had a good idea what the voters would say to a lesbian relationship, let alone a simple extramarital affair with a man.

After a moment, Rob went on, "Darla told me Inger had a 'fling' with Fred last summer. I took that to mean a dirty weekend at most."

" 'The voters wouldn't forgive her,' " Beth repeated. "I don't know about the voters. Her father wouldn't. Well, he would, but he'd agonize. It's hard to be adored."

Rob mouth relaxed in a faint smile. "I wouldn't know."

"I wish we'd get over our sexual pruderies. Including Karl and the pope."

Rob's mouth quirked.

"It's hard on gay kids here. They feel like they have to leave town, move to Portland or San Francisco. That's not entirely true, though it is for anyone who aspires to public office."

"Inger didn't leave town."

"Maybe I'm wrong. I probably am. My point would be, whatever her sexual preferences, Inger had to deal with her father and this community, not to mention Larry. She kept herself to herself." A wave of exhaustion swept over Beth. "We're not getting anywhere. What was it you thought I had to deal with tonight? Oh God, the press."

"Yes. You ought to hold a press conference."

"I can't," she wailed. "I've got the whole family here. Why don't *you* do it?"

"You promised me you'd deal with the media, Beth."

"Okay, you rat. Tell me what I have to say."

"Monday will be soon enough for the conference, but you'll need to talk to the prosecutor first and probably to Prentiss. Shall I set up a meeting here tomorrow afternoon?"

Beth nodded, numb with weariness.

———

When Rob came home for good, Meg kissed him, fed him, and sent him up to bed as soon as he'd made the inevitable phone calls. Then she sat at her computer and worked on staff appointments. She didn't want to have to look at Marybeth anymore, much less talk to her. She dreamed up complex and meaningless projects to which a rogue librarian could be assigned as penance. "Microfiche in the Digital Age" was a favorite, with "Virtual Readers for Virtual Books" a close second.

A tap at the kitchen door brought her out of her sadistic reverie. It was Charlie. He looked as much like the cat that ate the canary as was possible for a man of his coloring and lanky height.

She put out the cookies, which were evaporating, and poured two shots of scotch, which finished the bottle. Time to replenish supplies. "How goes the courtship?"

His smug look intensified. He sat and took a cookie, looked at it, and said, "I may be able to cram this in. I just ate dinner at the Columbia Gorge Hotel with Kayla and her mother." He rolled his eyes.

Meg smiled. "I know whereof you speak. But what is this? I thought Kayla couldn't chew. And I thought they weren't going to let her out of the hospital."

So Charlie regaled her with an account of his afternoon. He had driven Kayla to Hood River in the Civic and deposited her with her mother. "She was tired by then and in dire need of pain medication."

Meg shuddered, but she had to respect Kayla's urge to escape from the hospital, any hospital.

"Dede asked me to have dinner with them." Charlie grinned. "I didn't say no." With a couple of hours to kill, he'd gone to the Hood River public library with its spectacular view of the Columbia and spent the time reviewing for his licensing exam. When he returned to the hotel, he found Kayla's mother insisting that they eat in the dining room instead of her suite.

He didn't think that was a good idea. Kayla was used to being stared at. "But not because she looks like something out of a horror flick."

"Charlie!" Meg gasped.

"Half her face is bandaged or bruised, and her hair's all uneven. You saw her, Meg. She's going to adjust eventually, but you can't blame her for wanting to hide."

When he got back, Kayla was still sulking. She had dressed in one of her mother's outfits. Kayla was not a clinger, but she clung to his arm on what must have been an interminable walk through the dining room to their table. At that point Dede summoned the chef.

Meg could only gasp again. "What in the world did she say to him?"

Charlie chuckled. Dede had given the man a brief but colorful account of Kayla's heroism, explained her difficulty chewing, and assured him she trusted him to come up with a splendid menu for her wonderful daughter.

"It was a challenge," Charlie added, "and I'm bound to say he rose to it. I had the prime rib myself, but Kayla let me sample the goodies. I never tasted anything like the dinner soufflé."

"Truffles?"

"Probably. And some exotic cheese. Even the vegetables— squash swirled with parsnips and sour cream. My mother's squash never tasted like that."

"Nutmeg," Meg murmured. "Cardamom, maybe. I hope the chef didn't serve her mousse for dessert."

"Kayla's dessert was a real production. The Jell-O folks never made anything like it. It came in a parfait glass with this ruby syrup, pomegranate, Kayla said, and mint leaves. There was a wafer with it, and I thought oops, but she said she didn't have to chew it. It melted on her tongue." He eyes twinkled. "The chef came out to take a bow when we were ready to go. I never thought I'd see that little ritual."

Meg smiled.

Charlie sobered. "They quarrel, you know, Kayla and her mother, but Dede's cool. By the time we went up to the suite again, Kayla had forgotten about people staring at her."

Too busy quarreling with Mom, Meg thought cynically. She was

glad Charlie liked his putative mother-in-law, but she wondered whether he had a chance with Kayla and, if he did, whether she would be good for him. They inhabited different planets, or maybe universes.

When he took his leave, he gestured toward the upstairs. "A heavy day?"

"You could say that."

"I heard about the county clerk's death. He'll take it hard. I feel bad about the whole mess myself, since I started the ball rolling."

"You didn't cause the mudslide, Charlie."

"No, but if I hadn't raised questions about the hazard warning, nobody would have noticed it was missing. I stirred something up."

"Fred Drinkwater was killed before the public heard of the missing notice."

"True."

"And I suspect the state or the insurance investigators would have discovered the discrepancy eventually."

"Maybe." He smiled at her. "I wouldn't have your job for the world."

"The library?"

"Your job here. Picking up the pieces." He gave her a kiss on the cheek and went off, whistling.

Meg rubbed her cheek. No doubt Charlie meant well but she was not a nanny. She went to her computer, backed out of the frivolous game she had been playing with Marybeth's career, and logged onto the Internet.

She called up the county website. Rob had designed it shortly after he returned from California to oversee his grandmother's care. He had been working as a computer consultant then. The job as deputy had not come open until some months later. He had never explained to her satisfaction why he'd taken it. It wasn't clear why Inger Swets had been attracted to the county clerk's position either.

She had had some legal training, though she wasn't a lawyer, and her academic degrees (both from Washington State) were in

business. She was a CPA. According to the sparse little bio taken from the last voters' pamphlet, Inger had been elected to the position three times.

The post carried considerable responsibility and was well compensated relative to what Meg was making. In the state of Washington, the county clerk keeps all records of the Superior Court and has ultimate responsibility for police records as well. Inger also collected court fees and fines. She oversaw the county budget and the investment of trust funds for the court. Among her administrative duties, she was charged with ensuring that the Board of Commissioners hewed to official policies and guidelines. She had three deputy clerks to assist her, and a well-trained staff.

Though the board had its own clerk to deal with the minutes of its meetings, Inger would have been responsible for its records. That was what it boiled down to. No wonder Lt. Prentiss had gone directly to her office when he looked for a suspect.

I'm getting nowhere, Meg thought glumly and clicked Home. For some reason, the role of commissioners was not clearly defined on the county website. They had statutory duties, of course, and she could have gone to the state website for details, but she wasn't in the mood to read statutes. The bios provided were minimal, with Catherine Bjork's vaguer than the other two because she didn't have a day job. Hank was a real estate agent, Karl a dentist.

The voters' pamphlet for the special election that had put Cate in office included a concise statement of values that stuck to the Sierra Club line without sounding unduly contentious. She opposed "unrestrained building and population growth," spoke quite fiercely about clear-cutting and strip mining, and came down on the side of strict enforcement of drug laws.

She favored the preservation of natural amenities, and "beautification," whatever that might mean. In the Gorge, the natural beauty was such that it was a little hard to concentrate on other things like going to work and doing the dishes. To invest heavily with a local developer, then turn around and insist that the county restrict building seemed a bit hypocritical, but hypocrisy is a national pastime.

Cate's opponent had stressed creation of jobs and universal health care, which were worthy goals, but health care for the uninsured wasn't a problem that could be tackled locally, and jobs almost always involved the building of large, smelly plants that intruded on one's view of Mount Hood. Meg had voted for Cate's opponent, but she hadn't been heartbroken when he lost. Anyone would have been an improvement over her predecessor, Hal Brandstetter.

Annoyed, Meg called up the California newspapers and searched the archives for information on Lars Bjork. After all, he, not his wife, had been Drinkwater's backer. She started fifteen years before, about the time he must have married Cate. Two hours later she had a stack of printouts and was almost out of copy paper.

"It was self-indulgent," she admitted at breakfast the next morning.

Rob slurped hot coffee.

"I felt like a scandalmonger, reading all the dirt about that divorce. They fought over everything. And Cate was the classic Other Woman. I'm sorry for her, even if she did take the old boy away from his wife. She had to sign a pre-nuptial agreement waiving any claim to his estate. Of course, she got a large settlement first."

"All about money, was it?"

"And power and social position. The ex-wife sounded repulsive. On the other hand, so did Lars. I wondered if he was that nasty on the job, so I checked out the financial news, too. At the time of the divorce he was at the height of his power, the man to go to if you wanted start-up money for a new company or whatever. He was famous for investing in unlikely projects and making out like a bandit. A couple of years later, though, he began to lose his touch. He was senior vice president of the bank. When he turned seventy they forced him out."

"Not surprising."

"No, but it grates on me that they let him lose pension funds and private savings but didn't even try to curb him until he lost the bank's money. And they gave him a golden parachute."

"Incompetence must be rewarded."

Meg's coffee was cold. She poured it out and refilled her cup. "As

far as I know, he did nothing illegal, but the whole mess stinks. After his ouster, he moved his personal fortune north to Seattle. That's where he met up with Fred, who was putting in a lot of cheap condos for people who worked for Microsoft and Boeing. Some of the structures were built on land that's threatened by Mount Rainier."

"Nisqually." Rob swallowed coffee and looked at his toast.

"Oh, you know the territory?"

He slathered a piece of toast with lemon curd. "If Mount Rainier erupts the way Mount Saint Helens did, pyroclastic flows and mudslides will take out the whole Nisqually River valley and everyone in it. Worst case scenario."

Meg shuddered.

"Lady, you lived in LA." He chewed. "You know about optimists who build on impossible sites—earthquake faults, hillsides that alternate brushfires with mudslides, eroding coastlines."

"Well, yes."

"Nancy Reagan had it right," he mumbled through another mouthful of toast.

"What?"

"Somebody should just say no."

"Then you agree with Cate?"

He looked over at her. "I thought she was a tad less dishonest than her opponent. I voted for her." He popped the last morsel into his mouth.

"You may live to regret it."

"I already do." He wiped his lips, set the napkin down, and told her of Cate's venture to Two Falls. He'd spent a lot of time with Maddie on Saturday.

"Museum prices! That's gross." Meg scowled at her cooling coffee. "I guess I won't let the commissioner endow a branch library after all."

Rob laughed, as she had meant him to, and stood up. "I'm going to my office. No Sundays for the wicked. I'll probably find a report from Jeff on my desk with the same information less vividly expressed. Beth and I will confer with the prosecutor this afternoon at my house. Any other tidbits I should know about?"

"Cate was a P.E. major."

He smiled at her. "That's not a crime."

"No. Just a tidbit."

He laughed again and left. Meg considered going over to the main branch of the library. Sunday was always a big day, with line-ups at the computers and books flying in and out, but none of the branches opened until one o'clock, thanks to budget constraints. She also couldn't go to the pious liquor store, which was closed on Sunday, thanks to the state's obsolete blue laws. So she decided to bake oatmeal cookies, with and without raisins.

She was measuring out the dry ingredients when a thunder-ous knock sounded at the front door. Nobody thundered at Meg's house. Nobody kicked the door either, but she heard something horribly like wood splintering.

She grabbed her cell phone and started to dial 911, then thought of Charlie, who was closer. His cell number was on the speed dial, so she hit that and peered around the arch into the hall that led to the front door. A huge shadow blocked the light from the window in the door.

After four rings a sleepy voice answered.

"Help me," Meg shouted. "Somebody's breaking in." Glass shattered.

"Coming!" He broke the connection.

She slid out the kitchen door and edged around the house. A very large man was smashing at the front door with his fists and feet. Meg loved her front door. The window was beveled glass. Had been.

She retreated to her driveway, flipped the phone open again, and called 911.

As she was explaining things to the dispatcher, Charlie stum-bled across the street in jeans and unlaced boots. His shirt was unbuttoned, and he hadn't bothered with a coat.

"Who is it?" he asked.

"I think it's Inger Swets's husband. He's a big man."

"Drunk? Armed?"

Meg shivered. "I don't know. I didn't get close enough to talk."

All along the street, doors opened and people peered out. Tammy and Towser stood on the sidewalk. Marge Barnes emerged from the coffee stand on the corner, where Sunday business was slow, and stood by her solitary patron's open car window, talking. Beth's daughter Dany came out as far as Rob's front gate.

It was a good thing to have neighbors. Meg's racing pulse began to slow.

Larry Swets, if that was who the man was, peered in the broken window, yelling something. Meg heard Rob's name. As she watched, the man gave the door a last kick, turned to go, stumbled, and fell down on the porch. He must have cut his hand on a glass shard. Meg saw blood. He raised his hand to his face, stared at it, and hunched over with his shoulders heaving.

Charlie said, "I'm going to talk to him. Stay back, Meg."

"Is he crying?"

Charlie didn't answer. He walked slowly up to the porch, stood for a moment, then sat beside the shuddering hulk. By the time the patrol car wheeled up with its light revolving, Charlie was holding the weeping man by the shoulders and talking to him quietly. As she watched, Larry gave Charlie something. It looked like a small sheaf of papers.

Meg went to the patrol car. It was a city car and the young driver got out with exaggerated caution. Meg didn't blame him.

"I think the worst is over," she said.

"You never can tell. Who's that with him?"

"Neighbor across the street."

"Oh yeah, the geologist."

Everybody knew everybody.

Meg explained the situation as well as she could. The EMT van arrived with a single yelp of the siren. She repeated her explanation. Her phone rang. It was Rob.

"Are you all right?"

She explained again. She asked him if he was giving serious thought to the possibility that Larry had killed his wife.

S HE FIRED ME!" The small man, his hair in a bright yellow crest, perched on Rob's visitor chair like an indignant parakeet. "After a year and two months!"

Rob said cautiously, "Mrs. Bjork fired you, so you came to me. Why, Mr. Schwenk?"

"Because that woman deputy asked me who I worked for."

"Sergeant Ramos?"

"Her. I don't see why I should do Madame any favors, not now. I've worked for her all that time, keeping her husband clean, doling out his meds, sitting with him hour after boring hour, listening to the old fart ramble on about how rich and important he is."

"You worked a night shift?"

"I like working nights. Gives me half the day to myself. I'm a wind surfer," he added, surprising Rob, but why shouldn't small men surf? "Well, not now. It's too cold, but in the season."

Rob knew what he meant. The season was nearly eight months of wind and water perfection. It made the Gorge a magnet for wind surfers from all over the county.

"Early evening's best for surfing. The wind picks up then. If I get in a good run on the river, I'm all charged up for work."

"I see."

"Anyways, I come in to work last night like usual, and she tells me she don't need me no more, she's found somebody more reliable. By God, she better not say that to anyone else. I'll sue her for slander, libel, whatever. Sure, I was late once in a while, but I showed up, didn't I?" He spluttered on, obviously outraged.

At the first pause, Rob asked him about Lars Bjork's medications. Schwenk gave Rob the name of the prescribing physician. Rob asked whether quetiapine, the medication which had been found in Drinkwater's blood, was among the drugs prescribed, and Schwenk frowned, puzzled.

When Robert repeated the question, using the proprietary name, Schwenk nodded.

He looked defiant. "We give it sometimes when he can't sleep. He sleeps a lot these days."

"Who orders his prescriptions renewed?"

"Mrs. Bjork. She picks them up, too. She locks the pills in this cupboard out in the hall when we've taken out what we need for the shift. Like we're going to sell loose pills on the street." Resentment thickened his voice.

Rob changed the subject. "Did the commissioner use your telephone?"

"My cell phone? She lets me charge it. Some of our clients won't do that. In the den."

"The den?"

"Liberry. Book room. It's across the hall from the old man's suite. She won't have a phone in the suite, says he calls out and orders stuff. That's a lie. Maybe he did that in the early stages, but not now. He's beyond that." He reflected. "There's a baby monitor in the suite. If I need help I just yell."

"Do you keep your telephone records?"

"Sure. File 'em away. Why?"

"Could she have used the phone without your knowledge?"

Schwenk stared at him. "What for? I come on at ten o'clock at night."

"Some people like late-night conversations."

"Kinky sex?" He snorted. "For sure she's not getting any from the old guy. Yeah, she coulda used my phone. The door to the suite is closed and so's the door to the den. And Lars usually wants the TV running. Old movies."

"For the record, did you call Fred Drinkwater at any time from your cell phone?"

"No. Never heard of him before your sergeant asked me the same question."

"Did you ever phone Inger Swets?"

"No." Schwenk stared at him. "That the county clerk?"

Rob went over everything again, thanked the care-giver for coming, closed out the interview, and shook hands.

"Will I, like, have to testify?"

"Probably. We'll let you know. Secure your telephone records." Rob showed him out, returned to his desk, and pulled the list of phone numbers he had culled from Jeff's report. Then he called Linda, who was at the Swets residence going through Inger's belongings, and asked her to find the cell phone bills.

Larry had given permission for them to examine Inger's records the day before, when Rob brought him the news of her death, though Prentiss had already taken some of them, along with her personal computer. Larry was now in the hospital under sedation, so Karl had had to let Linda into the house. The episode earlier that morning, when Larry tried to break down Meg's door, had shaken Karl out of his mood of fixed hostility. It had shaken Rob, too.

He wondered whether to call Meg again, but she had seemed more annoyed by the damage to her beveled glass window than frightened. She was sorry for Larry, and grateful to Charlie, but not scared. That was Meg.

He checked his watch and willed Linda to hurry. On an off-chance, he called Prentiss and asked whether results had come in yet from tests on the sports drink found in the Redfern shack. Miraculously, one test had come in. Enough quetiapine to make even a large woman like Inger groggy, but probably not enough to kill her. She must have drunk a lot of it. The bottle was almost empty. The lab had tested for the drug first, at Rob's request.

The phone rang. He grabbed the receiver and identified himself, thinking it was Linda.

Warren Bjork said, "I talked to my lawyers. They're asking for full disclosure."

"And?"

"I should know by midweek whether that bitch has been siphoning money from my father's funds."

"Surely she's entitled to compensation for his care and living expenses."

"Above that."

"Out of curiosity, Mr. Bjork, how did you find out about your father's condition?"

A snort of unamused laughter. "By accident. I went to school with one of Cate's financial advisors. I'm doing a fund drive for the foundation, so I gave him a call. We talked over the good old days, and I made a remark about my father. My old buddy let something slip about power of attorney. He caught himself, but it made me suspicious, so I called Cate and asked to talk to Dad. Five minutes on the phone with him told me all I needed to know. He asked about little Whitney. Little Whitney is my sister, who hasn't been little since she was ten. And he did that dumb repetition thing. You answer a question, and a few seconds later he asks the same question again."

"Must have been a shock," Rob murmured.

"You could say that. So I told her I was coming up to see him. We quarreled on the phone. She hadn't told me, because she didn't think I was interested. So she said. I was interested." He huffed for a while, repeating himself.

"When was that?" Rob interjected when he paused for breath.

"When was what?"

"When did you discover your father was suffering from dementia?"

"Ten days ago."

Long after the dinner party. Just after the mudslide. "I thought you said you came north right away."

"I'm a busy man. I have important commitments. It took me several days to get things in order so my wife and I could leave."

"I see."

"I'm considering suing for guardianship."

"Good luck." Rob didn't care whether Cate Bjork had been stealing from her husband, and he thought it unlikely that Warren

would provide better care. "If I understand your stepmother's financial situation, it's to her advantage to keep him alive as long as possible. She won't inherit from him, but while he lives, and she has power of attorney, she can use his wealth to her own advantage. Maybe she's investing in junk bonds." That was malicious.

Warren sputtered and hung up.

Rob felt the tingle of adrenaline beginning to flow, closed his eyes, breathed carefully in and out, and cleared his mind. No hurry, there was no hurry.

On the other hand. He picked up the phone and asked Sergeant Howell to look up the number of the Columbia Gorge Hotel.

━━━━━

When Rob called, Kayla was drowsing on the queen-sized bed on her side of her mother's suite. Dede had gone down for the elegant Sunday buffet for which the hotel was famous. Rob shocked Kayla awake with the news of Inger Swets's death.

"God, that's awful. I never liked her much, but she didn't deserve that. What's happening to Klalo? It's supposed to be a good place to live."

He ignored the rhetorical question. "Did you know Inger well?"

"I took her wind-surfing once. She was too, I don't know, too rigid. I kept telling her to feel the wind, go with it, but she couldn't do that. It was funny to watch, but she doesn't…didn't have much sense of humor."

"I see. Darla ran with her sometimes. Did you?"

"I'm not a runner. Used to drive the coaches crazy. I played soccer in high school and did gymnastics. I was good at both, but when they tried to make me run laps I always threw up halfway around the track."

Rob chuckled. "Deliberately?"

"Well, sure. Running laps is boring. Did you call just to chew the fat, or did you have some ulterior detectival motive?"

"I need your expertise. Do you know two care-givers, not with the agency, by the name of Janet Reo and Barbara Olsen?"

"Sure. I had to take Janet off the roster last year. Patrick thought

she was too fat. Isn't that just like Patrick? As if heavy people can't do good work. Janet's okay. I call Barb in fairly often. In fact, she was working at Beaver Creek the day of the mudslide." She told him about the three aides who traveled all the way to Portland to bring her purse to her. "I talked to Barb yesterday evening. My mother created this theatrical spectacle at dinner you wouldn't believe—" She was set to tell him all about her embarrassment and her matricidal fantasies, but he interrupted, which wasn't like Rob.

"Do you know whether Ms. Olsen works for Catherine Bjork, the county commissioner? The husband is an Alzheimer's patient being cared for at home."

"Barb *did* work for the Bjorks, day shift, three days a week, but sweet Cate fired her yesterday for no reason, said she was making other arrangements. She gave Barb two weeks' pay in lieu of notice. I'd bet money La Belle Bjork is going to put that poor old man into a care facility."

Rob made a *whoosh*ing sound, as if he'd been holding his breath. "Thanks, Kayla. You're a peach."

"Kind of a bruised peach at the moment."

"Hey, bruises or no bruises, you're okay, kid. After all, they let you out."

"For good behavior?" she asked sourly.

He laughed. "I'll call you later to explain what's happening, Kayla, but right now I have to go." And he hung up without further palaver.

She stared at the phone and clicked it off, feeling ill-used. Charlie wouldn't hang up on her. She had a lot of questions to ask. Why was Rob so interested in Catherine Parrish Bjork?

Beth finally got around to showing John the bank statements Sunday morning after the excitement at Meg's house had died down. He was heading back to Portland with Lindsey and their youngest son, so the circumstances weren't ideal.

When Lindsey and Cier went off to the kitchen, however, John glanced through the statements. "They were in his file cabinet at work?"

"Yes. Why would he keep that account a secret from me, Johnny? There's over ten thousand dollars in it. We were always open with each other about money. I've thought and thought, and I can't come up with an innocent explanation."

He stared at her. "Innocent?"

She swallowed. She would not say the word *bribe.*

He riffled through the last three months' worth and burst into laughter. "Dad's Irish account."

"What?"

He sobered and said gently, "He was saving to take you to Ireland, Mom. For your golden wedding. He wanted to surprise you, and to do it in style."

"Oh, my God. Oh, Mack! But where did the money come from?"

"Well, a buck here, a buck there. Remember when he was diagnosed with hypertension? The doctor told him to stop eating lunch at Mona's, so he just ate a sandwich at his desk and saved the difference in a big manila envelope. He put his change in a jar, too. And every month he'd take the jar and the envelope to the bank. He was real proud of himself, told us all about it."

Beth was crying again, her tears a tangy mixture of love, relief, and guilt. How could she have suspected her Michael of anything so awful as taking bribes?

John sat on the arm of the recliner and patted her awkwardly. "Hey, come on, Mom. It'll be all right."

But Beth knew she had fallen from grace.

———

Maddie took it into her head to look for camas. She didn't hesitate to monopolize the pickup. Jack had gone off early with his brother and wouldn't be home until later.

The native lilies wouldn't be blooming yet, of course. It was at least a month too soon for that, but there would be green shoots of camas poking up. The day was pleasant, with a sharp little east wind and no rain. Fluffy clouds drifted in a deep blue sky, and she could see the base of Mount Hood from Highway 14 as she drove west. The apex of the mountain hid itself in cloud.

At County Road 2 she turned right, consulted the map she had printed from the Internet, and drove seven-tenths of a mile north to a private road that twisted through dense conifers. The road was graveled, well-kept, and quite narrow. She drove slowly, kicking up little dust because this was the first dry morning in at least a week.

She kept a critical eye on the greenery on both sides of the track, but saw nothing to alarm her. Salal, Oregon grape, and huckleberries grew on the road edge, mixed spruce and fir behind them, with native dogwood and rhododendrons throughout, and one spindly white oak. White oaks tend to be crowded out by a canopy of tall conifers, but the shortage of oaks would not be the Bjorks' fault. A few Douglas fir and one or two Ponderosa pine towered above the lower conifers.

The estate lay at the edge of the area where rhododendrons and other rainforest plants flourished. Ferns grew in the shaded spots, maidenhair, horsetail, and sword. Further east the land was too dry for them to grow abundantly, and too cold in winter, as it was for rhododendrons.

"At least she didn't plant shit like primroses or petunias along the road," Maddie muttered. She didn't dislike primroses, but they were emphatically not native plants. She halted to let a pregnant doe cross in front of her. Black-tail.

The Bjork house was supposed to lie two-tenths of a mile from the county road, the only house on the private drive. Maddie rounded a last curve, and the land opened up to a natural meadow. The huge house intruded grossly on the scene, but she had to admire it.

It paid to have good architects. The walls of the mansion showed stone and cedar. Blue slate covered the roof and the many gables placed at strange angles. The windows came in odd shapes, some with stained glass, and balconies that thrust out from the second story rode on heavy beams. The balconies would give excellent views, some of Mount Hood, others Mount Adams. As Cate had boasted at the dinner party, the house was surrounded by natural grasses flecked with early blossoms.

There was no blacktop. In front of the garage and entryway, the drive comprised hollow concrete paving blocks laid in an attractive design and filled with pea gravel. The blocks were mossy, which was normal after a wet winter, but the moss just gave a pleasant note of color. Maddie got out of the truck, with a passing thought about guard dogs, and trotted up to the front door.

She rang what looked like a doorbell, though she heard no sound. She saw no cars either. Maybe nobody was at home. She was about to turn around and go back to the pickup when the huge double door opened. She was greeted by her cousin Bitsy Thomas.

"Hey, Bitsy," Maddie said when she recovered from her astonishment. Last she'd heard, Bitsy had been working at the Marriot in downtown Portland as an assistant housekeeper.

"Hey," Bitsy said without enthusiasm.

"The commissioner in?"

"Yeah. Come in. She's with her husband." She led Maddie through a high-ceilinged hallway, past a huge, empty kitchen, and out into a glassed-in porch that overlooked a patio. The handsomely designed patio pavers were the same as those used in the driveway. Someone had to keep all those blocks weeded. Tall ceramic urns had not yet been planted with the non-native flowers Cate allowed herself. There were nice benches and chairs. Cedar.

Bitsy pointed to a flowered lounge chair. "Have a seat. Want coffee?"

"Sure. How you doing, Bits?"

"Fine. Back in a sec."

She was. The coffee, black and thick the way Maddie liked it, steamed on the cool air.

"Been here long?" Maddie took an appreciative sip.

"'Bout a week. I'm filling in for the housekeeper. I'll go get Mrs. Bjork for you." And she whisked from sight.

Maddie blinked and settled back to enjoy her coffee. She supposed Bitsy wasn't in the mood for a good talk. There were low terra-cotta trays of narcissi and jonquils set out on the glass-topped tables scattered around the porch. That was called forcing. Maddie

wondered whether camas could be forced. Apart from the flowers, there was no sign of life in the bright room, certainly no mess of living. It was quiet. The minutes stretched.

At last Bitsy returned. "More coffee?"

"No, thanks. What's the problem?"

"The mister's being difficult today."

"Isn't there a care-giver?"

"Yeah. She's resting. He was bad last night, too." Bitsy heaved a sigh. "Look, Maddie, it ain't a good time for a visit. Why don't you come back some other day? And, uh, call first, huh?"

Maddie got up and handed her cousin the cup, which was a pretty stoneware mug. "Sure. Talk at you later."

Bitsy showed her to the door. As Maddie drove off it struck her as odd that her cousin was "filling in," and that one care-giver was on duty day and night with only Cate Bjork to spell her. The Bjorks couldn't be having serious money problems, not in a house like this one. Maybe the commissioner had trouble keeping hired help.

Maddie regained the county road without incident. As she drove back to Two Falls she thought about the house. She liked the design, much more than she'd liked the McCormicks' new house. She'd seen very little of the Bjorks' interior, but she'd seen enough to know that two people would be lost in a place that size, isolated from each other and from the world, even with servants in residence. It was a house that didn't make sense.

What could justify it? If the Bjorks entertained large numbers, twenty or thirty people at a time, with some of them spending the night. If they had five children, eighteen grandchildren, and two old grannies to shelter. If they wanted to turn the house into a B&B. Maddie tried to remember whether Cate had entertained widely before the election, before her husband became ill, but nothing came to mind, which meant she hadn't entertained many local people. Maybe the house was symbolic. That, at least, was not an alien concept.

Maddie thought of the longhouses—lodges, so called—of the Klalos and other tribes in the area. They, too, had been very large, though not as large as the Bjork mansion. They had housed small

villages. Within larger villages, they had housed kin-groups, with the totem of the clan standing proudly outside in the rain.

Nobody wanted to live crammed together like that now. *Maddie* didn't. She liked her privacy. Still, she could imagine how intense the ties would have been among the people living in a longhouse, how secure a child or an elder would have felt in the enveloping busyness and warmth. She smiled to herself. And how many petty quarrels would have flared around the cook fire at the heart of things.

Beth managed to gather herself together by the time the county prosecutor, Ellen Koop, then Lt. Prentiss and Rob showed up to talk over the evidence and decide what could be released to the press and what could not. Meg had dropped by earlier on her way to the library, bringing a fresh batch of cookies, and Dany had made a big pot of coffee, so Beth didn't have to lift a hostessy finger. She spent the time worrying.

Ellen came first. A stocky woman about ten years younger than Beth, Ellen had battled her way to the top in the prosecutor's office after five futile years in a big Portland law firm. She was smart, disillusioned, and very successful. Like Mack, she was a shoo-in at election time. Her conviction rate was high, because she was careful not to prosecute unless she had solid, untainted evidence to back her up. Between Mack, with Rob's able help, and Ellen, Latouche County had an enviable conviction rate.

Dany showed Ellen to a seat on one of Hazel Guthrie's uninteresting sofas and whisked from the room.

For a short while they made polite conversation. Ellen asked about Peggy, commiserated again about Mack, and hoped that Beth's leg was healing properly. "Can't be too careful about broken bones at our age."

That was kind. "As far as I know, my leg is okay. It hurts a little, but that's to be expected. How's Reg?"

Reg was Ellen's husband, an organic farmer who did well with pesticide-free apples and peaches. He also raised llamas for comic relief. Or so Ellen always said.

"Do you know what that madman wants to do?" Ellen demanded, interrupting a polite llama query.

The doorbell rang. Since nobody regarded Reg as other than massively sane, Beth gathered that Ellen meant Rob.

"He just wants me to give a brief press conference. There are bound to be rumors floating around about Inger's death."

"Oh, my dear," Ellen said, pitying her.

Forestalling explanation, Lt. Prentiss entered, followed by Rob. Prentiss was scowling, Rob impassive. He had abandoned the blue sling. He gave the two women a nod of greeting and leaned on the tall-backed chair. Prentiss sat on a straight chair by Beth's recliner and glowered. His close-cut mustache twitched.

"What's happening?" Beth asked with resignation.

Ellen and Prentiss spoke together, looked at each other, and fell silent.

Rob said, "I'm sorry to seem mysterious, Beth. A bunch of information came in since I talked to you. I asked Judge Rosen to issue an arrest warrant, and Ellen and Ed think I've jumped the gun."

Arrest warrant? He couldn't mean for Larry Swets. "For Matt Akers?"

"No." He squared his shoulders. "I intend to arrest Catherine Bjork for the murder of Inger Swets."

IT WAS DUSK, almost five, before Rob was ready to move against Catherine Bjork, and only then because Beth and Ellen came around to his way of thinking. Though he had no reason to fear for Lars's safety, he had been feeling stirrings of alarm since Kayla told him that Cate had fired another care-giver.

He'd verified that, and Linda had secured proof that the three care-givers' numbers appeared repeatedly on Inger's phone records, including the ones listed on the morning of the mudslide and, very early, on the morning of her own death. And Inger had called the commissioner from the courthouse using Cate's landline, right after the interview in Rob's office. Prentiss kept insisting there could be an innocent explanation. Rob didn't think so. Neither did Judge Rosen, fortunately, or, with reservations, Ellen and Beth.

To his credit, Prentiss cooperated once the decision was made to act that afternoon instead of waiting for Tuesday morning and fuller results from toxicology. A state patrol car sat at the intersection of County Road 2 and Highway 14, and Prentiss had also alerted cars patrolling the highway east and west of the intersection.

Because he would be coordinating things from a patrol car, Rob called on Jake to drive him again, and deployed two other county cars along Highway 14. He stationed a car just north of the entrance to the Bjorks' private road.

Jake had pulled over onto the shoulder near the intersection of the two roads, and Rob was about to give the signal to move, when his cell phone rang. The radio crackled, alive with voices. When he

saw that his caller was Maddie Thomas, Rob stuck his finger in his left ear and slammed the phone against the right.

"What is it, Maddie?"

"Something weird is going on with Commissioner Bjork," Maddie said.

No shit. Rob opened his mouth to interrupt, but she went on, "I just had a call from my cousin Bitsy. She's working out there."

"Where?"

"At the Bjork place. She's the temporary housekeeper."

Rob sat up straight. "Yeah?"

"She says Cate Bjork left in the BMW more than half an hour ago with her husband and a couple of suitcases. Didn't say why, didn't say anything. And listen, Cate just drove through Two Falls with her pedal to the metal. I saw her car. Damned near ran into old Mrs. Ritchie's pickup at the light—"

"*Thank* you, Maddie. That's great information. Gotta go." He broke the connection and patched through to Prentiss, who responded immediately. To Rob's surprise, Prentiss was talking from a patrol car about halfway to Two Falls. He said he'd head east to the bridge. He was a hands-on kind of guy.

Jake revved the engine.

Rob jabbed his finger east. "Go. Fast. She's beyond Two Falls. Lights. Siren when you need it."

As the car rocketed onto the state highway, Rob saw another state car pull out ahead of them. "Forget the siren and lights. Follow the state car."

"Aw." Jake let it go at that. He knew better than to indulge in conversation.

The other car was moving fast, and Jake hung on its tailpipe while Rob tried to straighten things out. If they'd moved an hour earlier…He didn't waste time fuming. There was no point cluttering up the road with four county cars, so he told three of them to stand down and directed the fourth to hang out at Two Falls, in case Cate changed her mind and turned back to take the other route to Interstate 84, crossing the Bridge of the Gods.

It wasn't likely. She had chosen to go east. That meant she could

speed on to Biggs Junction, where US 97 headed north past Gold-endale to Yakima and a sizeable airport, or south to Bend, Oregon. But US 97 was a slow road. More likely, she would cross the Hood River Bridge and turn back toward Portland on the Oregon side. That bridge was closer to her house by a good twenty miles than the Bridge of the Gods and much closer than the bridge at Biggs Junction.

If she didn't know she was being followed, she would sail across, hop onto Interstate 84, and imagine she was home free. She wouldn't be. The Oregon police would stop her, but he would save a whole lot of paperwork if he could prevent her from crossing into another state.

Rob decided to keep the chase as inconspicuous as possible. No lights, no sirens. Yet. Then he asked the Oregon police to close the Hood River Bridge. They didn't like the idea of hot pursuit across a two-lane bridge, with innocent citizens crossing both ways, any better than he did. They promised to close the span at the toll gate. Rob set about closing it at the other end. Prentiss assured him that would be done. Jake and the state cop ahead of him, already doing eighty, picked up speed as the cars passed Two Falls.

Rob closed his eyes and tried to visualize the Hood River Bridge. The exercise led him to his obvious omission. He called Hood River County and asked for a patrol boat on the Columbia. He also asked Prentiss to send a boat out to watch the Washington side. Prentiss suggested asking the Yakama to alert their fisheries boat, too, and promised to warn river traffic. Rob thought of poor, miserable Larry Swets.

They sped on in the deepening gloom. He was glad of the darkness only because Cate was less likely to notice the unusual number of cop cars on the highway. It wasn't raining, one small blessing. He thought of the steel grate surface of the bridge on which a driver could lose control in wet weather. Not for nothing was the speed limit on the bridge twenty-five miles per hour.

"We missed her. She's nearing the bridge." Prentiss, sounding stressed.

"Anybody else?" Rob meant another vehicle.

"Looks like one set of lights coming this way, about a quarter of the way across."

"Shit." Rob wished he could see exactly where the cars were. Jake and the state cop ahead sped up.

"I'm going after her," Prentiss said.

"Wait! No!"

Goddamn cowboy. Prentiss had to be in the pursuit car. His driver had hit the siren. Maybe he couldn't hear.

Rob could, unfortunately.

Prentiss was shouting something at his driver. After a few seconds of loud confusion, he came back on, breathless. "Dammit, she turned right at the light without stopping, and she's speeding up. She's on the bridge!"

Jake and the other state car rounded the last curve and screamed onto the straightaway that led to the stoplight at the bridge turnoff. The town of Bingen lay about a mile further on. Rob could see the pursuing patrol car and what had to be the BMW. A car was still coming from the Oregon side. He thought it was slowing.

"Stop!" Rob yelled and braced himself as Jake stood on the brakes. Tires screamed and the rear end fishtailed. At least the airbags didn't deploy.

To the right lay the Heritage Park, a county park-and-ride lot, and just before it, the intertribal fishing area with its RV lot lit by a pinkish glow. Half a dozen fishermen stood gawking up at the drama on the bridge.

"Down there," Rob said, pointing to the RV lot. He thought the Yakama boat, or even the county boat, might pull up by the boat launch.

Jake bounced the patrol car across the train tracks and crawled down to the lot. Rob jumped out, stood by the open window, where he could hear the radio, and kept his eyes on the bridge.

The oncoming car had stopped. From the height of its headlights Rob thought it was probably a big pickup. He hoped so. Unlike the Bridge of the Gods, this span was low, and the guardrails were not much of a barrier between a small car and all that cold water. The wind gusted, and whitecaps glittered in the erratic light.

Prentiss roared at his driver. Rob could see that both Prentiss's car and the BMW were swerving on the slick steel grate. The patrol car moved into the left lane, then fell back just short of ramming the pickup head-on. The BMW and the patrol car must have grazed the truck. Both sped on in a flurry of sparks. The pickup's headlights rocked with the impact. Then its lights steadied and it began to move toward the Washington shore. The driver accelerated rapidly. Who could blame him?

"Hey, this is tribal land, guys." A voice beside him, curious rather than hostile, and a bulky presence.

Rob nodded, eyes on the bridge. "Have they launched the Yakama boat yet?"

"Friend downriver said they did. County boat's tied up at the pier."

"Where?"

The fisherman pointed. "Over there."

Rob dropped the microphone and ran for the longer pier, which stuck out into the river. Jake shouted something after him, but Rob was too late. The boat was well out into the river by the time he reached the mooring. He stared after it, panting a little, then ran back to the car. Prentiss's voice was still coming over the radio, calmer as they neared the other side and the toll booth where, it was to be hoped, Oregon patrol cars waited.

"We have her boxed," Prentiss was saying. "Slowing. Right. Keep...oh, Christ, she's turning!" Another flurry of disconnected noise. Then Prentiss gave a howl. "She got by us. She's going back. Get ready to take her! I won't pursue."

That was a good decision. Savagely, Rob wished Prentiss had made it sooner. He strapped himself in. "Let's go to—" He broke off, staring in horror. He could see the BMW's lights, moving rapidly toward the high drawbridge section, which gleamed like a child's Erector Set toy over the ship channel.

He and Jake watched in silence. The radio crackled. At the last moment, just before the car reached the rhomboid drawbridge, it sailed up and out over the western guardrail, the downriver side. The front end hit with a heavy splash, and the BMW floated briefly.

The headlights dimmed. Then the car sank out of sight beneath the water.

Almost at once he could see the wakes of two boats heading for a point downstream from where the car had disappeared. He shook his head, disbelieving. Voices squawked on the radio, and Jake let out something like a sob. The fishermen in the RV lot ran to the river bank.

—————

As the minutes stretched, Maddie grew more and more angry with Rob for cutting her off. Or rather, since she knew he was involved with the case, angry with him for not getting back to her. She had seen the patrol cars as they whizzed through Two Falls, so she knew something was up. Jack was watching the sports news. After a while he clicked the remote, and the screen blanked.

He stood up in stages. His knees hurt these days. "Come on."

Maddie got her jacket and cell phone.

They drove east without talking, and Maddie's mind drifted. Had the cops intended to arrest the commissioner? Why? Both a state and a county patrol car had passed through Two Falls, so Prentiss was involved. Perhaps Cate had induced Inger to remove the hazard warning, but why? Wasn't it more likely that *Fred* had used Inger?

She shook her head. Such speculation was foolish. It was better to think about things that made sense. Like the casino.

"There goes the Yakama boat," Jack said.

Maddie couldn't tell one boat from another at this distance and wondered that Jack could. "Why would they be out?"

Jack didn't know so he didn't say anything, one of his many good traits. The boat was really moving. They followed it upriver at pretty much the same rate of speed.

Maddie didn't have to point Jack to the tribal fishing area. He jounced down across the tracks as the county patrol car turned to leave the lot. It stopped. So did Jack. He and Maddie got out when Rob did.

"What happened?" she asked without the usual ceremony of greeting.

He stared at her.

Behind her, abruptly, a train hooted its approach. The track followed the river all the way down to Vancouver. Freights, and one passenger train a day, passed through the Gorge towns at the rate of one every few hours, so the sound was familiar. Tonight it made her jump nearly out of her skin. It neared and hooted louder, then passed them. The music dopplered down.

"Oh man, Jack, that car just *dived* into the river!" Jack's cousin Dave from Wishram. Dave was shouting as the train rattled past.

Jack rumbled a reply.

Maddie kept her eyes on Rob. He looked like a man who had seen a ghost.

"Chief Thomas," he said into the sudden silence, "thank you for your cooperation."

"You lost her." She didn't mean to sound accusing.

He nodded.

"State car chased her," Dave said. "All the way across. Then she turned around and come back. *Dived* off the bridge. Didn't slow at all."

"Guys in wetsuits got one body out," somebody else said. "Man, they were quick. Didn't take fifteen minutes."

"In the dark?" Maddie squinted out at the silent river but couldn't see much. The lights from a cluster of boats bobbed on the water. The Yakama boat joined them, going slow now.

"Must've had a grapple on her. It's shallower there."

A jumble of voices wanted to tell Maddie all about it. She kept her eyes on Rob.

Beside her, Jack shifted from foot to foot. She could always read his mood. At last he said, "Somebody says they found one body."

Rob shut his eyes, opened them. "Yeah, the commissioner's. They're looking for her husband."

Jack considered that, taking his time. "I seen the car when it went through Two Falls. There was just the driver."

Rob's eyebrows snapped together. He stared as if he wanted to see into Jack's head. "Are you saying she didn't have a passenger?"

"Just her in the car."

"You're sure."

Jack brooded, eyes veiled. "Yeah, unless somebody was lying down in back or something. Nobody in the passenger seat. I looked hard. She was speeding."

He had sharp vision. Maddie hadn't seen the driver, just the car.

Rob nodded and touched his arm. "Thanks." He went back to the county car and got in. They could hear him working the radio, talking to that state cop Prentiss.

Maddie turned to Dave. "Tell me about it." And Dave did.

Jack moved the pickup down beside Dave's. Somebody brought a folding lawn chair for Maddie, and maybe half a dozen fishermen gathered around while Dave told the story. They kept pitching in, so it was a little confusing.

Maddie thought the state cops had screwed up. They shouldn't have chased the woman. If they hadn't, the Oregon police could have taken her in without fuss, without tragedy. Maddie disapproved of high-speed chases. There was too much room for collateral damage. She wanted to extend her sympathy to the driver of the oncoming pickup. He was a victim who would never be called a victim, but she would not have had his nightmares for anything.

As Dave drew the tale to a close, Maddie saw Rob get out of the county car. He looked grim but less stunned than when she'd first spoken to him.

He walked slowly over to the cluster of fishermen around Maddie and waited until Dave had finished. "Jack, I need to talk to you."

She watched her husband walk off to speak with Rob privately. They talked a long time. Maddie's court dispersed. They were drinking beer now and repeating themselves, telling each other what they had all seen. She didn't know what to think, for once, and sat brooding in her lawn chair.

At last Rob got into the county car. It drove off. Jack came over to her.

"What's happening?"

"Rob thinks she shoved the old guy out of the car somewhere

along County Road 2. Search party at sunup." After a moment, he added, "He wants me."

Maddie didn't doubt that. She wondered whether Lars had been alive when he was abandoned. "Let's go home."

They did. She didn't think the fishermen would be in any condition to join in the search the next morning.

———

Meg fixed chili, her infinitely postponeable meal, because she thought Rob would not make it home before midnight. However, he showed up around nine, looking sick, and gave her a terse account of Catherine Bjork's death while she dished up his chili and sliced his bread. She was shocked and said so.

He didn't reply.

"Prentiss killed that woman."

He stared at her over a spoonful of chili, his eyes very dark gray. "She killed herself."

"If he hadn't chased her—"

"Let it go, Meg." From the weary disgust in his voice she knew he agreed with her, so she said nothing. She supposed state patrol officers must have a primitive attachment to high-speed chases, given the nature of their experience with speeders. She did not know Lt. Prentiss. She could only hope he felt remorse. It was obvious that Rob did, along with guilt and anger and other less well-defined emotions.

She thought about Catherine Bjork, or tried to. It was hard to imagine all that brittle energy snuffed out, but if she had murdered Inger and Fred Drinkwater, as Rob seemed to believe...

A sharp rap at the kitchen door interrupted her reflections. It was Charlie.

He let himself in, looking a little sheepish.

"Late for a social call, isn't it?" Rob sounded sour. She was tempted to smack him.

Charlie sat down opposite his cousin.

"Come to gloat?" That was just plain vicious. She stared at Rob. He didn't meet her eyes.

Charlie frowned. "Gloat about what?"

Meg said, "There are developments, Charlie. Catherine Bjork is dead." She explained, and Charlie expressed shock. While she talked Rob ate mechanically. Load spoon, stuff in mouth, swallow.

As she wound down, he shoved his bowl back. "Thanks, Meg. I'm going upstairs to phone Beth. She wants a report. It'll take a while. Good night, Charlie."

Meg said, "Sit back down and shut up, Robert. You feel rotten. Don't take it out on your cousin. Or on me," she added as he opened his mouth to respond.

Charlie, looking uncomfortable but determined, drew a sheaf of papers from his jacket. "I just came from the hospital. They finally let me see Larry Swets."

Rob shifted in his chair. "You helped Meg. I ought to thank you for that."

Charlie shrugged. "No thanks necessary. By the time I got to Larry this morning, he'd already…well, he wasn't in his right mind. He gave me these, told me to give them to you."

"So why didn't you?"

"Rob—"

"It's okay, Meg." Charlie's chair creaked. "That's a legitimate question. I read them. The thing is, they're personal. Larry's judgment was impaired. I wanted to make sure he hadn't changed his mind."

"Concealing evidence," Rob snarled.

"I'm not sure they are evidence. Well, they are, but evidence of what?"

"I'm the best judge of that."

"Maybe," Charlie acknowledged. "But Larry's wife wrote them. I talked to him. He seems to think Mrs. Swets had a lover, that she quarreled with the man, and that he killed her. Larry wants you to arrest the killer, only there's no way of telling who the guy was from these papers. And he…Larry could be wrong. I wanted to discuss them with the poor bastard, in case he had second thoughts."

Rob stared. "You don't think like a cop."

"Nope," Charlie said cheerfully. "I'm not a cop. I'm also not a Neill."

Meg held her breath.

The corners of Rob's mouth twitched. He didn't smile, but the steam went out of him. "I take your point." It was not quite an apology.

He held out his hand, and Charlie gave him the sheets. They were ordinary copy paper of the sort used in most computers, but they looked as if they had been crumpled and then smoothed and refolded. She could see scrawled handwriting. She remembered that Lt. Prentiss had confiscated Inger's personal computer.

Meg wondered whether there was a bit of Red Label left in the bottle she had bought the day she arrived in Klalo last October. Since she met Rob she had been drinking single malt. She went to her liquor cupboard and rummaged while Rob read. Charlie sat very still.

Chapter 20

KAYLA CALLED CHARLIE at midnight, fired up, demanding to be taken back to the hospital Tuesday morning.

"No. Can't do it. Sorry." He didn't sound sorry.

"But I've got to leave."

"Have your mother drive you."

"I want *you* to drive me." She had quarreled with Dede again. Dede was down in the bar, probably complaining to her husband on her cell phone.

Silence. She heard him inhale. "I can't take you this morning. I have an eight o'clock class." That meant he'd leave Klalo at six.

"So?"

"So. I don't get back until five, and I teach a class here in Klalo after that. I'll drive you to the hospital Wednesday."

"But I want to go this morning, and I won't ride with my mother."

"She loves you, Kayla."

"No, she doesn't. She loves Señor Marquez."

"She has a lot of love in her."

Kayla choked on a sob. "I thought *you* loved me."

Long silence. At last he said, "I do. But there are times when I don't like you very much. Shall I tell you about Commissioner Bjork's death?"

"What? Oh no!"

He told her. His account was brief but horrible. Questions rose in her mind like bubbles that burst on a new surface of awareness. Charlie was very sad and very tired.

Kayla swallowed. Her jaw ached. "Charlie?"

"What is it?"

"I don't need to go back tomorrow. Really. I can stand another day of Mother if I have to. If not, I'll make her drive me to Portland. You get some sleep. I'll call you tomorrow between classes."

They didn't talk long after that but his voice warmed. Even so, when she hung up, Kayla was shivering, and not just from the tale he had told. It was time to think hard about Charlie O'Neill. She had been putting that off.

Jake Sorenson, heavy-eyed but game, showed up at six A.M. in a clean Jeep patrol car. He had volunteered for the search in spite of his long stint the day before, and Rob took him at his word. Rob was ready, wearing boots and a hooded jacket with gloves tucked in one pocket and his cell phone in the other. Meg didn't twitch when he left. He'd made himself drink a cup of coffee and eat half of a rather dry bagel. Then he poured the rest of the coffee into a Thermos. It was going to be a long, miserable morning.

Ed Prentiss was off supervising the raising of Cate Bjork's car. He was afraid they would find Lars's body in the trunk or the back seat. Rob didn't think so.

He and Jake rendezvoused with Jack Redfern and two vans full of search and rescue people at the Bjork mansion before seven. Sunrise came at six-forty-five, but it was fairly light out by six-thirty. A heavy, fortyish woman, whom Jack introduced as Bitsy Thomas, gave them a pair of pajamas Lars had worn. Search and Rescue had brought the two dogs, who looked more enthusiastic than the human searchers.

Rob thanked the S and R team for coming and gave them a description of Lars. He asked Bitsy what the elderly man had been wearing.

She cocked her head, unsmiling. "I didn't look close. Gray slacks, I think, blue cardigan, dark blue anorak—nylon with a hood. Not a warm jacket. Want me to make coffee?"

Rob looked at Bat Quinn.

Bat beamed at Bitsy. "We brought our own, thanks. You're Leroy Thomas's mom, aren't you? Nice kid."

Her features relaxed in a slight smile. "Lee's a pill, Mr. Quinn, and we both know it."

Quinn patted her arm. "He'll be all right."

She sighed. "He will be when he's done growing up. Good luck with the search. The mister's a sick old man. Hope you find him."

Quinn was methodical. He sent one team through the woods around the house, although it wasn't likely that Cate had put her husband out of the car that soon. The other team, with the two dogs, set out to cover both sides of County Road 2, working south from the Bjorks' private road.

The previous evening when Rob set up the search, he had told Bat of Cate Bjork's flight, that there hadn't been time for her to take her husband very far off the road herself, though he might well have wandered. Rob had also explained the need for haste. That was redundant. It had chilled to forty-two degrees during the night, snowed at higher elevations. At least it wasn't raining now. Although Jake was eager to join the search, too, Rob posted him at the mansion to relay information as needed. Rob left him drinking a mug of Ms. Thomas's coffee.

While all this was going on, Jack stood quiet in the background. As the searchers went off, whooping and calling back and forth, the dogs giving a yelp or two from sheer exuberance, Rob turned to Jack.

"I'll go with you, if you don't mind."

"Okay."

"I might learn something."

Jack nodded. He never did say much.

To Rob's surprise, Jack got back into the pickup. He waited for Rob to join him, drove past the searchers, then speeded up. They rode in silence. At last Jack pulled over at a narrow lane that led off to the right. He set the brake and killed the engine.

Rob looked at him.

"She was an edgy woman. No patience. And she was in a hurry."

Rob digested that. "If he was giving her trouble—"

"Asking questions," Jack interposed. "Or the same question a couple of times. They do that."

"You think she would have put up with it about this far?"

"Maybe a bit farther, but this is the first likely place."

They got out carefully and stood on the edge of the asphalt surface. The sun shone through a thin layer of cloud. The morning shadows were long and black.

A few cars whizzed past, people on the way to work in Hood River or The Dalles or even Portland, but there was little traffic. Few families lived out this way.

Jack knelt down, grimaced, and squinted at the lane that led into the woods. "Old log road. Couple of summer trailers in there. Nobody home now."

"No mailboxes," Rob said.

Jack smiled. "Maybe you're not so dumb."

"Thanks a lot."

Jack chuckled and forced himself upright. "Reckon she didn't pull in here."

"Should we call his name?"

"No point." He got back in the pickup, and Rob followed suit.

Jack spent maybe ten minutes at the next pullover, a wide space at the edge of the forest that had once been graveled. At last he said a vehicle had stopped there recently, but he could see no sign that anyone had got out. Rob pointed to broken twigs and bent grasses in the undergrowth.

"Deer." Jack indicated the obvious deer sign, neat little turds in the grass.

Rob said ruefully, "Well, I did spot the beer cans in the ditch."

They stopped twice more without finding sign of human intruders.

"Maybe she was calmer than I thought," Jack said.

"We passed a couple of roads going off on the other side of the highway."

"Naw. She wouldn't turn around for nothing. Not her."

Rob thought he was right. It was eerie, trying to think like a dead woman. They drove perhaps five minutes longer. Then Jack

pulled over at another overgrown logging road. He climbed down stiffly.

Almost at once Rob saw that a car—not a big-tire pickup—had stopped and that someone had got out, more than one someone. The footprints scuffed and overlapped. When the vehicle left, it had peeled out, the tires digging into the soft brown dirt, spraying gravel. That was what Rob saw. He thought Jack saw a lot more.

"Now here's something," Jack said softly. He headed down the overgrown road, bent over. After a brief hesitation, Rob followed him, walking on the grass at the edge more from police instinct than because preserving the scene would do any good. If there was a crime, the perpetrator was dead.

At last, long out of sight of the pickup, Jack straightened and looked around. "You can call him now."

Rob shut his eyes and took a deep breath. "Lars!" he yelled. "Lars Bjork! Where are you?"

Jack raised his hand for silence. They listened. Nothing. Jack nodded, and Rob called again as loud as he could. He thought he heard something off to the right.

Jack held his arm. "One more time."

So Rob shouted again. The sound was more definite this time, something between a groan and a whimper.

Jack trotted along a rough track through the brush, skirting a blackberry patch, with Rob at his heels.

They found Lars Bjork lying beneath a huge old-growth cedar on a thick bed of needles. His hands and face were scratched and bloody, and he had lost a shoe. His eyes fluttered open when they called him, but he didn't say anything. At least he was alive.

"Better give me your jacket. He's damn cold." Jack shrugged out of his own coat.

Rob removed the cell phone from his pocket and handed Jack his parka. Cold bit through his shirt.

He tried the phone. "Goddamn, no signal."

"Go back to the truck and try from there. Keys in the ignition if you need 'em." Jack was bundling the old man into his jacket. "Hey there, Lars."

Lars moaned. Jack wrapped Rob's coat around Lars's legs.

Rob started to walk off.

"Other way." Jack smiled.

Rob found the road and half walked, half ran back on the weedy surface. His arm was sore and his back hurt, and he felt great. Twice he stopped to try the phone, to no avail. When he reached the pickup, he finally got a signal. Jake responded immediately. He promised to send the EMTs at once and call off the search.

"Where are you?"

By that time Rob was pretty sure Jack Redfern walked on water. He yanked the door of the pickup open and peered at the odometer. Sure enough, Jack had set it to zero when he left the mansion. Rob gave exact directions, indicating that a four-wheel-drive ambulance could probably negotiate the logging road, and signed off. He rummaged around behind the seat and found a thermal blanket and a wooly scarf with a pattern of bright flowers. He even remembered his coffee flask. Then he went back to Jack and the man Jack had saved.

The mystery of Inger's "suicide note" began to unravel that morning.

Rob reached his office before ten to find the courthouse under press siege. Beth had drawn up a fact sheet for them that was not only clear and well-worded but properly punctuated. Her husband had had an unaccountable fondness for random commas. After she directed Sgt. Howell to hand the sheet out and promise them a two o'clock press conference, the reporters took themselves off for breakfast at Mona's.

Rob called Meg at the library to give her the good news about Lars.

"I hope you thanked Jack."

"Good God, Meg." What did she think he was?

"I'm going to ring Charlie. His first class let out at nine-thirty." "Why?"

"It may have escaped your attention," she said with elaborate patience, "but your cousin feels some responsibility here. When

you leave him out of the loop he's hurt." She was, too. She didn't have to say that.

"Give him my best," Rob said crossly. He knew he was going to have to build bridges and didn't look forward to the prospect.

He had time for a short phone conversation with Larry Swets and a longer one with Karl Tergeson before Ed Prentiss showed up.

Rob shoved copies of Inger's papers at Prentiss. No way was he going to let the originals out of his hands. No way was he going to say anything about Prentiss's disastrous conduct of the high-speed chase.

"What's this?" Prentiss sounded glum but not hostile.

Rob explained.

"Your cousin—"

"My cousin went to Meg's assistance. Larry gave him the papers. Charlie read them, decided they were personal, and waited to talk them over with Larry."

"Personal!"

"I got them late last night. There they are. I gave them to you as soon as I could."

"Yeah, okay, I didn't mean to criticize." He cleared his throat. "I hear you found the old man this morning. Congratulations."

"Jack Redfern found him."

"Oh, yeah, the chief's husband."

Rob wondered whether Jack minded being known as somebody's husband. Probably not. He waited while Prentiss deciphered Inger's scrawls.

At last he shook his head. "What are they?"

"Rough drafts?" The papers involved a lot of repetition.

Prentiss stared.

"Larry said he found them in Inger's wastebasket. In her home office. That note in Inger's track suit—"

"The suicide note."

It *would* have been like Inger to write several drafts even of a suicide note. She was not wonderfully spontaneous.

Rob said, "I don't think it was a suicide note. It was a letter to

Cate Bjork that Inger never delivered. Cate killed her and over-
looked the letter when she dragged Inger's body to the river."

"You're making a lot of assumptions."

"Yes. I think Inger was dead when she went into the water."

"That's what they tell me. Not much water in the lungs." There
would have been other, subtler signs that Inger did not die by
drowning.

Rob waited.

Prentiss heaved a sigh. He did not want to give up his suicide
theory. "And the note was zipped into a pants pocket, not in the
jacket." Easy for Cate to overlook in the heat of the moment.

"Have the techs been able to read it?"

Prentiss reached into an inner pocket of his uniform jacket.
"See what you make of it." He, too, had a photocopy.

The note had been written by hand, fortunately with a ballpoint
pen. It was blotched and blurred, pieces of it were missing entire-
ly, and there was no salutation. Rob could see why Prentiss had
imagined it was a suicide note. It was clear that Inger felt anger
and an enormous sense of betrayal. "After all we had together," it
said. That phrase had been repeated in all three pages of the rough
drafts. "…did it to please you." Another repeated phrase.

"How long did Inger Swets know the commissioner?" Prentiss
didn't say Cate's name. Couldn't, probably. Cate was *his* victim.

"They were introduced more than five years ago, right after the
Bjorks moved to Latouche County. I called Larry this morning. He
said he and Inger had been asked to parties at the Bjork mansion.
He went with her the first time. He was pretty sure Inger spent
time with the Bjorks when he was out of town, especially in the
first year or so after they moved here. He knew she was bored, glad
she had interesting new friends."

"But the friendship cooled down?"

"Apparently. Drinkwater hung out with the Bjorks, too. Lars
was an investor."

"Nice. Cozy. Were they having an affair?"

"Who?"

"Inger Swets and Fred Drinkwater," Prentiss said impatiently,
"or Inger and Fred and Mrs. Bjork. A threesome."

Rob stood up and went to his window for a good look at the parking lot. Beth had a better view. "I don't know what the relationships were. I think, whatever they were, that Inger had a lot more emotion invested than Cate Bjork did. Especially at first."

"You think she was a dyke?"

Rob looked at him.

Prentiss made an impatient gesture. "A lesbian. Forgive me."

"It's possible, of course. It's also possible that Inger hero-worshipped Cate. That's a strong emotion, too."

"Well, yeah."

"Inger was a beautiful woman and used to the idea, but Cate was a lot of things Inger couldn't be—classy, fashionable, used to moving among the rich and powerful. Cate was sophisticated. Inger was a frustrated small-town girl. True, she had a locally powerful job, but how many kids want to grow up to be county clerk?"

Prentiss snorted.

"I'll tell you how I think it came down."

"Do that."

"I think Cate included Inger in her social circle, introduced her to out-of-town visitors here for the scenery or skiing or windsurfing. She and Inger ran together. Who knows, it may have been Inger who suggested that Cate stand for the vacant commissioner's seat, though I'm guessing that was Cate's idea. At any rate, all that attention probably went to Inger's head. I think, and this is a guess, that Cate had a long-term, not very passionate relationship with Fred Drinkwater, with or without her husband's knowledge, but that Fred and Lars were *cronies*. When the time came to put the Prune Hill development through the mill, to get approval from the Board of Commissioners, I think Lars asked Inger to substitute the favorable geological survey in place of the one the WSU team filed with the state."

"Lars."

"It was a couple of years ago. He was only diagnosed with Alzheimer's last year."

"Okay. I guess."

"Or it could have been Fred who asked. But it was not Cate Bjork."

"But Inger thought that was what Cate wanted?"

"Yes." Both of them sat silent, Rob thinking of Inger as she had appeared there in his office only a few days before, magnificently scornful.

Prentiss shook his head. "A damned waste."

Rob nodded. "It wouldn't have been easy for Inger to bring herself to switch the two surveys. I don't think she would have gone against her father's principles for money. Karl is all kinds of fool, but he's an honest man, and he and Inger were close."

" 'I did it to please you.' " Prentiss murmured Inger's words half under his breath. "Yeah, okay. She did what she thought the woman wanted. It was a misunderstanding."

"None of them expected that hill to slide."

"Your cousin did."

Charlie and his supervisor and the rest of the survey team. A fair number of exceptions. "You know how it is, Ed. People who build on scenic land or hazardous land think the regulations are there to inconvenience them. Even people who value the environment."

"Depends on whose ox is being gored?"

"That's right. Fred didn't think Prune Hill would collapse onto his kitschy mansions. Lars...well, who knows what he thought? Even Inger probably thought it was unlikely. When it happened, though, it shocked her and Fred to the core. It shocked Cate, too. I think she only found out that the hazard warning had been suppressed when she got her husband's power of attorney. At that point Fred probably confided in her."

"A year ago."

"Give or take."

"So she held her breath and hoped it wouldn't happen."

"That's my guess."

Prentiss winced at the word *guess*, and Rob didn't blame him.

"Think about the way she used the care-givers' telephones."

"She was protecting her ass."

"Minimizing her connections with Fred and Inger. When Prune Hill did slide," Rob went on, "she was furious with Fred and

furious with Inger. They consulted, the three of them, because all three were smart enough to know they were going to be in deep trouble."

"You know that because of the phone records."

"Yes. Fred went out twice the day of the mudslide. We may be able to find out where they met."

"Maybe." Prentiss sounded doubtful.

Rob added, with more confidence than he felt, "The last meeting was at Fred's house at Tyee Lake. I don't know that Inger was even there. Probably, but if not, it wouldn't have taken genius for her to figure out the next day that Cate had killed him. Inger probably even knew how she did it."

"And felt threatened."

"Threatened and conflicted. Inger loved her father, but she'd betrayed him."

"Yeah, your Board of Commissioners is in deep shit." The muscle by Prentiss's left eye twitched. "I guess I don't see a little woman like the commissioner taking out two big, aggressive victims."

"Christ, Ed, she *taught* martial arts. The real question is not whether she could do it but why."

Prentiss blinked. He'd been investigating Inger, but he must not have found her ties to the Bjorks interesting. He would have been looking at Drinkwater, not Cate.

Rob gave him a brief summary of Cate Bjork's background.

"So she taught classes at UC Santa Barbara."

"As an adjunct. The pay was lousy. After her first husband OD'd, she must have decided she'd be better off working as a personal trainer than struggling along as a grad student." Rob felt a stab of shame. He hadn't been kind to Charlie, who'd been in the same straits. Charlie hadn't asked for help. Rob felt sure Cate hadn't either. The experience had turned her in on herself. Charlie reached out, an important difference.

"So she taught martial arts."

"Self-defense for women. Comes to the same thing."

"She turned herself into a personal trainer, found this rich man, sank her hooks into him, and never looked back."

"I think she gave him his money's worth."

"Until last night."

"Last night she ran out of hope."

They were staring at each other, remembering the bridge. Prentiss's eyes dropped first.

S HERIFF McCORMICK," BETH said into the phone. She was sitting in Mack's office looking out at the bit of river she could see and wondering whether she would survive her second press conference.

"What is this, some kind of joke? I asked to speak to the Latouche County sheriff." A man's voice, querulous.

"This is she." Very like an English teacher.

There was a disconcerted pause. "Well, I'm Warren Bjork, and I want to know what the hell—"

Beth interrupted him. "Your father is at the county hospital, Mr. Bjork. I suggest that you call them at once. We've been trying to reach you since last night."

Bjork spluttered something about Seattle.

"If you're in Seattle, you should come back as soon as you can. There seems to be no serious injury, but he's suffering from hypothermia. At his age that's serious."

"I heard…is it true that my stepmother is dead?"

"Yes." Beth opened her mouth to explain the circumstances and decided she couldn't do it twice in less than an hour. She checked her watch. "If that's all, Mr. Bjork, I'm scheduled for a press conference in twenty minutes. My condolences on your stepmother's death. Good-bye." She hung up. What an unpleasant man. He'd probably sue the county.

She wondered what was going to happen to the Bjork estate and to Cate's estate. When Beth had talked to Maddie that morning, Maddie had described the elaborate house. Was it Cate's house,

or had it been built with Bjork money? If the latter, then Warren Bjork would own it eventually. The thought was intolerable. Beth let her mind ramble around possible solutions.

The press conference went as well as could be expected. Ellen Koop kindly sat in on it with her, though the only prosecution in the works was the case against Matt Akers for soliciting grievous bodily harm. Rob, the victim, wanted to drop it, Ellen didn't. Beth didn't care, and neither, she suspected, did the press. It was good to let Akers sweat.

Beth supplied the reporters with facts that were relevant to all the investigations. She had no doubt the media would engage in wild theories about Inger's conduct as well as her death. As for Cate Bjork's death, the spectacular dive into the river would call for internal investigation on the part of the state patrol, at the very least. However, Prentiss had not been in pursuit when Cate went off the bridge. Beth hoped none of the blame would slop over onto Rob. He had been trying to prevent a chase across the bridge, after all.

Beth had allowed fifteen minutes for questions after her prepared statement, and she managed to respond to them without catastrophe. Maddie Thomas was in the audience. Strictly speaking, she was not press, but Beth took her question anyway.

"Sheriff McCormick, have you given any thought as to who will replace Commissioner Bjork?"

No, but I'll bet you have. Beth almost said that. She responded with odious piety to the effect that it was way too early to think of replacements. She hoped that didn't make Madeline angry. They would surely hold another special election. She hoped *she* didn't have to choose the new candidate. On the other hand…

As she made her slow way back to her office, leaning heavily on the walker, she turned the question over in her mind. She found Rob, Karl Tergeson, and a wild-eyed Hank Auclare waiting for her.

Ramona said, "I thought it was best to put them in there. Shall I bring coffee?"

"Bless you," Beth said rather faintly. She hadn't dared to ask Ramona for coffee for herself. "Uh, are there enough chairs?"

"Rob doesn't want to sit." Ramona bustled off.

As Beth entered the office both commissioners stood, Karl shakily.

Rob was standing by the window. He turned. "How did it go?"

"Well enough."

"No thanks to me," Rob said ruefully.

"I didn't say that." She smiled at him. "Ellen had to leave." She turned to Karl, balanced on her good leg, and held out both hands. "My dear, I am so sorry."

Karl took her hands, tears in his eyes. "Thank you. I hung up on you, Beth. I wasn't…I didn't…"

"It's all right, Karl." She edged the walker over to her chair and sat with a thud.

"Unanswerable questions?" Rob again.

"Lots. I no-commented extensively."

Rob smiled.

"You have to talk Karl out of it," Hank wailed, coming out of nowhere. "He wants to resign!"

Beth shut her eyes.

Karl said, "I have to resign. My little girl…"

Karl's resignation was going to look like an admission of guilt. All of them knew that. None of them said it. And Hank was not a stalwart personality. If the Board were besieged he'd surrender at the first boom of the cannon. Then they'd have to replace all three commissioners.

Wait a minute, Beth thought. Is this a bad thing or a good thing?

With suspicious timing, Ramona came in at that point and even volunteered to pour. Beth let her. She didn't have the strength to lift the coffeepot herself.

———

When Meg came through the kitchen door at six-thirty Rob was already there. A bottle of Laphroaig reposed on the table, two New York–cut steaks marinated in a plastic bag beside a heap of thawing chanterelle mushrooms, and the aroma of baking potatoes reminded her that she had skipped lunch.

She plunked her bookbag, briefcase, and purse on the nearest chair and clasped her hands soulfully. "You're fixing your Meal!"

He gave her a sidelong grin. Rob wasn't a bad cook, but he had only one menu designed to impress the unwary. He had fixed it the first time he cooked for her. He turned back to the oakleaf lettuce he was washing.

"Where did you get the booze?" Her search for Red Label the night before had been fruitless. "Ah, you took Beth home and popped in for supplies while you were at it."

"It's useful to have two pantries." He began blotting the greens dry on a clean dish towel, at least she hoped it was clean.

"What's the occasion?"

"Bridge building. Fence mending."

"Ah. Well, it's Charlie you ought to be cooking for."

"First fences first. Besides, Charlie's teaching tonight."

"So he is." She grabbed her belongings and took them to her office. She had forty-two e-mail messages, thirty of them spam and one a nice long letter from Lucy. She saved that one and whisked into the bathroom. When she had scrubbed her hands and tidied her short curls she looked at herself. Am I ready for this? No.

She stalked to the kitchen. "About your cousin—"

"I know. Charlie's a good kid."

"Charlie is a good man."

A pause. "Yes, he is." The Laphroaig had disappeared, probably into the drinks cabinet. They tended to treat it like brandy. He poured two glasses of local pinot noir and handed one to her.

She sat. "Guess who came to the library this afternoon?"

"No idea." He saluted with his wine glass and took a sip.

"Dede Marquez and daughter."

"No kidding. How's Kayla?" He set out a plate of table water crackers and Brie.

"Bruised and bored but unbowed." She slathered a cracker with Brie, ate it, and began to feel more civilized. "You know how it is at the library at that time of day."

"Schoolkids doing homework and hanging out, mothers with toddlers, tourists wanting to use the Wi-Fi, unemployed guys reading the help-wanted ads, retired gents whose wives kick them out of the house—"

"It's a circus. I was at the Information desk when Dede and Kayla

entered. One of the teenagers spotted them and shouted, 'Hey, it's Kayla,' and the next thing I knew they were all applauding, even my staff, even little tots." She waved another laden cracker.

"No kidding?"

"They just stood there and clapped. Kayla turned bright red, and Dede started crying. *I* was crying." She sniffed, remembering. "I hustled them into my office before Kayla died of embarrassment, and some kind soul, not Marybeth, brought coffee."

Rob sighed. "Kayla ought to run for county commissioner."

Meg stared at him, eyes narrowed. Of *course* someone would have to replace Cate Bjork. "Why not? She's a hero."

"She is." Rob smiled. "She'll have to contend with my candidate, though."

"Who?"

"Bat Quinn. The search and rescue guy."

"Why not Jack Redfern?"

"A good idea if Jack wouldn't die laughing first. One politician per family, Meg."

"Must be a local custom." She thought he was probably right. "So what did you talk about?"

"Kayla didn't say anything. Dede and I talked about Cate Bjork."

He frowned over another sip of wine.

"Cate was on Dede's mind. They were good friends once."

"Maybe Prentiss should interview her." He sounded indifferent.

Meg fired up. "Dede may have a strange angle on things, but she's an observant woman."

"Sorry. I don't doubt it. I shy away from thinking about the late commissioner at all. I don't even want to consider Ed Prentiss's state of mind."

Meg touched his hand, she couldn't help it. She said carefully, "According to Dede, Cate was a perfectionist, obsessed with her image of herself, but she wasn't particularly greedy."

He nodded. "The pre-nuptial settlement she got was modest relative to his wealth."

"Sounds like a lot to me, but I suppose you're right." Meg cocked her head. "Even though Lars Bjork's family gave her a bad time, she

took pride in her impeccable public conduct. And she loved him. At least that's what Dede said. You know, Cate wasn't a wide-eyed, silicon-enhanced starlet. She was a smart woman in her thirties with a sad history. She was grateful to Lars for rescuing her and determined to be a perfect companion. What she couldn't stand was betrayal."

"Unlucky in love," Rob mused.

"In a sense her first husband betrayed her. Dede said she was still bitter about that."

Rob was listening, eyes dark and intent. "If Fred and Lars betrayed her by their manipulation of the geological surveys—"

"The mudslide was the betrayal," Meg interposed.

"Dede said that?"

"Nope. I did. None of them believed the slide was going to happen. But I'll bet Cate wasn't the one who persuaded Inger to switch the reports."

"I agree with you." Rob got up and started to tear lettuce into the salad bowls. "There's no way to prove it."

"Except by talking to Lars."

Rob shook his head. "He's beyond that."

"Not all the time. Long-term memory fades in and out."

"I can try." He chopped a green onion, *whack, whack, whack.* "Not that it will do any good."

"It might ease your mind."

He chopped a radish and sprinkled the thin slices into the bowl. Then he turned up the heat under a pot and came back to the table. "You said the mudslide was the betrayal."

"She had just been elected as a green candidate when it happened."

"Maybe Fred and Inger threatened to come clean."

"Fred wouldn't have. I can believe it of Inger, from what you've said of her."

He told her what he knew of the letter that had been found in Inger's track suit. "It's consistent with what I know of Inger's character. She intended to confess, but she had to let Cate know she was going to admit to her role in the disaster."

"But Cate didn't wait to hear about it."

"Or read about it. Both killings were swift and ruthless."

"Anger," Meg said.

"Anger and impatience." He looked thoughtful. "Jack thinks Cate was edgy and impatient when she shoved Lars out of the car. It's a little hard to reconcile that with what Dede said about her loving her husband."

"She loved him before he betrayed her."

"Whew," Rob said. "I'm getting indigestion. Ready for steak?"

"Ready for chanterelles."

"Christ, I forgot them." He dolloped butter into her omelette pan, turned the steaming pot on the stove off and the pan on, and began sautéing. Timing was all.

Meg got up and set the table. He'd forgotten that, too. She thought she'd probably forgive him.

———

Charlie called Kayla at 9:50, right after class. "Are you all right?"

Kayla leaned back on the soft heap of pillows and closed her eye. "I'm just fine. You're never going to believe what happened today." She told him all about the library incident, clowning, and he laughed.

"Did they ask for autographs?"

"One did. This little girl with long braids and braces. She wants to be a nurse."

"I hope you signed. You're one hell of a good example."

She felt herself blushing all over. "Do you really think so?"

"You know I do."

Something unknotted at the back of her neck. "Will you take me back to the hospital in the morning?"

"If you can be ready at six." He had a nine o'clock lab.

"I'll be waiting in the lobby. Thank you, Charlie. How did your class go?"

"Nobody asked for my autograph, but it was okay. I may take that teaching job at Portland State. It's temporary, but I want to look around for a while anyway, think things over."

"Me, too," she said softly. "Me, too." She wondered if she could work with children. She hadn't done much with pediatrics....

———

Rob got to his office fairly early the next day in spite of a languorous good time the night before. He'd walked to work and even had a brief conversation with Towser on his way. Tammy Brandstetter was walking the dog herself these days and looking all the better for it. Maybe he and Meg needed a dog. No, what they needed was matrimony.

Meg knew when to push and when not to. He supposed he would have to learn that from her, too. Now was not the time to push. He knew that much, but Beth was going to move out of his house within the next week. He would have to make decisions.

When he saw the heap of papers in his in-box he almost turned around and walked out, and there was twice as much on the computer. Any investigation generates paper. He had the mudslide and those deaths, his abortive investigation of the missing hazard warning, the deaths of Fred Drinkwater and Inger Swets, his own mugging, and now the death of Catherine Bjork and the search for Lars. Whoever took over Inger's job would be occupied sorting and securing the records at least until the special election.

He wondered if Tammy Brandstetter would want to run for county clerk. She hadn't said anything. Maybe she hadn't thought of it. He flashed on Towser roaming the courthouse halls, bouncing at complete strangers, and decided not to mention the possibility.

He had reached for the papers and picked up a pen when the telephone rescued him.

"A Mrs. Gottfried, Rob." Marlene on the switchboard.

"Okay." He scrambled for an identity. Ah, Fred Drinkwater's exwife. Jeff had interrogated her on the phone. There was a transcript toward the bottom of the paper mountain. He fumbled for it. "Mrs. Gottfried, this is Robert Neill."

"I just heard about that Bjork woman's death."

"Ma'am?" He was still fumbling.

"Your commissioner," she said impatiently. "She and my ex were lovers, off and on. I told him she was just using him because the old man was past it."

"Hmmm." He finally found the sheet.

"Detective Fong wanted to know about Fred's investors, right?"

"Did Catherine Bjork invest in your former husband's project at Prune Hill?"

"Not her. She was too smart. I told the deputy that. It was her husband. He was a regular fountain of cash. Then, when she got power of attorney, she told Fred she was cutting him off. They had words."

"You didn't mention that to Sergeant Fong?"

"Well, he kept asking about Lars." There was a rustle of paper as if she were consulting notes.

Rob scanned rapidly.

> JF: *Lars Bjork was a major investor?*
> HG: *Yes, there at Prune Hill, and at that place in the east county with the condos, and earlier, in Seattle. He was generous. Said Fred was like a son to him.*

The woman on the telephone was saying something about her daughters' private school fees.

Rob cleared his throat. "Let me get this clear. After Mrs. Bjork got power of attorney, she refused to give Mr. Drinkwater more money?"

"Well, not exactly. She said she'd see him through on the Prune Hill construction, but there had to be a proper accounting from then on. She put a stop to the big cash gifts. That was more than a year ago. Fred was a fool about the Bjorks. I told him they'd squash him like a bug when they got tired of him. There was some survey or other earlier…"

Rob held his breath.

"Something to do with soils. Sorry I can't be more specific. When Fred started bragging I stopped listening. He got Lars Bjork to ask one of the clerks at the courthouse for a favor, because otherwise the plans for the project wouldn't be approved."

"You're sure of that?"

"Well, it's kind of foggy. That was way back, a year and a half

at least. Fred was real happy. The bulldozers moved in that week and they dug the foundations. Then, a couple of months later, Mrs. Bjork quarreled with him. Told him she'd found copies of two surveys. They didn't agree, these two surveys. She'd consulted her lawyers, and would he please explain what the documents meant. Fred lost his temper, I guess, told her that it was her husband who had leaned on the clerk for a favor. That made Catherine mad. I told you they'd been lovers. After that, she wouldn't have anything to do with Fred socially. He saw her, but just in the way of business. He was worried, I think, though he still talked big."

Rob got out a fresh sheet of paper. "Okay, Mrs. Gottfried, I can see that I need to speak to you in more detail. Lieutenant Prentiss of the State Patrol may want to sit in on the interview."

She sounded frightened but agreed to come to Klalo after she had talked to her husband.

When they had both hung up, Rob called Warren Bjork and found out exactly when Cate had been granted power of attorney for her husband. By that time the Prune Hill construction had been well under way. It was not much satisfaction to know he had been right.

I'll have to call Charlie, he thought. He would have to tell Prentiss right away, of course, and Beth. And the prosecutor. Ellen would want a thorough examination of the Bjorks' business dealings in Latouche County. And Ellen or Beth would have to call the attorney general. The ramifications made Rob's head spin, and nothing he did was going to bring Mack back to life, or the Gautiers, or Inger, or Kayla's patient, or the poor kid in the lowrider, but at least there would be an accounting.

He drew the office phone to him to call Prentiss, then pushed it away, took out his cell phone instead, and called the main branch of the Latouche County Library. Meg answered on the first ring.

Epilogue

KAYLA GRAVES did not run for county commissioner. Bat Quinn did. Unopposed. After much persuasion, Karl Tergeson agreed to stay on the board until the next general election, but he intends to retire. Inger Swets's senior deputy was named to serve out Inger's term as county clerk, after Lt. Prentiss cleared her of any collusion. Beth McCormick declined to join the lawsuit the other survivors of the Prune Hill slide filed against the county. The case will be heard next year. It's likely the attorney general will settle generously, which may explain why Meg's levy failed to pass.

Madeline Thomas did not get her casino either. She doesn't need the casino. When Lars Bjork died of pneumonia about six months after his son placed him in the Memory Unit of the Beaver Creek Retirement Village, Warren announced, with much fanfare, that he was going to donate his father's Latouche County house to the Klalo Nation along with the road and a corridor of trees. The Klalos will operate the house as an exclusive destination resort for lovers of nature, with Maddie's cousin Bitsy Thomas as resident housekeeper. Profits from the hotel will fund a craft center in Two Falls. Sheriff McCormick is actively promoting a county health clinic in Two Falls as well. The remainder of Lars Bjork's county property, primarily forest surrounding the Klalo hotel, will go to the State of Washington in lieu of taxes.

Warren Bjork's fit of generosity came about as the result of delicate cajolery on the part of Chief Thomas, somewhat less delicate nudging in that direction on the part of Sheriff McCormick, and a hearty kick from the attorney general.

Catherine Parrish Bjork's substantial and well-invested estate, accrued from her marital settlement, was divided equally in her will among the Sierra Club, the Nature Conservancy, and the Columbia Gorge Foundation.

As for the county, it is still as beautiful as a Chinese watercolor on cold winter days, the prevailing winds still blow east and west, and when the mountains to the north and south rumble in their uneasy slumber, the land still moves.

Mickey Simonson

ABOUT THE AUTHOR

Sheila Simonson is the author of eleven novels, seven of them mysteries. She taught English and history at the community college level until she retired to write full-time. She is the mother of a grown son and lives with her husband in Vancouver, Washington. She likes to hear from readers, who can visit her website at http://sheila.simonson.googlepages.com.

MORE MYSTERIES
FROM PERSEVERANCE PRESS
🔎 *For the New Golden Age* 🔎

JON L. BREEN
Eye of God
ISBN 978-1-880284-89-6

TAFFY CANNON
ROXANNE PRESCOTT SERIES
Guns and Roses
*Agatha and Macavity Award
nominee, Best Novel*
ISBN 978-1-880284-34-6

Blood Matters
ISBN 978-1-880284-86-5

Open Season on Lawyers
ISBN 978-1-880284-51-3

Paradise Lost
ISBN 978-1-880284-80-3

LAURA CRUM
GAIL MCCARTHY SERIES
Moonblind
ISBN 978-1-880284-90-2

Chasing Cans
ISBN 978-1-880284-94-0

Going, Gone *(forthcoming)*
ISBN 978-1-880284-98-8

JEANNE M. DAMS
HILDA JOHANSSON SERIES
Crimson Snow
ISBN 978-1-880284-79-7

Indigo Christmas
ISBN 978-1-880284-95-7

KATHY LYNN EMERSON
LADY APPLETON SERIES
**Face Down Below
the Banqueting House**
ISBN 978-1-880284-71-1

**Face Down Beside
St. Anne's Well**
ISBN 978-1-880284-82-7

Face Down O'er the Border
ISBN 978-1-880284-91-9

ELAINE FLINN
MOLLY DOYLE SERIES
Deadly Vintage
ISBN 978-1-880284-87-2

HAL GLATZER
KATY GREEN SERIES
Too Dead To Swing
ISBN 978-1-880284-53-7

A Fugue in Hell's Kitchen
ISBN 978-1-880284-70-4

The Last Full Measure
ISBN 978-1-880284-84-1

PATRICIA GUIVER
DELILAH DOOLITTLE
PET DETECTIVE SERIES
The Beastly Bloodline
ISBN 978-1-880284-69-8

WENDY HORNSBY
MAGGIE MACGOWEN SERIES
In the Guise of Mercy
ISBN 978-1-56474-482-1

NANCY BAKER JACOBS
Flash Point
ISBN 978-1-880284-56-8

DIANA KILLIAN
POETIC DEATH SERIES
Docketful of Poesy
ISBN 978-1-880284-97-1

JANET LAPIERRE
PORT SILVA SERIES
Baby Mine
ISBN 978-1-880284-32-2

Keepers
*Shamus Award nominee,
Best Paperback Original*
ISBN 978-1-880284-44-5

Death Duties
ISBN 978-1-880284-74-2

Family Business
ISBN 978-1-880284-85-8

Run a Crooked Mile
ISBN 978-1-880284-88-9